FALAISE POCKET

DEFEATING THE GERMAN ARMY IN NORMANDY

PAUL LATAWSKI

SERIES EDITOR: SIMON TREW

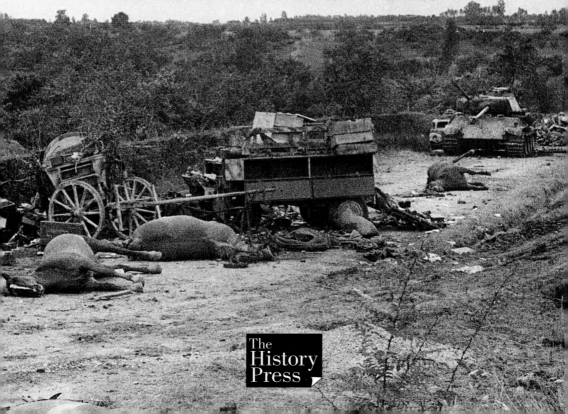

The History Press

While every effort has been made to ensure that the information given in this book is accurate, the publishers, the author and the series editor do not accept responsibility for any errors or omissions or for any changes in the details given in this guide or for the consequence of any reliance on the information provided. The publishers would be grateful if readers would advise them of any inaccuracies they may encounter so these can be considered for future editions of this book.

The inclusion of any place to stay, place to eat, tourist attraction or other establishment in this book does not imply an endorsement or recommendation by the publisher, the series editor or the author. Their details are included for information only. Directions are for guidance only and should be used in conjunction with other sources of information.

Front cover: American soldiers pose with a Nazi flag at Chambois on 20 August. *(USNA)*

Page 1: Monument in the town of Chambois commemorating the meeting of the Allied armies in their attempt to close the Falaise Pocket. *(Author)*

Page 3: A view of a road in the area of the Mace, possibly the D16. In the distance is a Panther, a tank that was highly feared by Allied tank crews. *(Polish Institute and Sikorski Museum [PISM] 2834)*

Page 7: On 26 August 1944, Sherman tanks of 4th Canadian Armoured Division drive through Bernay. *(NAC PA 135957)*

First published 2004 as part of the Battle Zone Normandy series
This edition published 2012

The History Press
The Mill, Brimscombe Port
Stroud, Gloucestershire, GL5 2QG
www.thehistorypress.co.uk

© Paul Latawski, 2004, 2012
Tour base maps © Institute Géographique National, Paris
GSGS (1944) base maps © The British Library/Crown Copyright

British Library Cataloguing in Publication Data.
A catalogue record for this book is available from the British Library.

ISBN 978 0 7524 7663 6

Typesetting and origination by The History Press
Printed in India.
Manufacturing managed by Jellyfish Print Solutions Ltd

CONTENTS

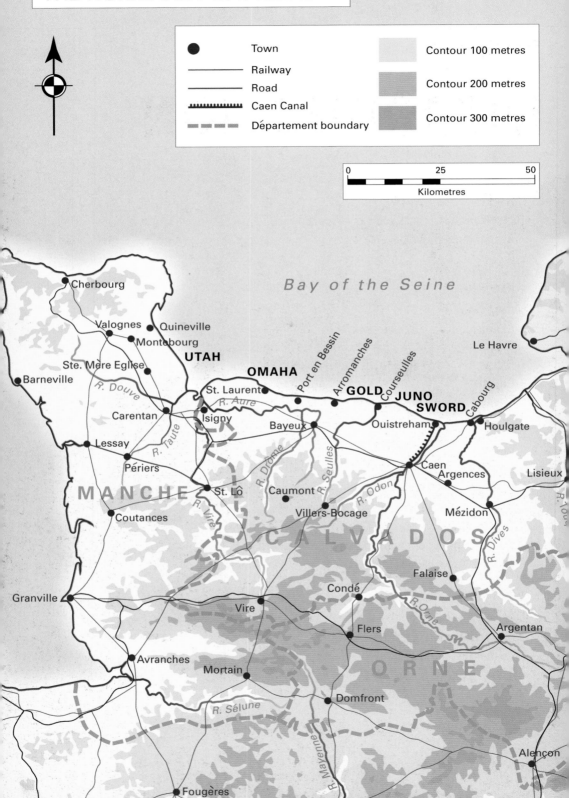

THE NORMANDY BATTLEFIELD

Legend
- Town
- Railway
- Road
- Caen Canal
- Département boundary
- Contour 100 metres
- Contour 200 metres
- Contour 300 metres

0 25 50
Kilometres

Bay of the Seine

Cherbourg
Valognes Quineville
Montebourg
Ste. Mère Eglise UTAH
Barneville *R. Douve* OMAHA Port en Bessin Arromanches Courseulles Le Havre
St. Laurent GOLD JUNO
Carentan Isigny *R. Aure* SWORD Cabourg
Lessay *R. Taute* Bayeux Ouistreham Houlgate
Périers *R. Drôme* *R. Seulles* Caen Lisieux
MANCHE St. Lô *R. Odon* Argences
Coutances *R. Vire* Caumont Mézidon
CALVADOS *R. Dives*
Villers-Bocage
Granville *R. Orne* Falaise
Condé
Vire *R. Orne* Argentan
Flers
Avranches **ORNE**
Mortain *R. Dives*
R. Séulne Domfront Alençon
R. Mayenne
Fougères

PART ONE

INTRODUCTION

BATTLE ZONE NORMANDY

The Battle of Normandy was one of the greatest military clashes of all time. From late 1943, when the Allies appointed their senior commanders and began the air operations that were such a vital preliminary to the invasion, until the end of August 1944, it pitted against one another several of the most powerful nations on earth, as well as some of their most brilliant minds. When it was won, it changed the world forever. The price was high, but for anybody who values the principles of freedom and democracy, it is difficult to conclude that it was one not worth paying.

I first visited Lower Normandy in 1994, a year after I joined the War Studies Department at the Royal Military Academy Sandhurst (RMAS). With the 50th anniversary of D-Day looming, it was decided that the British Army would be represented at several major ceremonies by one of the RMAS's officer cadet companies. It was also suggested that the cadets should visit some of the battlefields, not least to bring home to them the significance of why they were there. Thus, at the start of June 1994, I found myself as one of a small team of military and civilian directing staff flying with the cadets in a draughty and noisy Hercules transport to visit the beaches and fields of Calvados, in my case for the first time.

I was hooked. Having met some of the veterans and seen the ground over which they fought – and where many of their friends died – I was determined to go back. Fortunately, the Army encourages battlefield touring as part of its soldiers' education, and on numerous occasions since 1994 I have been privileged to return to Normandy, often to visit new sites. In the process I have learned a vast amount, both from my colleagues (several of whom are contributors to this series) and from my enthusiastic and sometimes tri-service audiences, whose professional insights and penetrating questions have frequently made me re-examine my own assumptions and prejudices. Perhaps inevitably, especially when standing in one of Normandy's beautifully-maintained Commonwealth War Graves Commission cemeteries, I have also found myself deeply moved by the critical events that took place there in the summer of 1944.

The hardback 'Battle Zone Normandy' series (now published in paperback with the series motif 'D-Day') was originally conceived by Jonathan Falconer, Commissioning Editor at Sutton Publishing, in 2001. Why not, he suggested, bring together recent academic research – some of which challenges the general perception of what happened on and after 6 June 1944 – with a perspective based on familiarity with the ground itself? We agreed that the opportunity existed for a series that would set out to combine detailed and accurate narratives, based mostly on primary sources, with illustrated guides to the ground itself, which could be used either in the field (sometimes quite literally), or by the armchair explorer. The book in your hands is the product of that agreement.

The series consisted of 14 volumes, covering most of the major and many of the minor engagements that went together to create the Battle of Normandy. The first six books deal with the airborne and amphibious landings on 6 June 1944, and with the struggle to create the firm lodgement that was the prerequisite for eventual Allied victory. Five further volumes cover some of the critical battles that followed, as the Allies' plans unravelled and they were forced to improvise a battle very different from that originally intended. Finally, the last three titles in the series examine the fruits of the bitter attritional struggle of June and July 1944, as the Allies irrupted through the German lines or drove them back in fierce fighting. The series ends, logically enough, with the devastation of the German armed forces in the 'Falaise Pocket' in late August.

Whether you use these books while visiting Normandy, or to experience the battlefields vicariously, we hope you will find them as interesting to read as we did to research and write. Far from the inevitable victory that is sometimes represented, D-Day and the ensuing battles were full of hazards and unpredictability. Contrary to the view often expressed, had the invasion failed, it is far from certain that a second attempt could have been mounted. Remember this, and the significance of the contents of this book, not least for your life today, will be the more obvious.

Dr Simon Trew
Royal Military Academy Sandhurst
December 2003

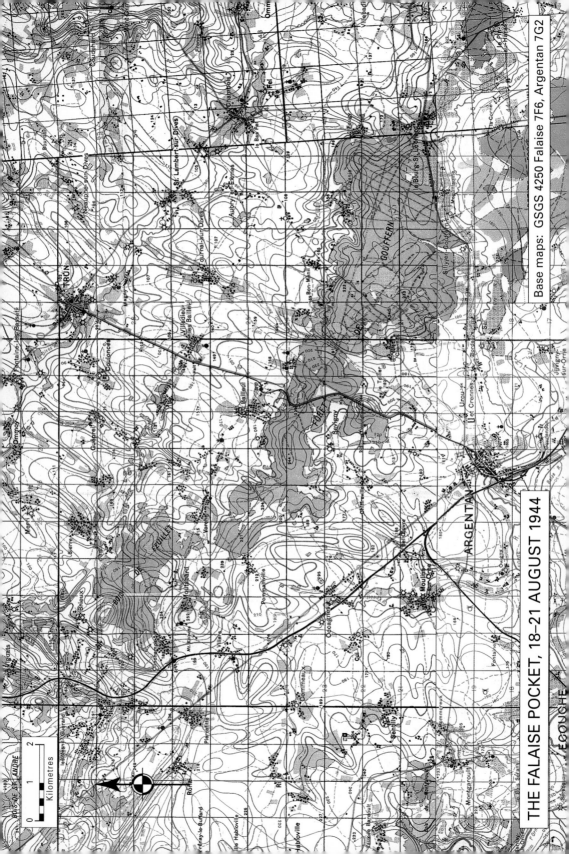

THE FALAISE POCKET, 18–21 AUGUST 1944

Base maps: GSGS 4250 Falaise 7F6, Argentan 7G2

FOREWORD

Struggling for the freedom of one's own country whilst on foreign soil is not a common experience in the history of warfare. In the case of Poland, battles for independence carried abroad were immortalised by the words of the National Anthem originating from the Napoleonic era. In keeping with this tradition, following the German invasion of Poland in 1939, many thousands of Polish soldiers escaped to the West to fight for the re-establishment of Poland, regardless of the hardship and sacrifice involved. The 'Sikorski Tourists' as the Germans called them, made their way to France and, after its fall, to England. I was one of Sikorski's tourists in the 1st Polish Armoured Division under the command of Major-General Stanisław Maczek.

1st Polish Armoured Division was formed of veterans of the Polish, French and Norwegian campaigns. The invasion of France in 1944 was, for the division, the beginning of its long-awaited main task. As part of First Canadian Army, in General Montgomery's 21st Army Group, it sustained considerable losses whilst engaged in the decisive action of the Battle of Normandy – the Falaise Pocket. On direct orders from Montgomery, the division surprised the Germans by penetrating deeply behind the front lines to close the Falaise gap. It plugged the gap by occupying the dominating hills near Mont-Ormel, which were dubbed the Mace (*Maczuga*) by Major-General Maczek as on the map the contour lines reminded him of the shape of this medieval weapon. For four days the Polish regiments on the Mace fought against the German troops now trapped in the pocket and against panzer divisions attacking from the outside in an attempt to re-open the routes of retreat. The Polish armour and infantry

Maj-Gen Stanisław Maczek in his command tank. *(PISM 2479)*

While parts of Falaise were still being cleared of pockets of German resistance, Canadian convoys were passing through other parts of the town as buildings still burned. The lorry is towing a 40-mm Bofors anti-aircraft gun. *(NAC PA-115570)*

fought alone on the Mace as other Allied units could not break through to their positions. Eventually the Canadians arrived bringing supplies and ammunition. Uncountable numbers of dead Germans and destroyed vehicles remained on the 'Polish Battlefield' as it became known amongst the British forces.

In August 1944 I was a 22-year-old lieutenant commanding a platoon of Sherman tanks in the 3rd Squadron of 2nd Polish Armoured Regiment fighting on the Mace. Those four days were amongst the most dramatic I experienced in the Second World War. Along with the other soldiers of the Allied armies, those of the 1st Polish Armoured Division contributed to the victory in Normandy by their efforts to close the Falaise gap on the Mace and at Chambois. Sixty years on from those trying days it is important to remember the sacrifice and losses of the American, British, Canadian and Polish soldiers in the battle of the Falaise Pocket. Although so many years have elapsed since those days of struggles, hopes and disappointments, they will always remain in our memories with the awareness of all duties well discharged.

Zbigniew Mieczkowski (Captain, Retired)
1st Polish Armoured Division

ACKNOWLEDGEMENTS

There are many people who deserve thanks for the role that they played in the gestation of this book. First my thanks go out to many of my colleagues: Dr Simon Trew who encouraged me to take on this project and who has been extremely helpful in passing on his experience and advice as series editor; Dr Christopher Pugsley for kindly gathering documents and photographs from the American archives and acting as a sounding board and endless well of enthusiasm; Dr Stephen Hart who generously shared his expertise on the Canadian Army in Normandy; and Andrew Orgill and his team at the Central Library, RMA Sandhurst, who patiently and efficiently addressed my many reference queries. Discussions with my distinguished gunner colleague, Major R.A. McPherson RA, helped me with the intricacies of Second World War artillery employment.

I also thank Monsieur and Madame Billaux of Chambois whose hospitality, memories of the war and keen interest in local history were so helpful.

A very big thank you goes out to Jonathan Falconer, Nick Reynolds, Donald Sommerville and the other members of the Sutton team who rose so magnificently to the challenges of such an ambitious series as the one of which this book is part.

Among the many institutions consulted in preparation of this book, one stands out as a treasure trove of papers and photographs: The Polish Institute and Sikorski Museum (PISM) in London. While many military historians are familiar with the American, British and Canadian Archives, PISM is less well known but contains an outstanding archival collection on the Polish armed forces in the west. Very special thanks go to PISM's Dr Andrzej Suchcitz, Keeper of the Archives, Captain Wacław Milewski, Keeper of the Archives (emeritus) and Krzystof Barbarski, Chairman of PISM for their great help in collecting material for this project. *Dziękuję Bardzo!*

US infantry enter Argentan on 20 August after heavy fighting. The German hold on this town was critical for units of the German Army seeking to make their escape from the Falaise Pocket. *(United States National Archives [USNA])*

In addition, I offer my sincere thanks to Mr Zbigniew Mieczkowski, formerly an officer of 1st Polish Armoured Division, who kindly agreed to provide the foreword to this book and who conveyed so many insights into the battle of the Falaise Pocket from his own experiences on the *Maczuga*.

Finally, I thank my wife Dorina and my son Christopher who so patiently endured my enthusiasm for military history and who were of great assistance in translating and navigating through the Normandy countryside during the preparation of this project. I dedicate this book to them with my love.

Dr Paul Latawski
Royal Military Academy Sandhurst

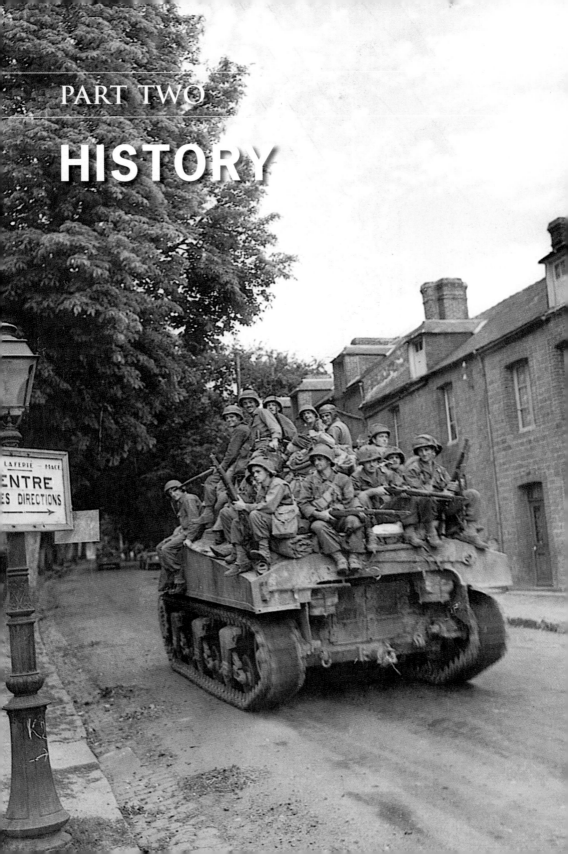

PART TWO

HISTORY

BACKGROUND

On 6 June 1944 the armed forces of the Allied coalition landed on the beaches of Normandy to begin what its commander, General Dwight D. Eisenhower, famously called the 'great crusade' to liberate Europe. The landing on D-Day of American, British and Canadian forces from 21st Army Group marked the beginning of the Battle of Normandy, which lasted almost three months before its successful conclusion in late August 1944. The Allied offensive in Normandy developed in a number of phases: the establishment of a bridgehead on the Normandy coast; the widening of the lodgement area and build-up of Allied manpower and matériel; the attritional battles fought against the *Wehrmacht* (German armed forces); and the culmination that saw the Allied break-out, encirclement and defeat of German forces in Normandy two and a half months later. The final defeat of

Right: A 17-year-old SS soldier captured in the first half of August 1944. The demeanour of this prisoner says much about the nature of *Waffen-SS* formations in Normandy. *(PISM 2529)*

Page 15: In First US Army's drive north to form the southern rim of the pocket, a Sherman tank enters la Ferté-Macé with infantry catching a welcome ride, 14 August. *(USNA)*

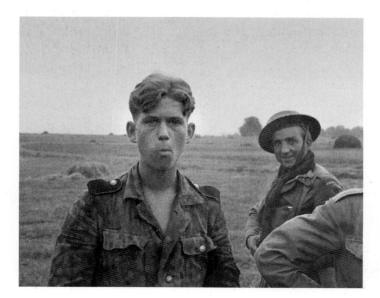

the German Army in Normandy came during the battle of the Falaise Pocket.

As the battle of the Falaise Pocket is the subject of this book, an essential starting point is to consider the terminology associated with this great clash of arms. The confusion in naming the battle is illustrated very nicely by the memoirs of some of the principal Allied commanders. In his own account General Sir Bernard Montgomery used the expression 'Mortain–Falaise pocket', describing the maximum length of the encirclement on a roughly west–east axis. By contrast, General Omar N. Bradley referred in *A Soldier's Story* to the 'Argentan–Falaise pocket', indicating, again in a general manner, the dimensions of the encircled area, but this time on a north–south axis. General George S. Patton, Jr., in his *War As I Knew It*, simply called it the 'Falaise gap', reflecting a perspective that focused on the struggle to close the eastern exit from the pocket. Among historians there is more agreement about what to call the battle. The author of what remains the standard history, Eddy Florentin, in both his English and French accounts, uses the battle of the 'Falaise pocket' (*la poche de Falaise*). Most histories of the Battle of Normandy also use this title. One notable exception is Martin Blumenson. In his official history of US operations, *Breakout and Pursuit*, he describes the battle as being for the 'Argentan–Falaise pocket', but in his more recent work, *The Battle of the Generals*, he uses 'Argentan–Falaise gap'. In choosing to use the term 'battle of the Falaise Pocket', this book not only follows what has emerged among historians as the standard usage but also, by using 'pocket', emphasises the widest perspective geographically in the development of the encirclement. The Normandy town that bequeaths its name to the battle, Falaise, is actually no more important to the story than other towns in that part of Normandy. Its name, however, has become inextricably linked to the battle.

Determining the end of the battle of the Falaise Pocket is easy enough. With the overrunning of the pocket by Allied armies on 21 August 1944 the struggle came to a finish, bar the mopping up of remnants of German units. Deciding when and where the battle began, however, is more difficult. On the

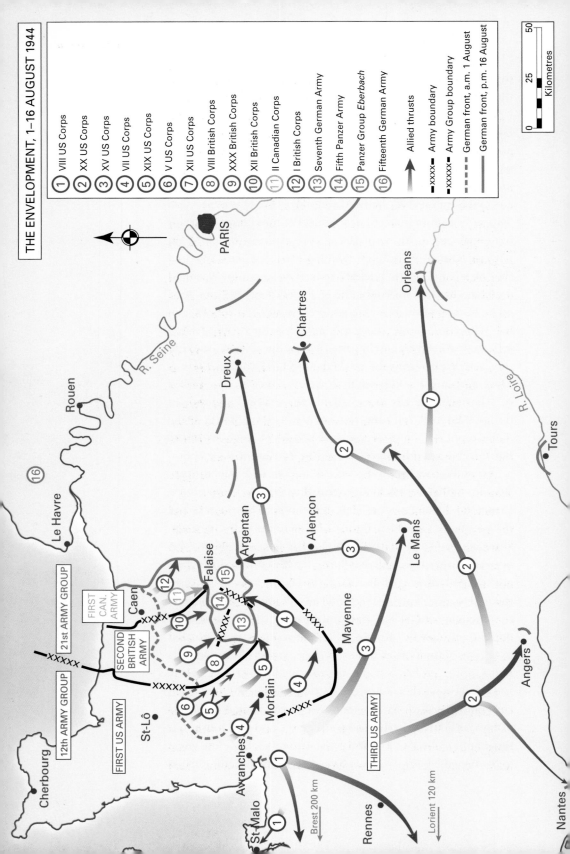

THE ENVELOPMENT, 1–16 AUGUST 1944

1 VIII US Corps
2 XX US Corps
3 XV US Corps
4 VII US Corps
5 XIX US Corps
6 V US Corps
7 XII US Corps
8 VIII British Corps
9 XXX British Corps
10 XII British Corps
11 II Canadian Corps
12 I British Corps
13 Seventh German Army
14 Fifth Panzer Army
15 Panzer Group Eberbach
16 Fifteenth German Army

Allied thrusts
xxxxx Army boundary
xxxxx Army Group boundary
German front, a.m. 1 August
German front, p.m. 16 August

Kilometres
0 25 50

PARIS

R. Seine

Rouen

R. Loire

Tours

Orleans

Chartres

Dreux

Le Havre

Argentan

Alençon

Le Mans

Falaise

Caen

Mayenne

St-Lô

Mortain

Avranches

Cherbourg

St-Malo

Rennes

Angers

Nantes

Brest 200 km

Lorient 120 km

21st ARMY GROUP

12th ARMY GROUP

FIRST CAN. ARMY

SECOND BRITISH ARMY

FIRST US ARMY

THIRD US ARMY

northern shoulder of the pocket stood the Anglo-Canadian 21st Army Group, including Second (British) Army and First Canadian Army, marking the pocket's limits from the beginning of August. Defining the southern perimeter of the pocket represented work in progress in early August; First and Third US Armies of 12th Army Group were wheeling northward from the Mayenne region at this time and only firmly established the pocket's southern boundary by mid-August. Arguably, the battle of the Falaise Pocket began only with the northward movement of First and Third US Armies. Nevertheless, while forming a necessary prelude, the encirclement from the south only set the stage for the final decision. With the completion of the pocket on three sides and only a narrow exit remaining on its eastern side for the beleaguered German forces, the battle of the Falaise Pocket approached its endgame. On 16 August, with Hitler's tardy approval, *Generalfeldmarschall* (Field Marshal) Günther von Kluge ordered a withdrawal eastwards out of the pocket by the German Seventh Army, Fifth Panzer Army and Panzer Group *Eberbach*. Thus the closure and final reduction of the Falaise Pocket took place between 16 and 21 August 1944 as the Allies pressed in on the retreating German forces.

As is evident from the discussion above, the struggle around the Falaise Pocket developed within the context of a battlefield that encompassed sizeable areas of Normandy and the periphery of other regions of France. Despite its scale, however, the battle of the Falaise Pocket was actually decided in a comparatively small rural area. Although this study does not use the word 'gap' in naming the battle, the struggle to close the gap separating the Allied armies and to complete the envelopment of German forces represents, in many respects, the key element in the battle. This struggle was conducted in a quiet corner of the Pays d'Auge in eastern Normandy.

Then, as now, the Pays d'Auge was a rural and lightly populated agricultural region. The Falaise Pocket battlefield largely comprised the gently rolling open country of the valley of the River Dives, bordered on the east and south by a ridge line that masked a landscape of small valleys and steep hills. Today, the open areas have been given over to cereal

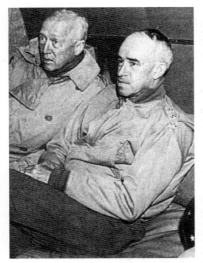

Patton (left)
and Bradley.
Despite Bradley's
subordinate
position to that
of Patton earlier
in the war, they
worked well
together in
1944, although
privately Patton
despaired from
time to time at
Bradley's lack
of imagination.
(USNA)

production and the higher ground is more often than not carpeted with woodlands. Although the apple orchards for which Normandy is so famous can still be found, they were a more dominant feature of the countryside in 1944.

Within this tranquil landscape, the epicentre of the efforts to close the gap and decide the battle of the Falaise Pocket was an 18 square kilometre triangle drawn between three points: the small towns of Trun and Chambois and the hamlet of Coudehard. Trun and Chambois are in the undulating but reasonably open ground of the Dives valley while Coudehard rests at the base of the ridge line and rugged country on the eastern edge of the battlefield. It was here that the defining moment of the Battle of Normandy took place as American, Canadian and Polish forces struggled to seal the Falaise Pocket. The fighting in this triangle provided some of the most dramatic and gritty actions of the Second World War and the most compelling images of wartime destruction of the men, machines and horses of the *Wehrmacht*. One of the principal historians of the battle described its destructive effects as being 'Stalingrad in Normandy'. The battle of the Falaise Pocket ended in an Allied victory but one full of pathos.

ALLIED TENSIONS: COMMANDERS AND CONTROVERSIES

The scale and nature of the Allied victory in the battle of the Falaise Pocket has been much debated. Indeed, the battle has emerged as one of the most controversial episodes of the Second World War, especially with regard to the decisions taken by the major Allied commanders. The figures at the centre of these controversies include Lieutenant General (Lt-Gen) Omar N. Bradley, who commanded 12th Army Group, and Lt-Gen George S. Patton, Jr., who was Bradley's subordinate and commander of Third US Army. At the time of the Normandy battle Bradley was 51 years old. He had been a classmate of Eisenhower at West Point and had been identified by General George C. Marshall, the US Army Chief

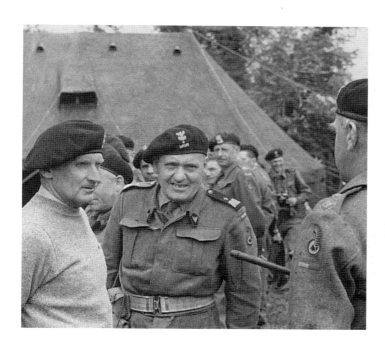

General Montgomery on a visit to the headquarters of 1st Polish Armoured Division. The division's commander, Maj-Gen Stanisław Maczek, introduces the 21st Army Group commander to a British liaison officer. *(PISM 2443)*

of Staff, as a rising star on the eve of America's entry into the war. From a family of poor Missouri farmers, Bradley possessed a homespun and unostentatious manner. Despite this, he displayed a number of qualities including pragmatism and toughness, even if some of his critics considered him lacking in imagination. Patton, his subordinate in Normandy, was strikingly different. Flamboyant and at times highly controversial, Patton was nevertheless one of the truly outstanding American commanders of the war. At 59, he was older than Bradley and the latter had actually served under him in North Africa and Sicily. The notorious incidents in Sicily when Patton slapped hospitalised soldiers nearly ended his wartime career and contributed to his becoming Bradley's subordinate in France. Despite some underlying tensions stemming from the role reversal, the Bradley–Patton relationship was a reasonably effective one in which each understood his own and the other's role – particularly the more experienced Patton who accepted his subordinate position.

During the Battle of Normandy, General Sir Bernard L. Montgomery not only led 21st Army Group but was also the senior Allied land commander. Montgomery was

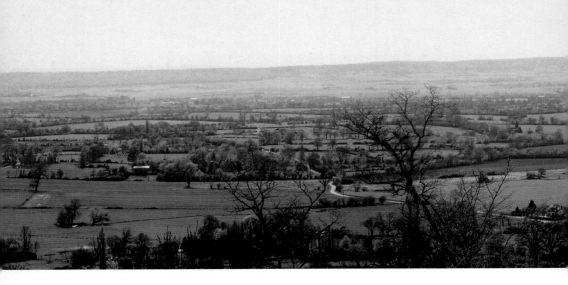

A panorama of the Dives river valley looking westward into the pocket from the Mace. This section between Chambois and Trun was the epicentre of the battle to close the Falaise Pocket. *(Author)*

without question the most experienced Allied general. He had led a British division ably in Belgium in 1940 and was the victor in North Africa at El Alamein and a series of other battles. Although Montgomery had a well-deserved and formidable reputation, arising from his organisational skills and an ability to grasp the essence of problems, his personal qualities were often a source of friction at the highest levels of command. In particular, he sometimes displayed a conceited and cocksure manner that irritated his American counterparts (and some senior British figures). In Normandy, Montgomery's command over both US and British armies was intended only as a temporary arrangement. America's larger contribution made this inevitable. General Dwight D. Eisenhower was already nominally Montgomery's boss and once Eisenhower moved his headquarters to France his role as overall commander of the Allied land forces would no longer be delegated. The 54-year-old Eisenhower was another of Marshall's stars. What Eisenhower lacked in wartime operational experience he made up for in diplomatic skills and strategic vision. Although his hands-off approach during the Normandy battle sometimes exasperated American commanders, Eisenhower had the difficult job of managing a coalition, which he did successfully.

All of these Allied generals were able, effective and successful. The very stellar qualities they possessed, however, also led to difficulties in their relationships. Indeed, the battle

of the Falaise Pocket has produced some of the most enduring and passionate debates about the conduct of operations resulting from the decisions of these senior commanders.

Despite the debates that have raged among historians over the battle of the Falaise Pocket, the indisputable fact is that it was a major Allied success which confirmed the defeat of the German Army in Normandy. Thousands of casualties were inflicted on the German forces, with thousands more ending up as prisoners of war. The German Army in Normandy also lost a large portion of its heavy weapons and transport. The victory also paved the way for the liberation of France and the pursuit of the German forces to the borders of their homeland. Estimates of the number of German soldiers who were killed, captured or extricated themselves from the Falaise Pocket vary. In his memoirs General Bradley stated that 70,000 Germans were killed or captured in the pocket. Martin Blumenson, in the US Army's official history, *Breakout and Pursuit*, estimated that the number of Germans who escaped numbered no more than 20,000–40,000, and that 50,000 prisoners and 10,000 dead remained on the field of battle. Statistics concerning the loss of German equipment tend to be rather more precise. The author of the British official history, Major L.F. Ellis, basing his information on a survey done by 21st Army Group's Operational Research Section, describes how 344 armoured vehicles, 2,447 lorries and cars, and 252 towed artillery pieces were destroyed

GERMAN COMMAND DECISIONS, AUGUST 1944

The failure of the Mortain counter-attack against the American break-through in Operation 'Cobra' and the crumbling defence elsewhere in Normandy meant that, by the middle of August 1944, the German Army faced the real possibility of a catastrophic defeat. In military terms, it was clear enough to any objective observer that the German position in Normandy was beyond retrieval and that the extrication of German forces across the Seine to more defensible positions was an urgent necessity to stave off disaster. Such military logic, however, did not prevail in the highest levels of command. The central reason for the lack of reality in German command decisions in Normandy can be attributed to Adolf Hitler. The attempt to rid Germany of Hitler on 20 July 1944 was a measure of the realisation in some quarters of the army that decisive action was necessary but its failure only added paranoia to Hitler's military ineptness.

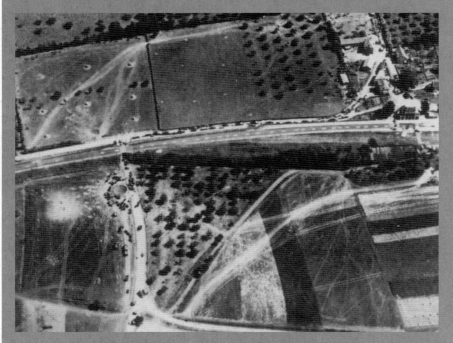

This Allied reconnaissance photo, taken near the village of Clinchamps, 11 km south-east of Falaise, illustrates the confusion of the German retreat from the Falaise Pocket. Part of the column is cutting across a field (upper left) while on the road itself the traffic is two or three abreast. Many vehicles, some camouflaged with branches of trees, can be seen (centre left) rounding a large bomb crater. (Imperial War Museum [IWM] CL839)

Hitler's decision to attempt to renew the Mortain attack rather than cut his losses in Normandy on 9 August was symptomatic of the lack of reality underpinning his decision-making. Hitler created Panzer Group *Eberbach*, tasked with renewing the drive toward Avranches. The Panzer group's commander, *General der Panzertruppen* Hans Eberbach, was given the target date of 11 August for the renewed counter-attack but quickly concluded that it could not begin until 20 August. Not only were the prospects of launching another counter-attack toward Avranches non-existent, the situation was changing so rapidly that the problem for the German Army was not improving the situation but simply surviving. With II Canadian Corps driving south toward Falaise and XV US Corps striking north from Le Mans the German Army faced a double envelopment. Moreover, the loss of Seventh Army's supply dumps at Alençon made an already difficult supply situation desperate.

By 15 August, the crisis required immediate action if the German forces were to escape the developing Allied envelopment. In the early hours of 16 August, the senior German officers who could be assembled met in Nécy to discuss the deteriorating situation. *Generalfeldmarschall* Günther von Kluge, *SS-Oberstgruppenführer* Paul Hausser, commander of Seventh Army, and *General* Eberbach attended. All agreed that the only solution to the crisis was withdrawal, as Eberbach's account of the conference revealed:

'Each of us told him [Kluge] that an attack with divisions now bled white, without air forces, and without a safe supply service, was unthinkable. Only a quick withdrawal from the encirclement could, perhaps, avoid a catastrophe. Kluge was now ready to give all orders for evacuation of the "finger", as we had proposed, but only after having communicated with Hitler's headquarters. Without its approval, he did not dare to make such a far-reaching decision. The people there, he said, lived in another world, without any idea of the actual situation here, as he knew from our reports and what he himself had experienced in the last 24 hours.'

Source: quoted in David C. Isby (ed.), *Fighting the Breakout*, pp. 191–2.

On 16 August, with Hitler's agreement, Kluge ordered the withdrawal of Seventh Army, Fifth Panzer Army and Panzer Group *Eberbach* from the looming encirclement. In the next five days, central command of the withdrawal gradually evaporated as small units and headquarter staffs alike ran the gauntlet of Allied fire in an attempt to escape. Of the three senior officers present at the conference in Nécy, Kluge committed suicide on 18 August, Hausser was wounded on 19 August but escaped the pocket and Eberbach, after escaping the pocket, surrendered himself to British soldiers at Amiens on 31 August.

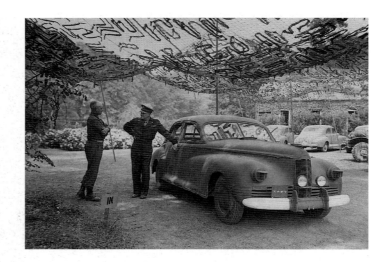

General Eisenhower, leaning against his impressive staff car, confers with Bradley on a visit to France in August 1944. Until he established his own headquarters in France, Eisenhower preferred not to interfere with the decisions made by his subordinates. *(USNA)*

or abandoned in the area where the Falaise Pocket was eventually sealed. By any measure, the uncertainty over exact numbers cannot mask the scale of the German defeat.

Only in terms of the military manpower that escaped death or capture can the German Army be considered to have salvaged something from the killing fields of Normandy. More recent studies suggest that many German soldiers got out of the Falaise Pocket and eventually across the River Seine to fight another day. Blumenson, in *The Battle of the Generals*, states that approximately a quarter of a million Germans escaped across the Seine. Although this figure includes men who were already outside the Falaise Pocket when it was formed, it points to the fact that the total number of men who got away was significantly higher than indicated either by contemporaneous military estimates or in the historical literature. It seems clear from available evidence that many Germans escaped from the Falaise Pocket, denying the Allies a truly comprehensive victory. Herein lies the core of the controversies regarding the outcome of the Battle of Normandy; did tensions and disagreements among the top Allied generals prevent a more decisive victory in the battle of the Falaise Pocket? Blumenson and others have speculated that greater harmony at senior levels could have meant 'a firm entrapment of the Germans west of the Seine, and a much earlier end of the war in Europe'. No doubt this central historical controversy will continue

SECOND (BRITISH) ARMY **30 JULY 1944**

General Officer Commanding	*Lt-Gen Sir Miles C. Dempsey*
VIII Corps	*Lt-Gen Sir Richard N. O'Connor*
Guards Armoured Division	*Maj-Gen A.H.S. Adair*
11th Armoured Division	*Maj-Gen G.P.B. Roberts*
15th (Scottish) Infantry Division	*Maj-Gen G.H.A MacMillan*
6th Guards Tank Brigade*	*Brigadier G.L. Verney*

** Attached to 15th (Scottish) Infantry Division*

XII Corps	*Lt-Gen N. M. Ritchie*
53rd (Welsh) Infantry Division	*Maj-Gen R.K. Ross*
59th (Staffordshire) Infantry Division	*Maj-Gen L.O. Lyne*
31st Tank Brigade	*Brigadier G.S. Knight*
34th Tank Brigade	*Brigadier W.S. Clarke*
XXX Corps	*Lt-Gen G.C. Bucknall*
7th Armoured Division	*Maj-Gen G.W.E.J. Erskine*
43rd (Wessex) Infantry Division	*Maj-Gen G.I. Thomas*
50th (Northumbrian) Infantry Division	*Maj-Gen D.A.H. Graham*
8th Armoured Brigade	*Brigadier G.E. Prior Palmer*

to simmer. Nevertheless, irrespective of how many German soldiers escaped the Allied trap, the results still speak for themselves – the battle of the Falaise Pocket was a crushing defeat for the *Wehrmacht* in Normandy.

When considering debates about the decisions made by senior Allied commanders, it must be remembered that the battle of the Falaise Pocket was fought as a coalition effort. Apart from the initial landings on the Normandy coast, perhaps no single phase of the struggle for Normandy brought the soldiers of the Allied armies so closely together in operational terms. The closure of the Pocket involved troops from Canada, Britain, France, Poland and the United States. As in any coalition operation, differences in perception, national approaches and temperaments conditioned the effectiveness of their co-operation, both at the highest levels of command and among the soldiers at the sharp end of battle. Despite the inevitable difficulties in managing the national diversity of the armies in the field, the Allies

FIRST CANADIAN ARMY **7 AUGUST 1944**

General Officer Commanding	***Lt-Gen H.D.G. Crerar***
I (British) Corps	***Lt-Gen J.T. Crocker***
6th Airborne Division	*Maj-Gen R.N. Gale*
49th (West Riding) Infantry Division	*Maj-Gen E.H. Barker*
II Canadian Corps	***Lt-Gen G.G. Simonds***
1st Polish Armoured Division	*Maj-Gen Stanisław Maczek*
4th Canadian Armoured Division	*Maj-Gen G. Kitching*
2nd Canadian Infantry Division	*Maj-Gen C. Foulkes*
3rd Canadian Infantry Division	*Maj-Gen R.F.L. Keller*
51st (Highland) Infantry Division	*Maj-Gen T.G. Rennie*
2nd Canadian Armoured Brigade	*Brigadier R.A. Wyman*
33rd (British) Armoured Brigade*	*Brig H.B. Scott*

* Attached to 51st (Highland) Infantry Division

delivered victory in Normandy – and the most indispensable ingredient in that victory was the valour of the American, British, Canadian, French and Polish soldiers. The battle of the Falaise Pocket stands as an enduring monument to their heroism and sacrifice.

THE BATTLE OF NORMANDY: OPPOSING FORCES

The balance sheet between the two opposing armies in Normandy was tipped against the Germans from the start. Despite the challenges posed by establishing a bridgehead against the defended Normandy coast, the Allies held major advantages that now make the outcome of the struggle appear almost inevitable, even if in 1944 this seemed less certain to those involved. At a strategic level, the German intelligence failure to anticipate the Allies' intentions regarding the location of the landings and the successful deception plan that convinced many Germans that the major threat was in the Pas de Calais conferred significant benefits on the Allies. The Allies achieved tactical and operational surprise and German divisions needed in Normandy stood idle in other parts of France. Despite the controversies that emerged during the battle among senior Allied military leaders, the confused and divided German hierarchy, suffering above all from the strategic direction of Adolf Hitler, meant that

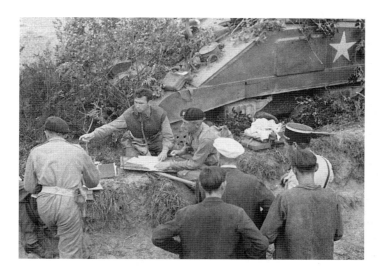

Polish officers gather information from French civilians and a policeman, August 1944. Note the Sherman camouflaged by the roadside. *(PISM 2530)*

unity and direction of command was far from optimal. The debate over whether to position the carefully assembled panzer divisions close to the coast or as concentrated reserves inland illustrates some of the consequences of this failure. When the lack of a coherent German anti-invasion plan is taken into account with other factors, it is not difficult to see what formidable advantages were possessed by the Allies in the struggle for Normandy.

Another major factor was Allied command of the air. Allied air supremacy meant that the German Army's ability to move men, equipment and supplies was much reduced. Air operations before D-Day sought to isolate the Normandy battlefield. Continual attacks on the rail and road network and the destruction of bridges across the Rivers Seine and Loire hampered the deployment of German fighting forces and their logistical support. Once a lodgement was established in Normandy, air supremacy meant that the Allies' logistical build-up proceeded without more than sporadic interference from the *Luftwaffe* (German Air Force). The Allied armies in Normandy could operate unhampered on the battlefield with the great advantage of suffering no more than nuisance raids by the *Luftwaffe*. Moreover, Allied air supremacy made tactical movement by German forces very difficult (particularly in daylight) and led to chronic supply problems for their troops in the field. During the battle the Allied

FIRST US ARMY 10 AUGUST 1944

Commanding General	**Lt-Gen Courtney H. Hodges**
V Corps	**Maj-Gen Leonard T. Gerow**
2nd Infantry Division 'Indian Head'	Maj-Gen Walter M. Robertson
VII Corps	**Maj-Gen J. Lawton Collins**
2nd Armored Div 'Hell on Wheels'	Maj-Gen Edward H. Brooks
3rd Armored Division 'Spearhead'	Maj-Gen Maurice Rose
1st Infantry Div 'The Big Red One'	Maj-Gen Clarence R. Huebner
4th Infantry Division 'The Ivy Division'	Maj-Gen Raymond O. Barton
9th Infantry Division 'Hitler's Nemesis'	Maj-Gen Manton S. Eddy
30th Infantry Division 'Old Hickory'	Maj-Gen Leland S. Hobbs
35th Infantry Division 'Santa Fe' *	Maj-Gen Paul W. Baade
* Attached from Third US Army	
XIX Corps	**Maj-Gen Charles H. Corlett**
28th Infantry Div 'Keystone Division'	Maj-Gen Lloyd D. Brown
29th Infantry Division 'Blue and Gray'	Maj-Gen Charles H. Gerhardt

air forces contributed close air support to the men on the ground, although their effectiveness in interdicting German rear areas probably brought more overall benefit. Given the challenges in identifying targets, 'blue-on-blue' or instances where Allied aircraft mistakenly bombed or strafed their own troops were an inevitable consequence of the limitations of existing technology and the 'fog of war'. When taken in the round, it is clear that during the battle of the Falaise Pocket the Allied air forces materially contributed to victory by inflicting considerable damage on the German Army.

Logistics was another element of Allied strength in the Battle of Normandy. While German efforts to keep their depleting formations supplied suffered from the ravages of Allied air power, the Allies amassed vast quantities of men and matériel. The build-up is truly impressive when one considers that almost everything had to be conveyed by sea and landed over beaches or through the artificial harbours (Mulberries) and that the Allies lacked a substantial deep water port to off-load shipping. By the end of June 1944 the Allies had already landed 850,279 men, 148,803 vehicles and 570,505 tons of stores in Normandy. The most serious obstacle proved to be the weather. The 'Great Storm' that raged for four days beginning on 19 June provided the

THIRD US ARMY **10 AUGUST 1944**

Commanding General	***Lt-Gen George S. Patton***
VIII Corps	***Maj-Gen Troy H. Middleton***
4th Armored Division	*Maj-Gen John S. Wood*
6th Armored Division 'Super Sixth'	*Maj-Gen Robert W. Grow*
8th Infantry Division 'Golden Arrow'	*Maj-Gen Donald A. Stroh*
83rd Infantry Division 'Thunderbolt'	*Maj-Gen Robert C. Macon*
XV Corps	***Maj-Gen Wade H. Haislip***
2nd French Armoured Division	*Maj-Gen Jacques Phillippe Leclerc*
5th Armored Division 'Victory'	*Maj-Gen Lunsford E. Oliver*
79th Infantry Division 'Cross of Lorraine'	*Maj-Gen Ira T. Wyche*
90th Infantry Division 'Tough Ombres'	*Maj-Gen Raymond S. McLain*
XX Corps	***Maj-Gen Walton H. Walker***
7th Armored Division 'Lucky Seventh'	*Maj-Gen Lindsay M. Silvester*
5th Infantry Division 'Red Diamond'	*Maj-Gen Stafford L. Irwin*
80th Infantry Division 'Blue Ridge'	*Maj-Gen Horace L. McBride*
Attached to First US Army	
35th Infantry Division 'Santa Fe'	*Maj-Gen Paul W. Baade*

greatest threat to the delivery of Allied supplies. The reality, however, was clear enough. In the logistical race between the two armies, Allied strength continued to grow remorselessly while German strength gradually drained away as attrition in men and matériel could not be made good.

For the Allied logisticians, apart from the lack of port facilities to off-load shipping, the break-out from the bridgehead and the increase in distances over which supplies would have to be delivered posed a different kind of challenge. By the time of the battle of the Falaise Pocket, the Allies were just beginning to get a glimpse of the logistical difficulties that would arise from their lengthening lines of communication.

Ultimately, on the battlefield it was the combat power and performance of the opposing armies that determined victory or defeat. In this context it is useful to draw some general comparisons between the major components in combined arms operations, namely the performance of infantry, armour and artillery on both sides. On the Allied side, it must be remembered that the soldiers who served in overwhelming majority were conscripts from democratic societies. The values of democratic societies placed limits on what Allied

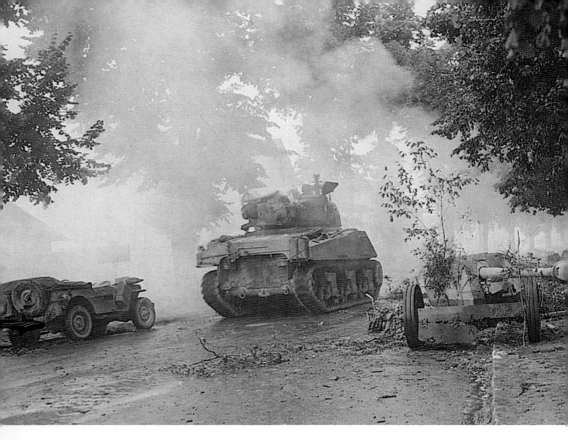

An American
Sherman tank
advances into
Dreux on
16 August. On
the right of this
photograph is
an abandoned
German 75-mm
anti-tank gun.
(USNA)

soldiers could be expected to do and on how many lives could be expended during operations. Indeed, finding replacements for battlefield losses proved to be a challenge for Allied armies of all sizes but for none more so than the British Army after five years of war. It would be wrong, however, to underestimate the effectiveness of the Allied citizen-soldiers.

Their opponents, by contrast, served a brutal, ideo-logically driven authoritarian regime. Theirs was a force that ranged from the fanatical soldiers of the *Waffen-SS* to 'volunteers' from Eastern Europe whose fighting qualities sometimes left much to be desired. Despite their diversity, though, the German land forces were a formidable enemy. Their effectiveness in Normandy was not only due to professionalism, training, adaptability and a tactical flair on the field of battle, but also to propaganda, fanaticism and a draconian disciplinary regime. Despite its undoubted strengths, however, the German Army's crushing defeat in the Battle of Normandy could not disguise fatal deficiencies on the German side.

Each side fought in Normandy in different ways using different equipment with consequently different strengths and weaknesses. The Germans fought a defensive battle with significant handicaps including inadequate logistics, poor provision of intelligence and unimpressive mobility. Defensively, German infantry at a tactical level relied heavily on the firepower of light machine guns such as the MG 42 with its high cyclic rate of fire. German armour also reflected the needs of defensive operations. Out-gunning and possessing heavier armour protection than Allied tanks, German tanks like the Panzer IV, Panther and the heavy Tiger were less mechanically reliable, less mobile and less numerous but unquestionably effective in a defensive role. The Germans also employed numbers of assault guns. These were built on tank chassis (often from smaller obsolete types) with a limited traverse gun mounted at the front of the vehicle in a sloping armoured glacis plate. Such a design allowed a heavier gun to be carried behind thicker armour than on the parent vehicle but the lack of a turret meant that these vehicles were most suited for defensive fighting. Because of Allied command of the air and the strength of Allied counter-battery fire the Germans often operated without effective artillery support. In order to compensate for this disadvantage, German forces relied on the use of mortars and various multiple rocket launchers called *Nebelwerfer* to provide fire support, since these weapons were more mobile and more easily concealed.

On the Allied side, weaknesses in specific areas were compensated by strengths in others and the overall effect of combined arms teamwork helped them to prevail in combat. Allied soldiers were similarly armed to their German counterparts with the exception, perhaps, of light supporting machine guns. The magazine-fed British Bren gun (also used by the Canadians and Poles) and the American Browning Automatic Rifle (BAR) could not offer a volume of fire comparable to the belt-fed MG 42. Historical analysis has often identified limitations among the Allied infantry in terms of training and flair at the tactical level, but these analyses cannot ignore the fact that their performance was good enough to achieve victory. Allied armour suffered from a qualitative

ALLIED ARTILLERY

The role of artillery was a critical factor in the success of Allied operations in Normandy. For both the British and American Armies, the introduction of modern equipment on the eve of the war had increased the striking power and lethality of their artillery. In the British Army the standard field gun was the 25-pounder gun-howitzer. It could fire an 11.3-kg (25-lb) shell to a range of 12,250 metres. Complementing the 25-pounder was an effective medium gun that offered longer range and greater weight of shell. The 5.5-inch medium gun was an accurate weapon that fired a 45.5-kg shell up to 14,815 metres. Throughout the war the 25-pounder gun-howitzer and the 5.5-inch gun were the mainstays of the British gun line. In addition, British heavy regiments deployed the 7.2-inch howitzer, which fired a 91.5-kg projectile to a maximum range of 16,000 metres. On occasion, heavy anti-aircraft regiments were also used to bombard German positions. These units used the 3.7-inch anti-aircraft gun, which fired a 12.5-kg shell up to 18,000 metres.

The standard field artillery pieces of the US Army were the 105-mm and 155-mm howitzers. The former fired a 15.0-kg shell to a range of 11,160 metres and the latter a 43.1-kg shell to a distance of 14,955 metres. Weapons that offered longer range and/or greater weight of shell complemented the more numerous 105-mm and 155-mm howitzers. These included the 155-mm 'Long Tom' gun, the 8-inch gun and 8-inch howitzer. Overall, the US Army managed a more comprehensive modernisation of its artillery than the British Army.

Whatever the technical features of Allied artillery, the guns were only as effective as the organisation and doctrine for their employment. In the British Army, the relearning of lessons about the concentration of artillery fire in the North African campaign meant that British artillery by the time of the Normandy battle was very effective. In the Royal Artillery, the direction of guns followed a simple but vital principle: artillery was to be commanded at the highest level but directed at the lowest. What this meant in practice was that artillery officers were embedded in headquarter staffs at virtually all levels down to regiment and battalion to ensure the greatest co-ordination with unit commanders of infantry and armour so that they would get effective and appropriate artillery support. Such a role at the divisional level, for example, would be fulfilled by a CRA (Commander, Royal Artillery). At the lowest end of the spectrum was the FOO (Forward Observation Officer) who would be at the sharp end of battle attached to infantry or armoured units (FOOs rode in their own tanks). The FOO exercised considerable control over the guns and could, if necessary, call down large concentrations of artillery fire on his own authority. For example, a 'Mike' target involved the concentrated fire of the guns of a regiment of artillery, an 'Uncle' target of the guns of a division and a 'Victor' target brought down the fire of the guns of a corps-worth of artillery, giving those on the receiving end a progressively larger and more unpleasant shower of high-explosive shells. A

communication net tied the system of artillery control and direction together and gave it the necessary speed and flexibility during operations.

The US Army, albeit with a slightly different structure, arrived at the same sort of solution as their British counterparts. The American model of the centralised Fire Direction Center (FDC) at higher formations and observers attached to fighting units achieved a high degree of effectiveness.

As the war progressed, artillery direction from the air made important strides but the observer on the ground remained crucial for control at the forward edge of battle.

Both the American and British Armies supplemented the field artillery organic to infantry and armoured divisions with larger medium and heavy calibre guns in regiments or battalions assigned to corps level formations. These formations varied in size according to needs. In the US Army they were organised into artillery 'groups' and in the British Army into AGRAs (Army Groups, Royal Artillery).

During the battle for Normandy, massed artillery fire, flexibly employed, conferred a crucial advantage on the Allies. When used in the combined arms battle, it could help overcome deficiencies in skill or inferior equipment associated with infantry or armour. Moreover, it was the only firepower asset that could claim to be an all-weather, 24 hours per day weapon. Perhaps the greatest accolade was from the German Army, which respected the potency of Allied artillery.

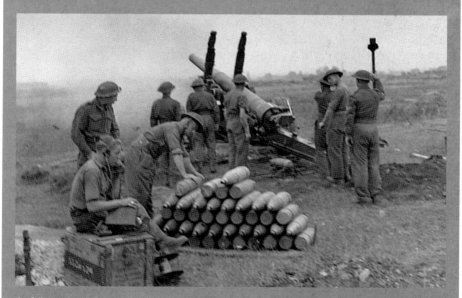

In full recoil, a 5.5-inch medium gun of the Royal Canadian Artillery during a fire mission in Normandy. The fact that the gun is not dug in, that ammunition is stacked in the open nearby, and the casual attitudes of the crew all bear testimony to the problems faced by the Germans in delivering effective counter-battery fire at this stage of the battle. (NAC PA 168703)

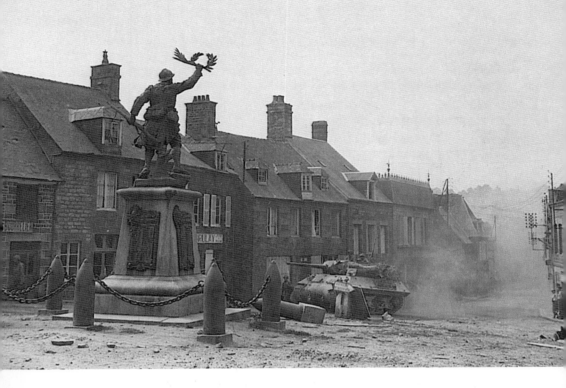

A US tank destroyer in Lonlay l'Abbaye, 16 August. The long list of names on the First World War monument is mute testimony to French sacrifice in the Great War. (USNA)

inferiority that was only beginning to be addressed by the end of the war. Their tanks and tank destroyers, however, were available in very large numbers. What was lost in quality was made up in quantity providing, as the cliché goes, a quality all of its own. The inferiority of British and American tanks over their German counterparts, however, did little for the morale of Allied tank crews who had seen comrades pay the price in combat. One area of Allied excellence, however, was in the realm of artillery. In quality and quantity, and in how it was employed on the battlefield, the Allies enjoyed significant advantages over their opponents. The US, Canadian and British armies could quickly mass artillery fire using a sophisticated and flexible system of control. Artillery was among the most important firepower assets (along with control of the air) possessed by the coalition forces. During the battle of the Falaise Pocket, Allied gunners exacted a fearful price on the trapped German forces. Indeed, artillery was one of the key factors underpinning Allied victory in the Battle of Normandy.

CHAPTER 2

CREATING THE POCKET: THE AMERICAN ATTACK

The success of the American 'Cobra' operation (25–30 July) in breaking through the German lines and its development into a break-out from the Allied bridgehead provided the necessary conditions for the creation of a grand encirclement of German forces west of the River Seine. At the beginning of August the newly activated Third US Army under the command of Lt-Gen George S. Patton, Jr., exploited the gap created by Cobra by spilling westwards towards the seaports of the Brittany peninsula. More important, Patton would soon be pointing his forces eastwards towards the Seine–Orléans gap. At the same time the British and Canadians made grinding progress in Operations 'Spring' and 'Bluecoat'. Second (British) Army fought its way through difficult *bocage*

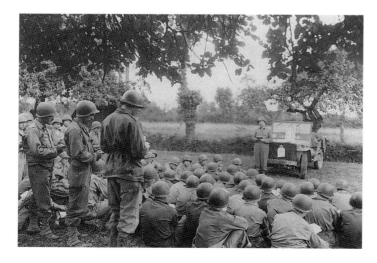

Giving attention to the spiritual needs of soldiers in the field was the role of chaplains. Here a US Army chaplain conducts a Jewish service in an apple orchard on 15 August. *(USNA)*

American medics
load an injured
boy on to a jeep
for evacuation to
an aid station to
have treatment
for burns. French
civilians in the
front-line areas
suffered all the
hazards of war
and too often
became its
victims. *(USNA)*

country (a system of fields surrounded by high earth banks planted with trees and hedges – a natural field fortification) and into the ruggedly hilly part of Normandy called the Suisse Normande (so called because of an alleged resemblance to the foothills of the Swiss Alps). VIII and XXX British Corps eventually reached a line beginning 5 kilometres (km) east of the town of Vire, meandering in a north-easterly direction to the dominating terrain feature of Mont Pinçon. As a consequence of these Allied operations the German Army's fighting power was steadily eroded.

In the face of the American break-out, the Germans mounted a counter-attack by LXVII Panzer Corps on 7 August that advanced through Mortain against First US Army under Lt-Gen Courtney H. Hodges, aiming for Avranches and the sea. The counter-attack was intended to split the American forces pouring out of the Normandy bridgehead and to halt the break-out. On the face of it the German counter-stroke represented a major threat. The Mortain counter-attack, however, would in fact assist and hasten the encirclement of German forces in Normandy. The German drive westward provided Lt-Gen Bradley, commander of the newly-formed 12th Army Group (activated on 25 July and consisting of Hodges' First US Army and Patton's Third US

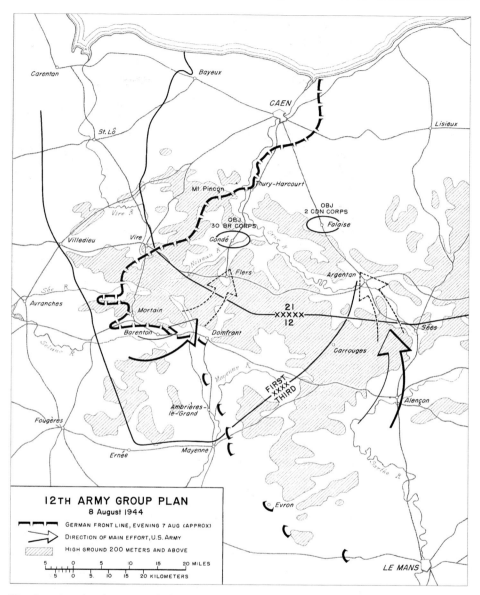

Carentan · Bayeux · CAEN · Lisieux · St. Lô · *Vire R.* · Mt. Pincon · Thury-Harcourt · OBJ 2 CDN CORPS · OBJ 30 BR CORPS · Falaise · Villedieu · Vire · Condé · Flers · Argentan · *Noireau R.* · Avranches · *Sée R.* · Mortain · 21 XXXXX 12 · Sées · Barenton · Domfront · Carrouges · *Sélune R.* · *Mayenne R.* · FIRST XXXX THIRD · Alençon · Ambrières- le-Grand · Fougères · Ernée · Mayenne · *Sarthe R.* · Evron · LE MANS

12TH ARMY GROUP PLAN
8 August 1944

GERMAN FRONT LINE, EVENING 7 AUG (APPROX)
DIRECTION OF MAIN EFFORT, U.S. ARMY
HIGH GROUND 200 METERS AND ABOVE

5 0 5 10 15 20 MILES
5 0 5 10 15 20 KILOMETERS

The American break-out attack Operation 'Cobra' at the end of July 1944 and the German counter-attack around Mortain in the first week of August dramatically shifted the initiative to the Allied forces in Normandy. Lt-Gen Omar N. Bradley, heading the newly activated 12th Army Group, saw the possibility of enveloping the German Army and bringing about its complete destruction. This map, taken from Martin Blumenson's *Breakout and Pursuit* in the US Army's official history series illustrates Bradley's conception of the encirclement that envisaged First and Third US Armies swinging north to form the southern perimeter of the Falaise Pocket.

US infantry passing through Le Mans to their jump-off positions for the attack northwards are welcomed by the inhabitants of the city, 9 August. (USNA)

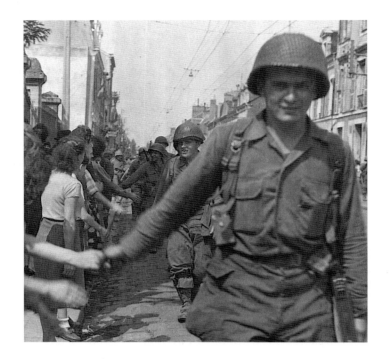

Army) with the opportunity to encircle the German forces in Normandy. Although the Mortain counter-attack caused some worrying moments, 30th Infantry Division's resolute defence meant that the German assault was soon contained and doomed to failure; it ended on 9 August. Bradley saw Mortain as an opportunity because the longer the attack persisted, the greater the chances that more German forces would be trapped deep in a pocket about to be formed by the advancing Allied armies.

On 8 August Bradley telephoned Montgomery, who was still in overall command of 12th Army Group and 21st Army Group. (This arrangement would stay in place until Eisenhower established his headquarters in France to assume command of both army groups a few weeks later.) With Montgomery's approval, Bradley proposed that First and Third US Armies swing northwards towards Flers and Argentan respectively with the aim of trapping and annihilating the German forces between the American and British army groups. Bradley set in motion what was to become the closing and decisive phase of the Battle of Normandy.

THIRD US ARMY: THE DASH NORTHWARD, 10–13 AUGUST

Apart from the divisions committed to clearing Brittany, Patton's Third US Army was also driving eastwards during the first week in August. Maj-Gen Wade H. Haislip's XV Corps, consisting of 79th and 90th Infantry Divisions and 5th Armored Division, made rapid progress through the Mayenne region, securing Laval and, by 8 August, Le Mans. Issuing Patton with a new directive to give substance to his envelopment plan, on the morning of 8 August Bradley instructed Patton to change the axis of advance of XV Corps by 90 degrees, turning it to face north. XV Corps was to advance from Le Mans on a south–north axis of Alençon–Sées up to an east–west line running from Sées to Carrouges. Moreover, XV Corps was to be prepared for further movement north in the direction of Argentan.

Once Haislip had been issued his orders by Patton, XVCorps set in motion preparations for the attack to begin on the morning of 10 August. Haislip had taken command of XV Corps in February 1943 and Patton had a great deal of confidence in him (Haislip eventually took command of Seventh US Army in June 1945). In order to increase the combat power of XV Corps, Patton added to Haislip's command 2nd French Armoured Division (*2ème Division Blindée*), led by Major-General (Maj-Gen) Jacques Phillippe Leclerc, whose real name was Viscount Phillippe de Hautecloque. After joining the Free French forces he adopted a pseudonym to protect family left in France and quickly showed his flair in operations in French Colonial Africa and later in North Africa. In August 1943 he was given command of 2nd French Armoured Division. He brought to XV Corps wide operational experience but a prickly independence that at times placed French political interests above the coalition's operational requirements.

With the addition of this seasoned French division, Haislip's corps now included two armoured and two infantry divisions to mount its attack towards Alençon. The divisions were arrayed around Le Mans: 5th Armored to the east, 79th Infantry to the south, 90th Infantry to the north and

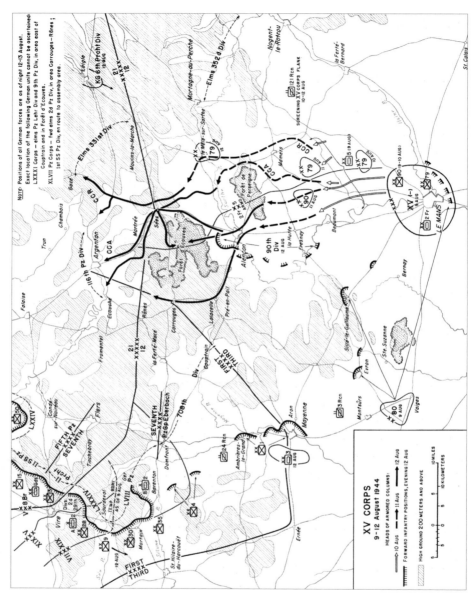

The three-day attack of Maj-Gen Wade Haislip's XV US Corps driving north from Le Mans to a line running roughly between Écouché to Gacé dramatically illustrated the effective employment of US armoured divisions in an offensive manoeuvre role. The speed of the American advance took the German senior commanders by surprise and contributed to making the German Army's position in Normandy untenable. This map, taken from *Breakout and Pursuit*, shows the three stages of the attack. It also highlights the risks being taken as XV Corps' flanks were completely exposed.

east and 2nd French Armored passing through 90th Infantry to its assembly area north of the town. In preparation for the attack, US Army engineers constructed three bridges to assist the movement of divisions in XV Corps (the Germans had demolished many existing crossings). A Bailey bridge was rapidly erected over the River Huisnes in the centre of Le Mans, and two other bridges were built over the River Sarthe north of the city to facilitate 2nd French Armoured Division's advance on Alençon. In a period of roughly 48 hours, XV Corps of over 50,000 men and many thousands of vehicles was re-supplied and completed preparations for a major attack on a completely new axis.

Haislip's plan envisaged XV Corps advancing north in two columns. On the left, 2nd French Armoured Division would lead, moving on a line of advance that would take it first to Alençon and then on to Carrouges, with 90th Infantry Division following the path of Leclerc's command. On the right, 5th Armored Division led the advance on a line that took it first to Mamers and then on to Sées. 79th Infantry Division marched behind the armour to tackle any remnants of German opposition. The disposition of Haislip's corps was designed to exploit the mobility and striking power of his armoured divisions placed in the van of the attack. The armour was meant to keep moving as rapidly as possible into the enemy's rear to prevent a coherent defence being organised. Centres of resistance that could not be easily or swiftly overcome were to be bypassed. The infantry divisions, following the armour, would deal with pockets of resistance and consolidate XV Corps' hold on the ground taken. Given the nature of the operational plan, both flanks of Haislip's corps would be exposed. On the western side of the corps' line of advance there was a gap of roughly 48 km separating XV Corps from units of First US Army. To the east of XV Corps, an armoured cavalry battalion screened its even more open right flank.

The German capacity to impede Haislip's advance, however, was limited. Opposing XV Corps were parts of two German divisions, 708th Infantry and 9th Panzer. There were also various units in the line of the American advance

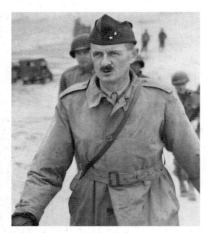

Maj-Gen Jacques Phillippe Leclerc, commanding officer of 2nd French Armoured Division, striding ashore on the Normandy beaches on 2 August. He exerted a prickly independence in decision-making as part of XV US Corps. *(USNA)*

that needed reconstitution owing to heavy losses already suffered in men and matériel (mainly from Panzer Lehr and 352nd Infantry Divisions. 708th Infantry Division was not an impressive formation, having earlier displayed poor fighting qualities in action against 90th Infantry Division. 9th Panzer Division was more robust, although its Panther tank battalion had temporarily been sent north to support the defence of Falaise. Compared to Allied divisions, many German units were well below their nominal strengths. A division might only have the manpower and equipment of a regimental-sized battlegroup (*Kampfgruppe*).

2nd French and 5th US Armored Divisions jumped off from their lines of departure on the northern edge of Le Mans around 0800 hours on the morning of 10 August. 5th Armored Division advanced in two columns formed by its Combat Command A (CC A) on the left and CC R on the right, moving forward parallel with one another. Both columns of 5th Armored Division encountered stiff resistance from German tanks and artillery. Despite this opposition, CC R made good progress, knocking out nine tanks and two armoured cars and taking 116 prisoners. CC A faced stiffer resistance but nevertheless continued to move forward. By nightfall 5th Armored Division had advanced 24 km and was halfway to Mamers. Resuming the attack the next morning, Combat Commands A and R bypassed the towns of Marolles-les-Braults and Mamers, although they continued to meet frequent roadblocks covered by tanks or anti-tank guns and, in some instances, concentrated fire from German artillery. Nevertheless, resistance was not strong enough to slow, let alone stop, 5th Armored Division's drive north.

The experience of 2nd French Armoured Division on the left of XV Corps' advance was similar to its American counterparts on the right. Sharp tank actions with elements of 9th Panzer Division and the breaching of roadblocks characterised French progress along their assigned lines of attack. 2nd French Armoured Division was organised along

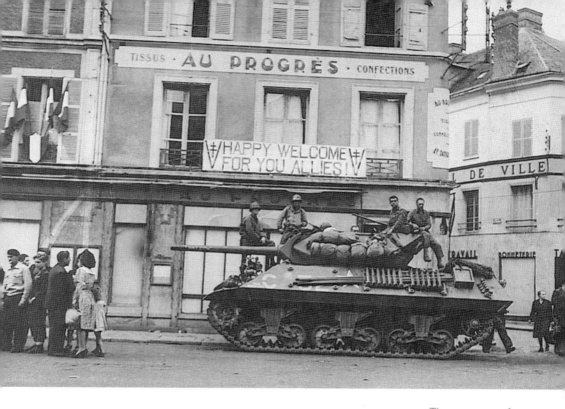

American lines, with the attack led by two combat commands called *Groupements Tactiques* (GTs) and differentiated by the initial of the surname of the GT commander. Hence the GT led by Colonel Dio was known as GTD. Crossing the start line covering a 6-km front on 10 August, GTL (Colonel de Langlade) advanced on the right by way of St-Mars-sous-Ballon, Congé-sur-Orne, Lucé and Rouessé-Fontaine. On the left, GTD followed a route that took it to Ballon, Coulombiers, Bourg-le-Roi and Champfleur. The third combat command, GTV (Colonel Warabiot), followed behind GTD as the division reserve. Leclerc impressed upon his combat commands the need to move forward with speed and audacity. On 11 August the GTs continued along their axis of advance and by that evening lead elements of the division were 6 km south of Alençon.

On 12 August the two XV Corps armoured divisions enjoyed some spectacular success and some irritating frustrations. In the early hours of 12 August, after a night march, 12th Cuirassier Regiment's 4th Squadron entered Alençon with infantry support and seized key bridges over the River Sarthe.

The crewmen of an American M10 tank destroyer relax in the centre of Dreux. The sign above them reflects the genuine warmth of the liberated French population toward the Allied armies. (USNA)

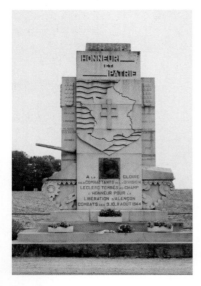

A monument to 2nd French Armoured Division on the N138 south of Alençon, commemorating the division's role in liberating that city. It stands at the place where the division's leading elements incurred casualties overcoming German roadblocks. *(Author)*

Maj-Gen Leclerc, who believed in leading from the front, was personally involved in securing the bridges. French *élan* thus led to the capital of the Orne *département* being secured without a fight. The liberation of this key communication centre removed a significant obstacle to the continuation of XV Corps' rapid advance. 2nd French Armoured Division's audacious *coup de main* had relieved one major worry, but the prospect of negotiating the two forests lying in the path of the XV Corps' advance provided a difficult conundrum.

The Forêt de Perseigne, east of Alençon, was the first of these obstacles, and mostly lay in the path of 5th Armored Division. Intelligence, which in the event proved mistaken, suggested that the Germans would use the concealment and limited room for manoeuvre on forest roads and tracks to exact a fearful toll on the advancing armoured columns. On 11 August Haislip ordered his columns to bypass the Forêt de Perseigne when they resumed their march northwards. Moreover, Haislip requested that the forest be bombed with incendiary oil bombs and tasked three XV Corps artillery battalions to interdict forest exits. In the event, on 12 August Haislip cancelled the bombing of the Forêt de Perseigne and the French and American armoured divisions bypassed the woods without difficulty as the Germans had already retreated north.

Having cleared this illusory obstacle, the attack of XV Corps' two armoured divisions became intertwined on their advance northwards, with fateful consequences for the closing of the Falaise Pocket. By 11 August the progress registered by his troops had encouraged Haislip to make Argentan the next objective in the light of his orders from Patton. His armoured divisions had by 12 August all but reached his corps objective of the Carrouges–Sées line. In terms of the developing encirclement of the German armies in Normandy, Argentan was a critical objective. The town lay astride roads which the Germans needed to control if they

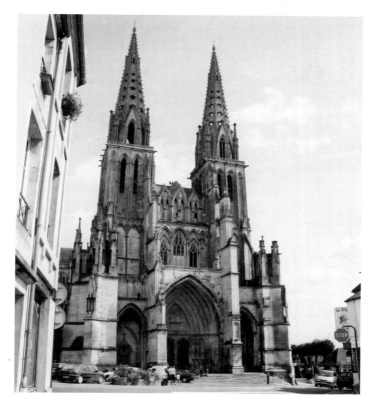

The medieval cathedral in Sées survived the war unscathed after 5th Armored Division captured the town against negligible resistance. *(Author)*

were to escape east and north-east and thus avoid complete envelopment and destruction at the hands of the Allies. Accordingly, Haislip directed that 5th Armored Division now make Argentan its objective. 2nd French Armoured Division was given the task of taking Carrouges further south-west. The line of advance of the two armoured divisions tilted the axis of XV Corps' movement slightly to the north-west.

Standing in the way of the two Allied armoured divisions was the Forêt d'Écouves. In order to give each division adequate room for manoeuvre, and taking into account the road network, Haislip ordered Leclerc's armoured division to proceed to the west of the Forêt d'Écouves. The independent-minded French general, however, chose not to follow this directive. Instead his division advanced on Carrouges in three separate columns. One column bypassed the Forêt d'Écouves on its western side, another drove through the forest while a third column skirted the eastern side of the forest. All were to

A column of
French armoured
infantry, riding
in American-
made White
half-tracks, halted
in the centre
of Alençon
in August
1944. Aerial
recognition
panels are draped
across the front
of the vehicles
to avoid the
attention of
Allied fighter-
bombers. *(USNA)*

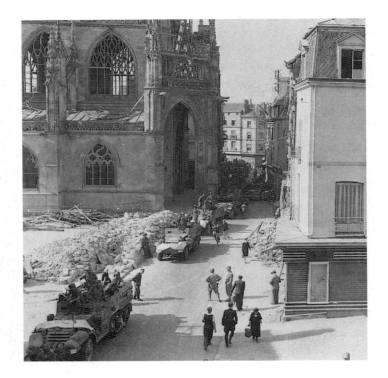

move towards Ecouché, about 8 km south-west of Argentan. In this process the easternmost column of 2nd French Armoured Division trespassed across divisional boundary lines into the zone assigned to 5th Armored Division, occupying a road vital for the latter division's attack.

On the morning of 12 August 5th Armored Division's Combat Commands A and R resumed their attack against light resistance. By 1000 hours the two combat commands had taken Sées against the modest efforts of a hapless German bakery company. Moving north of Sées, CC R tilted north-east towards the market town of Gacé, with CC A continuing to attack in a north-westerly direction towards Argentan. CC A made steady progress towards its objective, fighting its way through roadblocks that were often tenaciously defended by German anti-tank guns or tanks. By 2000 hours CC A had succeeded in fighting its way to within 8 km of Argentan but halted its attack because of a lack of fuel.

The delay to CC A's supply convoy was the result of a column of 2nd French Armoured Division occupying the

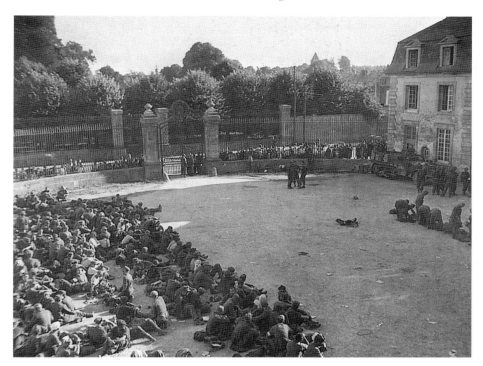

road through Sées in the zone assigned to 5th Armored Division. The fact that the French troops were fêted by their fellow countrymen no doubt added to the delay. By the time CC A was refuelled it was just before dark and the attack towards Argentan made little ground before night halted the advance. Both the French and American armoured divisions sent patrols into the town, but the next morning they would see the opportunity to seize Argentan slip away.

German prisoners in a courtyard in Sées. Managing large numbers of prisoners became a major problem during the battles of the Falaise Pocket. *(USNA)*

Realising the dangers involved if XV Corps captured Argentan, XLVII Panzer Corps – which had just arrived in this area – scrambled to organise a defence of the town. Using the remnants of 9th Panzer Division and 116th Panzer Division – which arrived during the night – the Germans shored up their defences and prepared to meet the Americans the next day.

> The consequences on 13 August were all too apparent for Combat Command A:
>
> 'At 0700 hours... CCA resumed the attack on Argentan. It met with strong resistance and was

The consequences of an attack on a column of German half-tracks near St-Aubin d'Appenai, 14 August. American tank destroyers attached to 79th US Infantry Division surprised and poured fire into the retreating column of a Panzer division. *(USNA)*

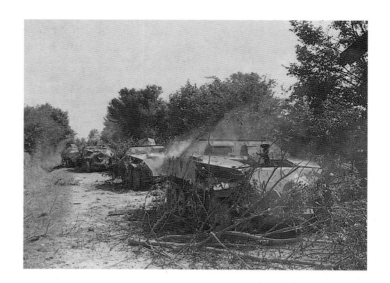

repulsed. During the night the enemy had moved in more infantry and anti-tank guns. 88s had been placed in concealed positions on the flanks and on the dominating ground to the North of the town. The 34th Tank Battalion lost seven M4 tanks, and its commander Lt Col Thomas B. Bartel, who was seriously wounded and evacuated.'

Source: 5th Armored Division, Report After Action Against Enemy – August 1944, US National Archives (USNA).

For the infantry divisions following the two armoured divisions, the rapid advances meant long days of marching to keep up with their mechanised colleagues. In XV Corps, the bulk of the riflemen in 79th and 90th Infantry Divisions advanced on foot. At most, only the equivalent of one of the three organic infantry regiments in each division was motorised for the attack. Compared to the largely horse-drawn vehicles of the German Army, however, Allied provision of transport was lavish. High levels of motorisation generally allowed for rapid movement and generous supply of formations in the field.

Depending on whether the infantry rode in trucks or walked, there were significant variations in the rate of advance. The

distances covered by 79th Infantry Division's 315th Infantry Regiment, following the armour on the right of XV Corps' advance, illustrate what was possible in a day's march. On 10 August 315th Infantry Regiment covered just under 32 km; on 11 August 13 km; and on 12 August 28 km. These three bounds took 315th Infantry Regiment north to St-Julien-sur-Sarthe, where it was allowed to rest on 13 and 14 August.

> Near the town the footsore American soldiers found a welcome treat:
>
> 'A regular U.S. "swimming hole" was discovered in the River Sarthe, and to say that the men took delight in the advantages which it had to offer would be a gross understatement. For many, it was the first chance to get really clean since the arrival of the Regiment in France and combined with the heat of the day, it was probably the most enjoyable day that the Regiment had spent for a long time.'
>
> *Source*: 315th Infantry Regiment, Report After Action Against Enemy – August 1944, RG 407, USNA.

The role of the infantry units was to secure key elements in the lines of communications, such as river crossings, and generally to hold the ground gained in the advance. 90th Infantry Division, moving behind 2nd French Armoured Division, deployed for this mission in a way that clearly reflected this role. Beginning its advance in three columns, with infantry in the outside columns and engineers and artillery in the middle one, 90th Infantry Division covered similar distances in its daily marches to its counterpart on the right. Each column was built around a regimental combat team with an infantry regiment at its core. Hence RCT9 contained 359th Infantry Regiment with detachments of other divisional assets.

As RCT9 was motorised, it moved quickly in the wake of 2nd French Armoured Division with the aim of consolidating the bridgehead across the River Sarthe at Alençon. Given the gap between the units on XV Corps' left flank and elements

90TH US INFANTRY DIVISION 'TOUGH OMBRES'
16 AUGUST 1944

Commanding General **Maj-Gen Raymond S. McLain**

Assistant Divisional Commander *Brig-Gen William G. Weaver*
Artillery Commander *Brig-Gen John M. Devine*

Organic units

357th Infantry Regiment *Colonel George H. Barth*
358th Infantry Regiment *Colonel Christian H. Clark, Jnr.*
359th Infantry Regiment *Colonel Robert L. Bacon*

90th Cavalry Reconnaissance Troop
325th Engineer Combat Battalion
343rd, 344th, 915th Field Artillery Battalions (105-mm howitzer)
345th Field Artillery Battalion (155-mm howitzer)

Attached units

537th Anti-Aircraft Artillery Automatic Weapons Battalion (Mobile)
712th Tank Battalion
40th and 173rd Field Artillery Groups
B Battery, 3rd Field Artillery Observation Battalion
693rd Field Artillery Battalion (105-mm howitzer)
999th Field Artillery Battalion (8-inch howitzer)
607th Tank Destroyer Battalion (Towed)

of First US Army, RCT7 (based on 357th Infantry Regiment), as the westernmost column, provided flank security during 90th Infantry Division's march northwards. By 13 August the division was mostly north of the River Sarthe and had significantly expanded and consolidated the bridgehead beyond Alençon. RCT7, plus the attached 345th Field Artillery Battalion, occupied high ground south-east of Carrouges. It spent the day collecting prisoners from disorganised German units trying to escape eastwards out of the rapidly forming pocket. On 14 August the division continued to consolidate its positions and to mop up areas within its zone of operations. Two battalions of 359th Infantry Regiment and one battalion from the neighbouring 357th Infantry Regiment cleared the Forêt d'Écouves directly north of Alençon with little drama. XV Corps' pattern of operations, however, was about to

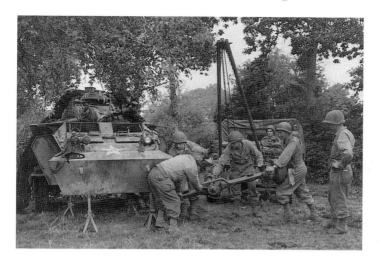

Members of the maintenance company of a US armoured division change an axle on an armoured car. The maintenance and logistical support required to keep an armoured division in the field were considerable. *(USNA)*

change radically on 15 August. Just as XV Corps was poised to continue its strike north, Bradley and Patton decided on a new objective.

FIRST ARMY: COMPLETING THE SOUTHERN RIM, 12–17 AUGUST

Lt-Gen Courtney H. Hodges' First US Army successfully held the line in the German Mortain counter-attack. Like Patton's Third US Army, Hodges' First US Army had been ordered by Bradley on 9 August to wheel northwards as part of the envelopment scheme. Because of the need to deal with the Mortain counter-attack, Hodges could not begin his attack until the German panzer divisions disengaged and began to withdraw. The attacks of Maj-Gen Leonard T. Gerow's V Corps and Maj-Gen Charles H. Corlett's XIX Corps began on 12 August, but VII Corps under Maj-Gen J. Lawton Collins had to begin operations a day later. Collins' divisions, near Mortain, had to displace south-east to Mayenne before starting their attack northwards.

Gerow's V Corps towards the east of First US Army's front operated on the narrowest sector and his 29th and 2nd Infantry Divisions mounted their attack through difficult country with few roads. After three days of difficult fighting Gerow's corps captured the town of Tinchebray from Seventh Army, but the retreating Germans escaped contact and V Corps, facing

Then: The rubble-filled street of the medieval hilltop town of Domfront in the middle of August 1944. The steeple of St-Julien church can be seen in the distance. Allied bombers attacked many Normandy towns because of their importance as road junctions. *(USNA)*

almost directly east, was pinched out of the line. Corlett's XIX Corps, launching its attacks from near Sourdeval, met with more success. His 28th Infantry Division was reinforced by 14 August with 2nd Armored and 30th Infantry Divisions, transferred from VII Corps. With this significant augmentation in combat power, Corlett swung his advance northwards, pivoting on the town of Ger. Elements of XIX Corps moving on an eastward axis took the heavily damaged medieval town of Domfront, which had been bombed to impede German movement, against insignificant opposition from a scratch battalion of supply personnel, convalescents and men who had lost their units. As with so many Norman towns, clearing the rubble-filled streets of Domfront now became an urgent task to keep American troops and supplies moving along its principal roads. XIX Corps reached Flers by 15 August and made contact with British forces (from VIII Corps) sweeping across its front. Like Gerow's troops, Corlett's men were pinched out of the line.

Collins' VII Corps was the last to begin its attack, on 13 August. Leaving the starting line near Mayenne, Collins

Now: Beautifully restored, Domfront has regained much of its charm. Ironically, the St-Julien church with its concrete framework was built in 1926–33, replacing its more historic but structurally dangerous predecessor. *(Author)*

pushed north-east with three divisions under command, namely 3rd Armored and 1st and 9th Infantry Divisions. VII Corps' advances over a five-day period succeeded in taking over 3,000 prisoners and destroying considerable amounts of equipment. These gains were made at the cost of heavy fighting against determined resistance offered by elements of 1st SS Panzer Division *Leibstandarte*, notably near the town of Rânes (10 km north-west of Carrouges). Most important, VII Corps closed the gap between the closest units of Hodges' First US Army and Patton's Third US Army, creating a continuous front on the southern side of the pocket. On 17 August Collins' corps made contact with British forces advancing from the north-west.

Having completed its advance, by 16 August Hodges' First US Army was deployed along a shallow curve running in an east–west direction, with his easternmost division at the boundary with Patton's Third US Army. In the west, however, Hodges' divisions had been gradually squeezed out by 21st Army Group's thrust in an easterly/south-easterly direction. The British advance was collapsing the pocket as the German forces retreated eastwards, attempting to escape the sack that was being drawn around their increasingly precarious position. Those of Hodges' divisions that had been squeezed out of the line now became available for employment elsewhere. Moving them to other sectors of the southern rim of the pocket became necessary if valuable combat assets were not to be left idle. Indeed, Hodges would eventually absorb into his command sectors previously controlled by

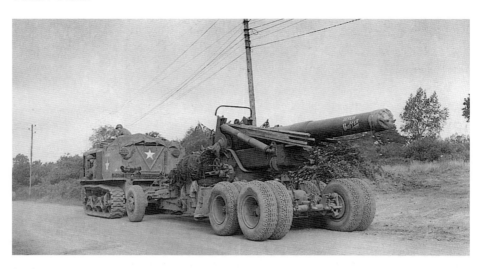

An American 8-inch gun of First US Army on the move to new positions. Larger-calibre artillery was controlled by corps level command and was assigned to support particular divisions and operations. *(USNA)*

Third US Army. Maintaining the pressure on the retreating Germans required his divisions to shuffle eastwards like soldiers dressing a line on the parade ground.

BRADLEY'S STOP ORDER AND PATTON'S TURN, 13–15 AUGUST

For the German Army in Normandy, the capture of Alençon and Sées and the arrival of Allied troops at Argentan created a major crisis. The defence of Argentan by elements of Panzer Group *Eberbach* therefore became critically important to the German position as the threat of complete encirclement and annihilation loomed. The distance between the lead elements of First Canadian Army to the north and Patton's Third US Army to the south was no more than 40 km. Despite the failure to take Argentan on the morning of 13 August, Patton was undaunted and intended to maintain XV Corps' advance towards Falaise in order to link up with the Canadians. However, Bradley had instructed Patton late on the previous night to halt Haislip's corps and not to advance beyond Argentan. Bradley's order would be among the most controversial in the Battle of Normandy.

The decision to halt Patton's advance northwards lost what most historians now agree was the best opportunity to encircle the German forces in Normandy and to achieve their complete destruction. Clearly, conflicts and tensions among

senior Allied generals played a significant role in losing the opportunity for a more complete victory. All of them, to varying degrees, share the blame. Montgomery, in command of both Allied army groups, had established a boundary line on 8 August running along an east–west line through the towns of Mortain, Domfront, Carrouges and Sées between the American and British armies advancing towards each other. The rapidity of Third US Army's advance made this line irrelevant as the leading elements of XV Corps moved beyond Sées to the edge of Argentan. Montgomery, however, was unwilling to shift the boundary northwards towards the Canadians as the latter moved south. Bradley, who chafed under the arrangements that left Montgomery in overall command, was unwilling to press Montgomery to move the army group boundary line to facilitate an American advance further north. Bradley's position was astounding considering that he had pressed Montgomery to accept his encirclement scheme a week earlier.

Despite a unified command structure, each part of the coalition gave every appearance of fighting its own battle. Bradley, on his side, gave the impression of wanting to have as little as possible to do with Montgomery. Montgomery understood that, given the growing American military strength in Normandy and the limited time remaining in which he would be directing Allied armies, he could only

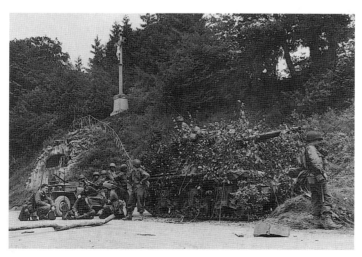

A camouflaged American tank destroyer near a calvary covers a road outside Domfront on 16 August. Despite efforts to camouflage the tank destroyer, soldiers seem remarkably unconcerned about exposing themselves at the road-block. *(USNA)*

persuade and co-ordinate rather than firmly order the US side of coalition operations. Inter-Allied tensions and egos aside, there is also a strictly military perspective to consider. Bradley indicated in his memoirs that he believed that XV Corps lacked the combat power to close the remaining gap and to keep it shut. Bradley stated that he 'much preferred a solid shoulder at Argentan to the possibility of a broken neck at Falaise'. Closing the pocket with inadequate strength risked exposing Allied troops to the concentrated strength of the Germans attacking to break out of the pocket, or thrusting into it from the east to create an escape corridor. Patton, in his memoirs, not surprisingly took another view of Bradley's decision: 'This halt was a great mistake, as I was certain that we could have entered Falaise.' For Patton, the prize of the complete destruction of the German forces justified the risks implicit in an attempt to close the Falaise Pocket.

Patton, however, was not one to let an opportunity slip away. Rather than keep XV Corps idle, he proposed to Bradley that he point Haislip's troops eastwards and towards the Seine, thus developing a wider envelopment of the German forces. Patton's idea was echoed by Montgomery's directive of 11 August, which underpinned the coalition's efforts to encircle the Germans in Normandy. Bradley was persuaded by Patton and on 14–15 August authorised him to begin an attack eastwards with three corps (XV, XX and XII) assigned to Third US Army, including major elements of Haislip's corps hitherto pointed towards Argentan and Falaise. This decision, together with Bradley's earlier order to halt XV Corps' advance north, robbed the Allied coalition of the opportunity to achieve a more comprehensive victory in the Battle of Normandy. Bradley, seemingly concerned about maintaining a hard shoulder at Argentan, now denuded that sector of strength, while Patton galloped eastwards to the River Seine. The two divisions of XV Corps left behind, 2nd French Armoured Division and 90th Infantry Division, only provided a screening force. The reduction of American combat power on Third US Army's sector of the southern shoulder of the pocket is nicely illustrated by the reduction in assigned artillery. On 14 August 22 battalions of artillery were in the sector

near Argentan, but one day later only 7 artillery battalions remained, with the others moving eastwards to support XV Corps' advance on Dreux. Bradley effectively abandoned his short hook encirclement plan for a wider envelopment at the point when his earlier plan was on the verge of success.

NEW ATTEMPTS TO CLOSE THE POCKET, 16–17 AUGUST

2nd French Armoured Division and 90th Infantry Division were now alone responsible for the southern shoulder of the pocket. Directed by a skeletal corps headquarter staff based at Alençon, 2nd French Armoured Division, on

A plaque of Maj-Gen Leclerc, commemorating the liberation of Omméel. *(Author)*

the left flank of XV Corps' positions, extended its front east to cover the approaches to Argentan, now vacated by 5th Armored Division. 90th US Infantry Division, on the right of the French, covered a line running along the road from le Bourg-St-Léonard to Exmés. The frontage covered by the two divisions thus ran from Ecouché to Exmés, a distance of roughly 24 km. 80th Infantry Division from XX Corps near Evron was ordered to reinforce the two divisions and increase the density of forces holding the sector.

Given the reduction in combat power caused by the departure of two divisions of XV Corps, together with most of its artillery, there seemed to be little chance of closing the gap from the American side. Remarkably, on the suggestion of Montgomery, on 16 August Bradley re-launched efforts to shut off the pocket from the Argentan sector with forces that had been greatly reduced in strength. The objective of the American attack and meeting point between the Allied armies was to be the town of Trun; about 10 km north of the attack's start line.

Patton acted on Bradley's instruction with his usual energy. One of Patton's first tasks was to create a corps headquarters to direct the three-division attack northward. He created a provisional corps headquarters near Alençon under the command of Third US Army's chief of staff,

SECOND (BRITISH) ARMY **30 JULY – 17 AUGUST 1944**

While the American break-out and exploitation was taking place in the first half of August 1944, Second (British) Army was not inactive. Switching the British centre of gravity from south of Caen, Lt-Gen Miles Dempsey's Second Army was now tasked to drive south toward Vire and Mont Pinçon in Operation 'Bluecoat' across a line running from near Caumont to Caen. The timing of Bluecoat roughly paralleled that of Cobra, the American break-out operation. Designed to maintain pressure on the German Army in Normandy, Bluecoat had the aim of fixing German divisions facing Second Army and preventing them from being used to confront the Cobra attack. Facing Second Army were some seven Panzer divisions (four of them SS Panzer divisions) and six infantry divisions. Because of its timing and successes some historians have dubbed Operation Bluecoat the 'British break-out'. Progress during Bluecoat, however, was to be more measured than Cobra, given the natural defensive positions offered to the Germans in the *bocage* country through which Second Army would have to advance.

Bluecoat began on 30 July and ran into the first week of August. The attack involved three British corps of Dempsey's Second Army. In the westernmost part of the British line was VIII Corps, with 11th and Guards Armoured Divisions and 15th (Scottish) Infantry Division. At the boundary line with First US Army to the west, VIII Corps' zone of operations took it south through the Forêt l'Evêque toward Vire. To the east of VIII Corps was XXX Corps, consisting of 7th Armoured Division and 43rd (Wessex) and 50th (Northumbrian) Infantry Divisions. XXX Corps' line of advance took it in a slightly south-easterly direction with the key objective of Mont Pinçon in the centre of the corps' area of operation. Part of a ridge system, this high ground of around 360 metres was the most prominent feature, offering the Germans a good defensive position. XII Corps, consisting of 53rd (Welsh) and 59th (Staffordshire) Infantry Divisions, was the easternmost of the three attacking corps. Its line of advance went due south across the River Odon.

Maj-Gen Hugh J. Gaffey. With a headquarters staff consisting of four officers, Gaffey set off on his assignment in the early evening of 16 August to prepare his corps for an attack set to begin the next morning.

In preparation for his assault, Gaffey changed the disposition of his forces. 2nd French Armoured Division was to deploy one of its combat commands to the west of Argentan, with a view to cutting off the road running between Argentan and Falaise. 80th Infantry Division was to move towards the southern approaches to Argentan, filling

The British attack made progress across the Second Army front with the Germans exacting a heavy price in men and matériel for each leap forward. The armoured divisions of VIII Corps attacking south encountered hard resistance from elements of 9th and 10th SS Panzer Divisions but by 1 August the British 11th Armoured Division had taken le Bény-Bocage and by 5 August its tanks were north-east of Vire.

Second Army's most important objective was Mont Pinçon in the line of advance of XXX Corps. Capture of this dominating feature would fracture irreparably the German Army's defence in this part of Normandy. The task of taking Mont Pinçon fell to the troops of 43rd (Wessex) Infantry Division. After some costly fighting, by the evening of 6 August this key piece of high ground was under British control and the positions of the German Fifth Panzer and Seventh Armies were becoming untenable.

On the easternmost part of the Second Army front, the successes of XII Corps took it into the Suisse Normande district. Apart from a German counter-attack mounted by 10th SS Panzer Division against 11th British Armoured Division east of Vire, the hard grind of *bocage* fighting was gradually shifting into more open country. Bluecoat gradually changed in the first week of August from an attrition battle to a general advance. By 17 August, Second Army formed the western and northern rim of the Falaise Pocket, occupying a line that snaked from Briouze to near Falaise. After the hard-fought gains of the previous months, Second Army was now remorselessly squeezing the life out of the German Army in Normandy.

positions vacated by the French. The main effort would come from 90th Infantry Division, which was tasked to capture Chambois and cross the River Dives, which ran through the town. Another combat command of 2nd French Armoured Division would then pass through 90th Infantry Division to drive on to Trun, 7 km north-west of Chambois. When briefed on the plan, Leclerc balked at the arrangements, complaining about the piecemeal arrangements for committing his division. After much frank discussion, Leclerc accepted his orders. 2nd French Armoured Division, however, had been frustrated at its relative inactivity during the previous week and, with Patton driving to the Seine, Leclerc's gaze was shifting from rural Normandy towards Paris and the political kudos associated with its liberation. After resolving his coalition disputes, Gaffey planned to attack at 1000 hours on 17 August. The attack, however, was not to take place because Bradley ordered its cancellation until a new corps commander and his headquarters could be put into place.

NARROWING THE GAP: CANADIANS AND POLES

While US troops had been shaping the southern perimeter of the pocket to trap the German forces in Normandy, during the same period the 21st Army Group was trying to close the gap separating the Allied armies. Between 7 and 10 August, II Canadian Corps mounted a complex set of attacks beginning with Operation 'Totalize'. Developed in three phases, Totalize began with an infantry-led break-in battle and in its later stages was intended to become a break-out conducted by II Canadian Corps' two armoured divisions. The attack was mounted astride the main road running south from Caen (now the N158), with the objective being to reach the town of Falaise, birthplace of William the Conqueror.

The guiding force in the planning of Operation Totalize was Lt-Gen Guy Granville Simonds, the 41-year-old II Canadian

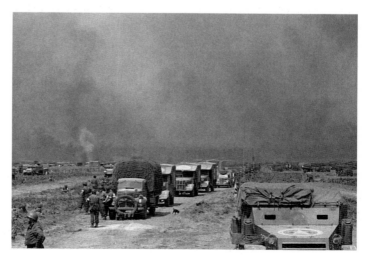

Smoke billows from 1st Polish Armoured Division's staging area as a result of short bombing on 8 August. Friendly fire incidents where Allied aircraft attacked units of II Canadian Corps were a persistent problem. *(PISM 2469)*

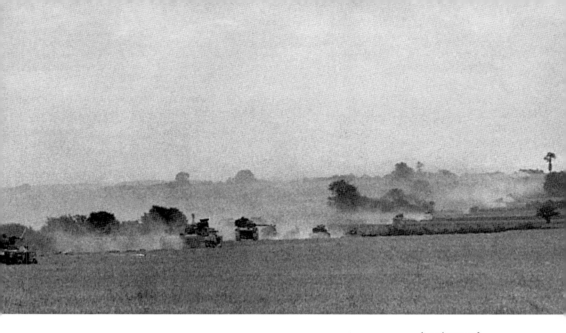

Corps commander. A gunner by trade, Simonds began the war as a major, serving as a staff officer. By April 1943 he was a divisional commander and in January 1944 he took command of II Canadian Corps. Under him, preparations for Operation Totalize were elaborate and in some aspects innovative. The use of converted tracked self-propelled artillery vehicles, the so-called 'unfrocked priests', as armoured personnel carriers was an inventive solution to get Canadian infantry forward under protection. Furthermore, Totalize was supported by elaborate artillery fire plans and the use of massed attacks by heavy bombers against the deep German positions that faced the attacking Canadian and Polish divisions.

The two armoured divisions tasked with the break-out phase of Totalize were both recent arrivals in Normandy. 4th Canadian Armoured Division, commanded by Maj-Gen George Kitching was relatively green, although efforts had been made to involve it in small scale operations soon after its arrival in France. Kitching was a 34-year-old infantryman who took command of the division in February 1944. His previous operational experience was with a Canadian infantry brigade in Italy. 1st Polish Armoured Division (*Pierwsza Dywizja Pancerna*), led by Maj-Gen Stanisław Maczek, could scarcely be described as 'green'. At 52 years of age, Maczek was easily the oldest and most experienced senior officer in II Canadian

A column of Polish armour advances in the first half of August 1944. Language difficulties and initial setbacks in Operation 'Totalize' led to some misunderstandings between the Canadian and Polish coalition partners. *(PISM 2538)*

ORGANISATION OF ALLIED ARMOURED DIVISIONS

During the battle to close the Falaise Pocket, manoeuvre by large Allied formations was introduced to the Normandy battlefield after the grinding battles to break out from the lodgement area. In particular, Allied armoured divisions began to operate in the fashion for which they were intended by penetrating into the German rear areas, bypassing centres of resistance and disrupting the possibility of a coherent organised defence.

By the summer of 1944, the organisation of Allied armoured divisions approached something close to their definitive wartime format. British and American experiences, however, led to different patterns in terms of their size and structure.

Britain had been at war for two years longer than the Americans and the experience of North Africa and Italy shaped the development of its armoured divisions. The 1944 British armoured division was built around two brigades; one armoured (containing three Sherman or Cromwell tank regiments and a motorised infantry battalion) and one infantry (with three battalions). In addition it had an armoured reconnaissance regiment (usually with Cromwell tanks), four artillery regiments (two of field artillery and one each anti-tank and light anti-aircraft) and a host of supporting units. The manpower of the 1944 British armoured division included 14,964 soldiers (all ranks). The division possessed 3,414 vehicles of all types including 246 cruiser (medium) tanks (Cromwells or Shermans) and 44 light tanks (Stuarts). Other major firepower assets were 48 25-pounder artillery pieces (half self-propelled and half towed), 78 anti-tank guns (6-pounder and 17-pounder) and 141 light anti-aircraft guns (20-mm and 40-mm).

The American armoured division was influenced by the effective German use of armour in the Polish and French campaigns of 1939–40. In terms of pre-Normandy battle experience, failures and successes in operations in Tunisia in 1943 provided an accelerated learning curve for the development of American armoured formations. Although the US Army would field to the end of the war two types of armoured division, a 'heavy' and a 'light' version, the most numerous and effectively the definitive version was the 'light' pattern that emerged in September 1943. None of the divisions featuring extensively in this book was a 'heavy' armoured division.

Structurally, the American armoured division differed markedly from the British pattern. The American divisions were built around combat command headquarters. Within the division existed three combat commands, CC A, CC B and CC R (reserve), each usually containing an armoured, infantry and artillery battalion with attached supporting elements such as engineers and anti-aircraft guns. The 1943 'light' armoured division (and the earlier 'heavy' pattern) therefore generally operated with three combined-arms battle groups. The 'light' pattern division had a total personnel strength of 10,670 (all ranks) making it roughly a third smaller than its British counterpart. Similarly, the number of tanks possessed by the

American division was smaller: 263, including 186 medium tanks (Shermans) and 77 light tanks. A total of 54 105-mm self-propelled howitzers made up the divisional artillery. Like its British counterpart, the American armoured division contained many hundreds of other vehicles to sustain it during operations.

In comparing the organisations of British and American armoured divisions, one thing stands out as a critical factor in assessing their operational effectiveness – the ability to fight as integrated all-arms formations. In this regard, the structure of the British armoured division was found wanting. Its two-brigade organisation (one armoured and one infantry) did not lend itself easily to all-arms integration. In Normandy, too often the two brigades of a British armoured division fought their own battles, a tendency reinforced by the regimental mentalities of their component battalions and regiments (for example armour tended to be the domain of former cavalry regiments). The costly battles for Caen forced the British armoured divisions to change the way they operated and to fight as combined-arms battle groups. Practice most definitely improved as a result of costly experience but command structures remained awkward. The brigades had the necessary headquarters infrastructure but the regimental or battalion level lacked adequate command and control capacities. In contrast, the American combat command system both in structure and practice was more effective in operations. The combat command headquarters were leaner than those of a brigade and yet more robust than those of a battalion and provided a more effective model of command and control for integrating infantry, armour, artillery and the various combat support elements.

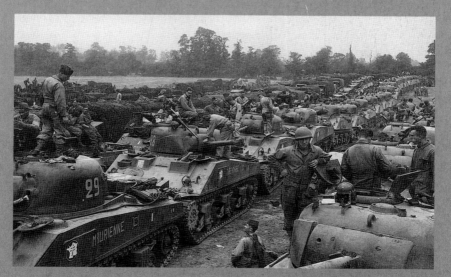

The tanks and wheeled vehicles of 2nd French Armoured Division massed in a staging area near Utah Beach on 1 August ready for the advance inland. The image illustrates the considerable fighting power and mobility of an armoured division. (USNA)

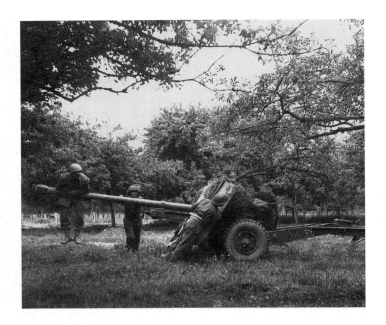

Canadian soldiers wrestle a 17-pounder anti-tank gun into position in an orchard in Normandy, illustrating its tactical limitations. Despite its bulk, the 17-pounder was the most effective Allied anti-tank gun. (NAC PA-128793)

Corps. His military experience included service in an elite Austro-Hungarian mountain infantry regiment during the First World War, in the Polish-Soviet war of 1919–21, and in a variety of command appointments in the inter-war Polish Army. From October 1938 he commanded 10th Cavalry Brigade, Poland's first mechanised unit. Maczek and the bulk of his division's soldiers, of whatever rank, had fought in the Polish and French campaigns in 1939 and 1940 respectively. 1st Polish Armoured Division, however, was assigned to II Canadian Corps only 48 hours before Totalize began and had not trained or worked with its Canadian counterparts before; language difficulties were to be another factor challenging close co-operation. Coalition partners who do not know each other can be prone to misunderstandings. This was the case throughout the operations of II Canadian Corps.

Operation Totalize began with promising gains but in its later phases stalled dramatically (see *Road to Falaise* in this series). Many reasons have been cited for the failure of Operation Totalize. In its second phase, many critics of Simonds' plan have argued that 4th Canadian and 1st Polish Armoured Divisions, attacking on both sides of the Caen–Falaise road, were assigned too narrow frontages –

4TH CANADIAN ARMOURED DIVISION **18 AUGUST 1944**

General Officer Commanding **Maj-Gen G. Kitching**
 General Staff Officer, Grade 1 *Lt-Col F.E. Wigle*
 Commander, Royal Artillery *Brigadier J.N. Lane*

4th Canadian Armoured Brigade *Brigadier E.L. Booth*
 21st Canadian Armoured Regiment (Governor General's Foot Guards)
 22nd Canadian Armoured Regiment (Canadian Grenadier Guards)
 28th Canadian Armoured Regiment (British Columbia Regiment)
 The Lake Superior Regiment *(motor battalion)*

10th Canadian Infantry Brigade *Brigadier J.C. Jefferson*
 The Lincoln and Welland Regiment
 The Algonquin Regiment
 The Argyll and Sutherland Highlanders of Canada (Princess Louise's)

Divisional units
 29th Canadian Reconnaissance Regiment (South Alberta Regiment)
 5th Anti-Tank Regiment, RCA
 8th Light Anti-Aircraft Regiment, RCA
 15th and 23rd Field Regiments, RCA

c. 900 metres – thereby restricting their room for manoeuvre. Short bombing by Allied bombers on 8 August before H-Hour caused casualties and disruption to 1st Polish Armoured Division, about to launch its attack, and to 3rd Canadian Infantry Division as it moved forward. Simonds, however, believed that a lack of drive and the inexperience of his two armoured divisions were the most decisive factors in explaining the operation's failure. This perception certainly did not reflect an accurate or fair view of the motivation and combat experience possessed by members of 1st Polish Armoured Division. The tenacious resistance by 89th Infantry Division and elements of 12th SS Panzer Division *Hitlerjugend* (from I SS Panzer Corps) was probably the most significant factor in the failure to achieve a break-out. Simonds did not accept the difficulties faced by his armoured divisions on the ground and this masked what was in fact achieved through their efforts. Despite the determination displayed during the skilfully conducted defensive battle, Totalize mauled the German formations and left their positions critically

1ST POLISH ARMD DIV (PIERWSZA DYWIZJA PANCERNA)
19 AUGUST 1944

Commander **Maj-Gen Stanisław Maczek**
 Assistant Divisional Commander *Colonel Kazimierz Dworak*
 Artillery Commander *Colonel Stanisław Noel*

10th Armoured Brigade *Colonel Tadeusz Majewski*
 (10 Brygada Kawalerii Pancernej)
 1st Armoured Regiment *(1 Pułk Pancerny)* Lt-Col Aleksander Stefanowicz
 2nd Armoured Regiment *(2 Pułk Pancerny)* Lt-Col Stanisław Koszutski
 24th (Lancer) Armoured Regiment *(24 Pułk Ułanów)*
 Lt-Col Jan Kański
 10th Dragoon Regiment (Motor) *(10 Pułk Dragonów)*
 Lt-Col Władysław Zgorzelski

3rd Polish Infantry Brigade **Colonel Marian Wieroński**
 (3 Brygada Strzelców)
 Polish (Highland) Battalion *(Batalion Strzelców Podhalański)*
 Lt-Col Karol Complak
 8th Infantry Battalion *(8 Batalion Strzelców)* Lt-Col Aleksander Nowaczyński
 9th Infantry Battalion *(9 Batalion Strzelców)* Lt-Col Zdzisław Szydłowski

Divisional units:
 10th Mounted Rifle Regiment *(10 Pułk Strzelców Konnych)*
 Major Jan Maciejowski
 1st Anti-Tank Regiment *(1 Pułk Przeciwpancerny)*
 1st, 2nd Field Artillery Regiments *(1, 2 Pułk Artylerii)*

weakened in front of II Canadian Corps. When Totalize ended on 11 August, II Canadian Corps had advanced 14 km towards its objective of Falaise.

OPERATION TRACTABLE: 14–16 AUGUST

With Totalize having ended, Simonds paused before renewing his attack. His operations were now going to be shaped more directly by the consultations between Bradley and Montgomery held on 8 August, which led to the US attack northwards from Le Mans and the formation of the southern half of the Falaise Pocket. On 11 August Montgomery issued a new directive that included the substance of his

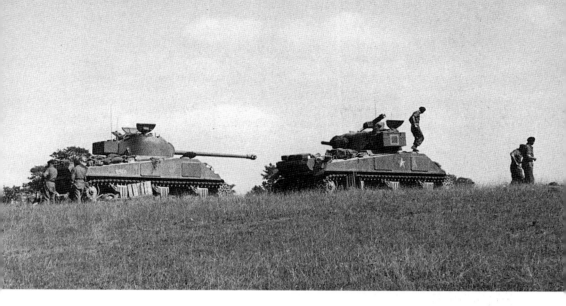

oral concurrence with Bradley's scheme of operations. In his new directive Montgomery ordered First Canadian Army (in particular II Canadian Corps) to take Falaise and then move 'with strong armoured and mobile forces to secure Argentan'. He also held out the possibility of a wider encirclement of German forces towards the Seine should they attempt to escape from Normandy.

On the surface, Operation 'Tractable' was a re-run of Totalize. An infantry break-in operation was to be followed by a break-out and exploitation by II Canadian Corps' two armoured divisions. Large-scale artillery support and use of strategic bombers were to be provided to assist the assault. To a great extent, however, Tractable sought to avoid the shortcomings of Totalize by learning from previous mistakes. Nevertheless, not all the problems that dogged Totalize could be avoided and some new ones appeared. On 14 August another short bombing incident caused casualties and disruption to Canadian and Polish formations. Similarly, the River Laison in the corps' path of advance proved to be a more formidable water obstacle than anticipated. Even so, on 14 August 3rd Canadian Infantry Division, 4th Canadian Armoured Division and 51st (Highland) Infantry Division made steady progress, fighting their way towards Falaise. Against the massive pressure of II Canadian Corps' attack

Polish Sherman tanks harbour on a hilltop during a lull in operations. The tank on the left is a Sherman Firefly armed with a 17-pounder gun. (PISM 2649)

The view
looking south
to the village of
Damblainville
from the hill
to the north.
4th Canadian
Armoured
Division's attack
on 17 August
became stalled
by heavy German
fire from south
of the village.
(Author)

the German defensive efforts began to crumble. By the end of 15 August 4th Canadian Armoured Division was east of Falaise with its leading elements established on high ground north of Damblainville some 6 km away.

1ST POLISH ARMOURED DIVISION: THE DIVES BRIDGEHEAD

On the second day of Tractable Simonds launched 1st Polish Armoured Division on an easterly axis of attack almost perpendicular to the main thrust of II Canadian Corps. Sprung loose from the rigid arrangements of Totalize, the Polish division came into its own as a manoeuvre formation. 1st Polish Armoured Division moved forward in two columns, the northern one aiming for Vendeuvre and the southern one for Jort, with the objective of finding a crossing over the River Dives. The divisional reconnaissance regiment, 10th Mounted Rifle Regiment (*10 Pułk Strzelców Konnych*), together with a company of motorised infantry from 10th Dragoon (Motor) Regiment (*10 Pułk Dragonów*), dashed ahead and managed to seize a crossing across the Dives at Jort by the evening of 15 August. Despite attempts by elements of the German 272nd and 85th Infantry Divisions to contain the Polish advance, the leading armoured regiments held on to their gains. Consolidating his bridgehead, during the night of 15/16 August Maczek put his infantry brigade

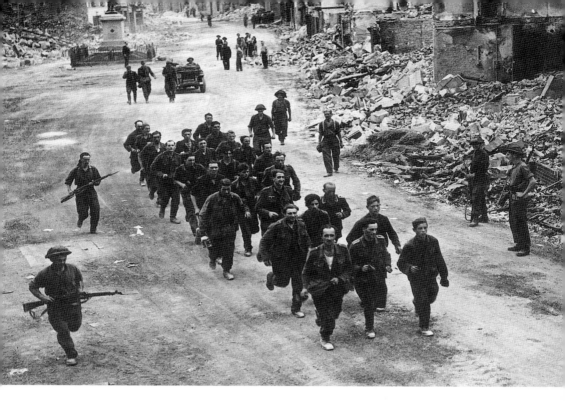

Then: Canadian soldiers escort a group of German prisoners through the main square of Trun, August 1944. *(IWM SF10)*

Now: The same square today reflects a more peaceful scene, typical of a quiet market town in rural Normandy. In honour of Trun's liberation by the Canadians on 18 August 1944, the square has been renamed Place du Canada. *(Author)*

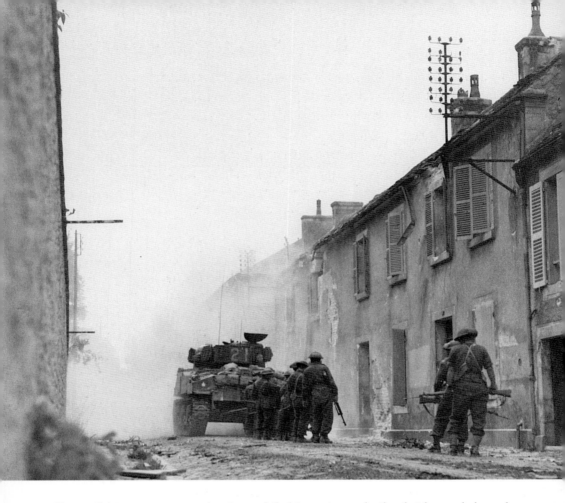

Clearing Falaise was a dangerous business for Canadian infantry. Soldiers of Les Fusiliers Mont-Royal follow a Sherman tank in what proved an unsuccessful attempt to deal with German snipers, 17 August. *(NAC PA-132194)*

across the river while his engineers built a bridge and cleared mines to support the advance. Having broken into open country and gained a bridgehead across the Dives, Maczek was in a strong position to drive south-east into the flank of the retreating German columns.

On 16 August 1st Polish Armoured Division moved two battlegroups south of the bridgehead at Jort. The western group, consisting of 24th (Lancer) Armoured Regiment (*24 Pułk Ułanów*), infantry of 10th Dragoon Regiment and an anti-tank battery, moved to near Morteaux-Coulibœuf; the eastern group, made up of 1st Armoured Regiment (*1 Pułk Pancerny*), 8th Infantry Battalion (*8 Batalion Strzelców*) and an attached anti-tank battery, moved towards Barou-en-Auge.

On 17 August, 1st Polish Armoured Division's objectives changed as a consequence of a new directive from 21st

Army Group headquarters. At 1445 hours on 17 August, Montgomery ordered II Canadian Corps to close the remaining gap through which German forces were escaping:

> 'It is absolutely essential that both Armd Divs of 2 Cdn Corps, i.e. 4 Cdn Div and 1 Pol Armd Div, close the gap between First Cdn Army and Third US Army. 1 Pol Armd Div must thrust on past TRUN to CHAMBOIS at all costs, and as quickly as is possible.'
>
> *Source*: C.P. Stacey, *The Victory Campaign*, p. 252.

Maczek's battlegroups, in shifting combinations of units, therefore continued their advance in a south-easterly direction, with Chambois now the divisional objective. On 17 and 18 August the eastern and western groups fought their way through pockets of resistance including some from elements of 2nd SS Panzer Division *Das Reich*. The western group took a route running from Moutier-en-Auge to Louvières-en-Auge, with the eastern group paralleling its advance through open country. The Polish battlegroups found that their rapid exploitation outran the ability of their division's logistical elements to keep them supplied. Moreover, the fact that they were operating in areas interspersed with retreating German columns meant that they suffered from 'blue-on-blue' attacks by Allied tactical air forces looking for targets of opportunity. On some occasions Polish re-supply was hampered by attacks from Allied aircraft that left the leading echelons short of fuel, ammunition and rations. Despite these difficulties, by the evening of 18 August the two Polish battlegroups had crossed the Trun–Vimoutiers road (now the D916) and 'harboured' for the night in positions north-east of Trun. The leading units of 1st Polish Armoured Division were now a short drive away from Chambois.

CANADIAN OPERATIONS FROM FALAISE TO TRUN

Although Falaise remained an objective, it was becoming much less significant in terms of the development of the battle of encirclement. Moreover, by the middle of August this market town was a rubble-strewn ruin as a consequence of heavy bombing which resulted from its importance as a

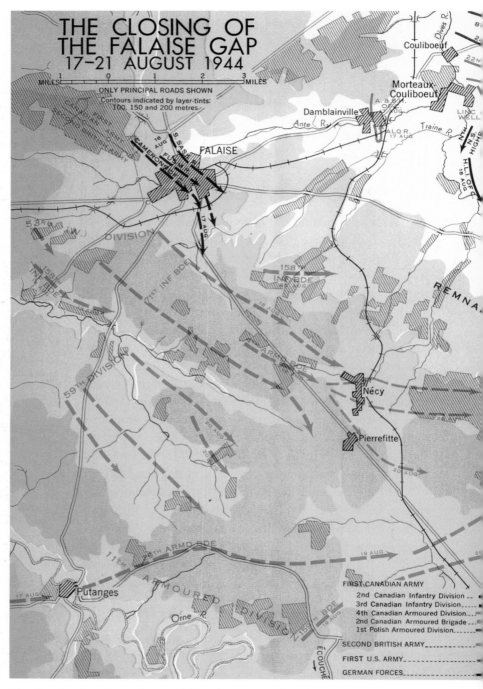

The Canadian Army's attack toward Chambois to complete the northern part of the encirclement gained momentum between 17 and 21 August. The movement of units

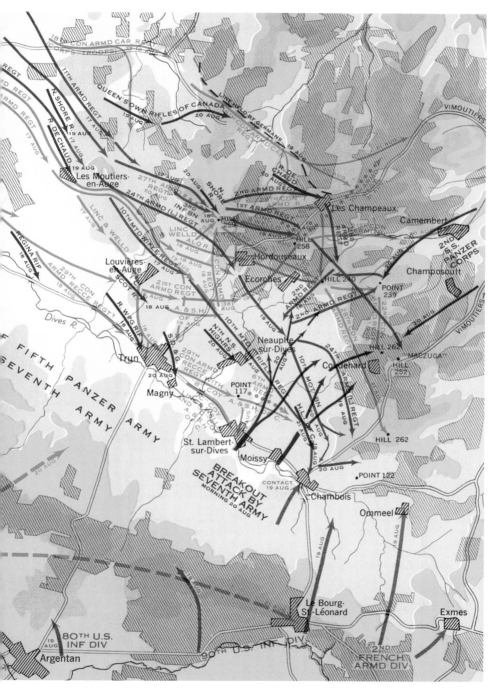

became fluid and complex, as indicated on this map, from *The Victory Campaign*, the official Canadian history of operations in North-West Europe.

road junction. Although 3rd Canadian Infantry Division fought to the edge of Falaise, the task of taking the town went to 2nd Canadian Infantry Division, moving from the area of Clair Tizon. The battle to take Falaise proved to be a difficult urban clearing operation. The division's 6th Infantry Brigade received the assignment and advanced into the town. The attack began on 16 August and the last pockets of German resistance were not extinguished until 18 August. The most difficult part of the operation to clear Falaise proved to be at the *école supérieure* (high school) near the main southern road out of the town. Garrisoned by between 50 and 100 fanatical 'Hitler Youth' from 12th SS Panzer Division, the school was cleared by Les Fusiliers Mont-Royal, with all but two of the German defenders perishing when the building caught fire. With Falaise liberated, II Canadian Corps attained what had been one of its key objectives, but one whose importance had been overtaken by events.

On 15 August Montgomery modified his orders for II Canadian Corps to reach the market town of Trun, in the gap between Falaise and Argentan. A day later Simonds directed 4th Canadian Armoured Division to advance on Trun by the most direct route. Maj-Gen George Kitching, commanding 4th Canadian Armoured Division, massed his force north-east of Falaise on some high wooded hills near the village of Damblainville. He intended to mount an attack southwards through Damblainville, establishing a bridgehead across the Rivers Ante and Train and driving south-east towards Trun. At 0730 hours on 17 August Kitching launched his attack using the infantry of The Argyll and Sutherland Highlanders of Canada and tanks of 29th Armoured Regiment (The South Alberta Regiment). The village and the key bridge were quickly secured but attempts to move south or east on the other side of the river met with intense fire from mortars and machine guns, which were manned by the determined survivors of 12th SS Panzer Division.

While the lead elements of the division were halted by German fire, the rest of the division began to move down the long hill leading to Damblainville, creating a traffic jam and an exposed target for German fire and a rare appearance

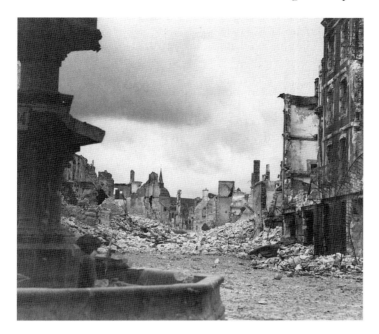

A view of the destruction in the centre of Falaise, 16 August. Note the soldier in the fountain using its stone side for protection. *(NAC PA-116503)*

from the *Luftwaffe*. Kitching committed fresh troops and tanks to try to get his division moving. These efforts proved equally unsuccessful. At around 1600 hours, at the behest of General Simonds, Kitching decided to disengage his division and move it across the Ante through the neighbouring village of Morteaux-Coulibœuf. The bridge here had been seized by a platoon of The Algonquin Regiment, providing another route to Trun. By early evening, after some impressive traffic control, Kitching got his three tank regiments and armoured reconnaissance regiment across the Ante. Around nightfall his armoured units 'harboured' a short distance from Trun and the D916 between Trun and Vimoutiers. On 18 August, motorised infantry of The Lake Superior Regiment and tanks of 22nd Armoured Regiment (The Canadian Grenadier Guards) took Trun without too much difficulty. Apart from delays caused by Allied aircraft bombing the town, Trun was secured by the afternoon of 18 August. With the seizure of Trun, II Canadian Corps was finally moving closer to shutting off the remaining gap.

CLOSING THE POCKET, 19–21 AUGUST

The battle to close the Falaise Pocket had reached its critical point by 18 August with a narrow gap remaining between Trun and Chambois for the Germans to withdraw north and east to safety. The fate of the German Army in Normandy was going to be decided by the fighting that took place in the 18 square kilometre triangle drawn from three points consisting of the towns of Trun and Chambois and the hamlet of Coudehard. For the Allied forces moving from the north and south, it was a dangerous moment. With 4th Canadian Armoured Division, 1st Polish Armoured Division and 90th US Infantry Division converging, there was the inevitable risk of inter-Allied 'blue-on-blue' incidents. The danger of friendly fire incidents was all the greater because the formations engaged in combat followed different procedures and, in some instances, spoke different languages. A further challenge lay in the desperation of the trapped German forces, which were able to concentrate on relatively narrow sectors. For the Allies (particularly the Canadian and Polish divisions), the transition from a fluid manoeuvre battle to a positional defensive action marked an abrupt and challenging shift in the nature of the struggle to close the gap. American, Canadian and Polish soldiers faced hard fighting against a dangerous opponent who showed remarkable resilience under the most catastrophic of circumstances.

THE JUNCTURE OF THREE ALLIED ARMIES, 19–21 AUGUST

The attempt by 4th Canadian Armoured Division to close the gap centred on the village of St-Lambert-sur-Dive between Trun and Chambois. The task fell to 29th Armoured Regiment

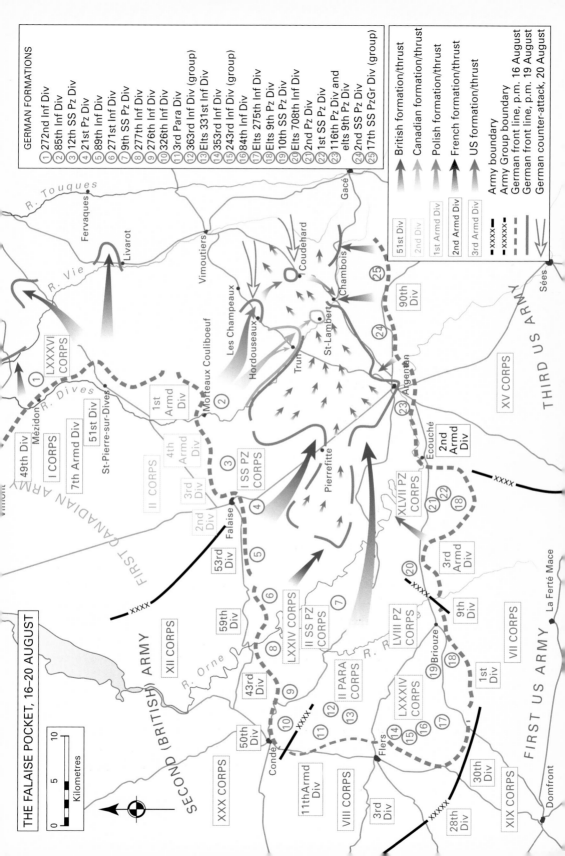

THE FALAISE POCKET, 16–20 AUGUST

GERMAN FORMATIONS

1. 272nd Inf Div
2. 85th Inf Div
3. 12th SS Pz Div
4. 21st Pz Div
5. 89th Inf Div
6. 271st Inf Div
7. 9th SS Pz Div
8. 277th Inf Div
9. 276th Inf Div
10. 326th Inf Div
11. 3rd Para Div
12. 363rd Inf Div (group)
13. Elts 331st Inf Div
14. 353rd Inf Div
15. 243rd Inf Div (group)
16. 84th Inf Div
17. Elts 275th Inf Div
18. Elts 9th Pz Div
19. 10th SS Pz Div
20. Elts 708th Inf Div
21. 2nd Pz Div
22. 1st SS Pz Div
23. 116th Pz Div and elts 9th Pz Div
24. 2nd SS Pz Div
25. 17th SS PzGr Div (group)

British formation/thrust
Canadian formation/thrust
Polish formation/thrust
French formation/thrust
US formation/thrust

Army boundary
Army Group boundary
German front line, p.m. 16 August
German front line, p.m. 19 August
German counter-attack, 20 August

51st Div
2nd Div
1st Armd Div
2nd Armd Div
3rd Armd Div

xxxx
xxxxx

Kilometres
0 5 10

SECOND (BRITISH) ARMY
FIRST CANADIAN ARMY
THIRD US ARMY
FIRST US ARMY

R. Touques
R. Vie
R. Dives
R. Orne
R. R.

Fervaques
Livarot
Vimoutiers
Coudehard
Gacé
Chambois
St-Lambert
Trun
Les Champeaux
Hordouseaux
Morteaux Coulibœuf
St-Pierre-sur-Dives
Falaise
Pierrefitte
Argentan
Écouché
Sées
Briouze
Flers
Condé
La Ferté Macé
Domfront
Mézidon

XXX CORPS
XII CORPS
I CORPS
II CORPS
I SS PZ CORPS
LXXIV CORPS
II SS PZ CORPS
II PARA CORPS
LXXXIV CORPS
LVIII PZ CORPS
XLVII PZ CORPS
VIII CORPS
VII CORPS
XV CORPS
XIX CORPS
LXXXVI CORPS

49th Div
7th Armd Div
51st Div
1st Armd Div
4th Armd Div
3rd Div
2nd Div
53rd Div
59th Div
43rd Div
50th Div
11th Armd Div
3rd Div
28th Div
30th Div
9th Div
1st Div
2nd Armd Div
3rd Armd Div
90th Div

Soldiers of the
Argylls of Canada
advance into
St-Lambert-sur-
Dive, 19 August.
(NAC PA-152375)

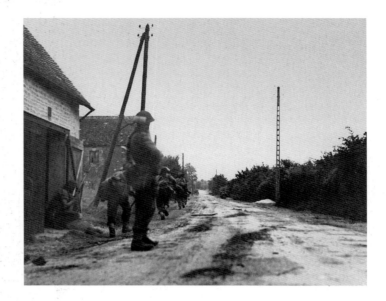

(The South Alberta Regiment). The remainder of the division was positioned on the road (now the D5) running between Trun and Vimoutiers. From the evening of 18 August to the afternoon of 21 August St-Lambert-sur-Dive was the scene of very hard fighting (*see Tour A, pp. 115–37*). The aim of moving beyond St-Lambert to Moissy, less than 2 km away, and then on to Chambois to link up with the Americans and Poles, proved too much for the South Albertas. Instead, they found themselves fully engaged in a difficult defensive action trying to hold St-Lambert and block the exit of the escaping Germans along that stretch of the Dives river valley.

On the evening of 18 August a small battlegroup led by Major David V. Currie, consisting of the South Albertas' C Squadron and an under-strength company of infantry from the Argyll and Sutherland Highlanders of Canada, was ordered to take the village. Arriving at dusk, their initial attack on St-Lambert failed but the next day Currie secured the village by mid-morning. The remaining South Alberta squadrons (A and B) and other regimental assets, along with a scratch company of infantry from the Lincoln and Welland Regiment, made up the remaining Canadian forces engaged in the area of St-Lambert. Canadian dispositions placed Major Currie's C Squadron along with supporting

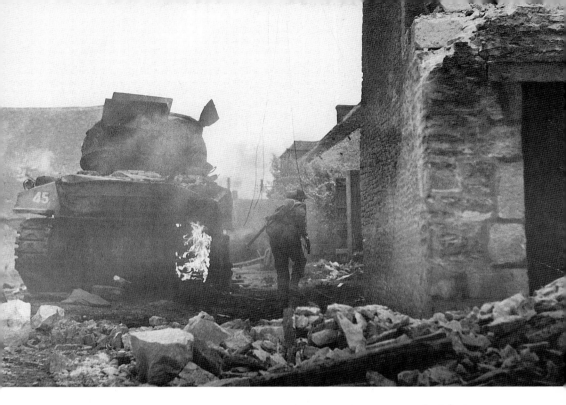

An infantryman of the Argylls of Canada moves forward past a burning Canadian Sherman tank in St-Lambert-sur-Dive, 19 August. (NAC PA-132192)

infantry in St-Lambert, where they attempted to hold its critical bridge and to block the escape of German units during 19–21 August. Meanwhile, between 18 and 20 August the Albertas' B Squadron was east of St-Lambert and north of Moissy, attempting to cut off another escape route; A Squadron was astride what is now the D13 protecting the regiment's line of communications. The South Albertas' regimental headquarters was on Hill 117 (Hill 118 today), directly north of St-Lambert, from where the regiment's commanding officer, Lt-Col Gordon 'Swatty' Wotherspoon, directed his units.

The most dangerous period was on 20 August when German forces, led by 353rd Infantry Division and 2nd Panzer Division, followed by elements of at least three SS Panzer Divisions (1st, 10th and 12th) and remnants of other formations, mounted a succession of break-out attacks. St-Lambert was the central arena for the Canadian action and although many of the Germans escaped, in the end Major Currie managed to cling on to part of the village. His leadership earned him the Victoria Cross.

SHERMAN TANK

The backbone of the Allied tank fleet in Normandy was the American-built M4 Sherman tank, which operated in a number of versions. With just under 50,000 produced, the Sherman has the distinction, like the Soviet T34, of being among the most numerous of armoured fighting vehicles produced during the Second World War. Sherman tanks figured prominently in the order of battle of Allied armoured divisions in Normandy. By 1944, however, the Sherman was out-gunned and inadequately armoured when compared against the best of German tanks, the medium Panther and the heavy Tiger. Indeed, for Allied tank crews the inadequacies of the Sherman's firepower and protection were a daily hazard and by no means made up for by the tank's virtues of reliability and the quantity available. The short-comings of the Sherman in combat were clearly encapsulated in the memoirs of Lieutenant Belton Y. Cooper, a junior maintenance officer serving in 3rd US Armored Division. In his job of identifying tanks to be recovered and repaired or replaced, Cooper became fully aware of the Sherman tank's limitations on the battlefield:

'The combination of superior firepower and heavier armor allowed the German tanks to engage and destroy the M4 Sherman at long range. There were many cases where Shermans would score multiple direct hits on the front of a Panther or Tiger, only to see the shells bounce off harmlessly. In comparison, the German high velocity guns could not only penetrate the lighter armor of the Sherman with a single shot at long range, they could knock out a Sherman even after shooting through a brick wall and, in at least one instance, by shooting through another Sherman tank. Whereas the Sherman had to get within six hundred yards of a Panther and hope to catch it on the flank, the Panther could knock out a Sherman at two-thousand yards head-on.'

Source: Belton Y. Cooper, *Death Traps*, p. 308.

On 17 August 1st Polish Armoured Division had been ordered to reach Chambois, where it was to join up with US forces and close the remaining gap. By the evening of 18 August it was within 10 km of its objective. The division had been operating on a parallel line to the north of 4th Canadian Armoured Division. Maczek directed his division towards two mutually supporting objectives: to Chambois to meet 90th US Infantry Division (as per his orders from General Montgomery) and towards two hills (262 North and South on 1944 maps, both measured as 263 metres today) on a ridge north-east of Chambois. On the map the

With a weight of about 32 tons, armour with a maximum thickness of about 76 mm and a road speed of 38 km/hr, most versions of the M4 Sherman in Allied service were armed with a low velocity, short-barrelled 75-mm gun that lacked penetrative power. American efforts to improve the firepower of the tank led to the 75-mm gun being replaced with a higher velocity 76-mm gun. This was an improvement, but its effectiveness against the better-armoured German tanks was still limited. Just over 100 were in service at the start of Operation Cobra in late July. The most effective version of the Sherman was the British-modified Sherman Mark Vc Firefly that mounted the long-barrelled, high velocity 17-pounder gun. Throughout the fighting in Normandy it was the only Anglo-American tank with sufficient firepower to take on the best of the German armour. However, during the Normandy operations, shortages of the much-prized 17-pounder gun meant that only one tank per troop in British, Canadian and Polish armoured units was a Firefly. Because of its effectiveness and distinctive long barrel, the Firefly was often first to receive the attention of the German armour in an engagement. Despite its obsolescence in 1944, the Sherman still saw operational use during the Korean War (1950–53) and in revised forms as late as the Arab-Israeli War in 1967.

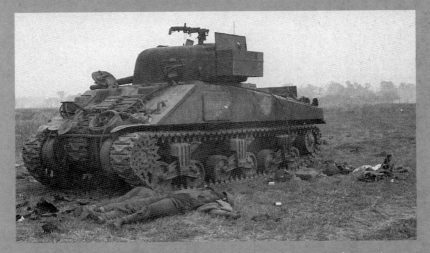

A disabled Polish Sherman tank. The shot penetration in the turret can be seen just to the left of the rear stowage box. The dead members of the tank crew alongside the vehicle are a sad reminder of the Sherman's inadequacies. (PISM 2503)

contour lines reminded Maczek of a medieval weapon, the mace, and for the soldiers of 1st Polish Armoured Division and historians alike, this position soon became known as the 'Mace' (*maczuga* in Polish; pronounced ma-choo-ga).

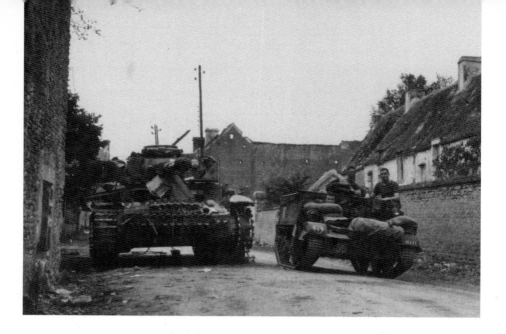

A disabled Panzer IV by the roadside in the village of Damblainville, 20 August. Stubborn German resistance forced 4th Canadian Armoured Division to bypass the village and seek another crossing of the River Dives in a neighbouring village. *(IWM CL843)*

Maczek, a former mountain infantryman, understood the value of high ground, and with the shift from a manoeuvre to a positional battle, the Mace afforded him a good defensive position that commanded the D16 and D242 roads to Vimoutiers which were important to the retreating German forces. By the evening of 19 August the bulk of Maczek's division had reached these two objectives.

Two-thirds of 1st Polish Armoured Division's fighting strength was now on the Mace. Between 19 and 21 August this force was cut off and attacked from virtually all sides by German units trying to fight their way out of the pocket and by others (from II SS Panzer Corps) trying to break into the pocket to create an escape corridor (*see Tour B, pp. 139– 60*). The action of the Polish battlegroup which reached Chambois is examined below (*and in Tour D, pp. 175–85*) in conjunction with the efforts of 90th US Infantry Division.

The Polish action on the Mace, like that of the Canadians at St-Lambert, was one of the most heroic episodes of the battle to close the Falaise Pocket. On the Mace were 1st and 2nd Polish Armoured Regiments, 8th and 9th Polish Infantry Battalions, the Polish (Highland) Battalion (*Batalion Strzelców Podhalański*) and supporting anti-aircraft and anti-tank detachments. When the Poles arrived on the Mace their units were short of fuel, ammunition and provisions;

during the course of the action they were also cut off from re-supply. Polish defensive positions resembled the walls of a medieval fortress, the tanks as the towers with infantry interspersed between them. Command on the Mace was highly decentralised, mainly because there was no brigade headquarters to manage the battle. Each battlegroup, consisting of an armoured regiment with attached infantry, defended its own section of the fortress wall. With the position no more than 2 km across at its widest point, the action was very much a close-quarter battle involving mêlées with tanks at very close ranges.

While the Canadians and Poles fought their battles to the north, 90th US Infantry Division occupied thinly strung-out positions running along the east–west road (now the D14) between the villages of le Bourg-St-Léonard and Exmés. Le Bourg-St-Léonard was critical for 90th US Infantry Division in any attempt to close the gap towards Chambois. The village stood on a ridge line that ran east–west and offered very good observation points over the Dives river valley

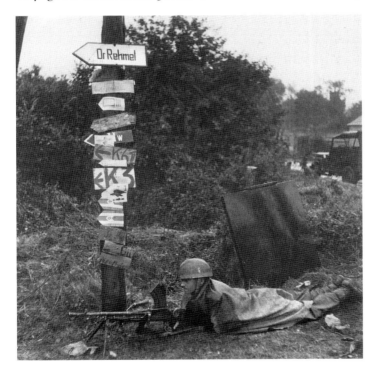

Bren-gunner beneath a German signpost near Trun. *(IWM SF)*

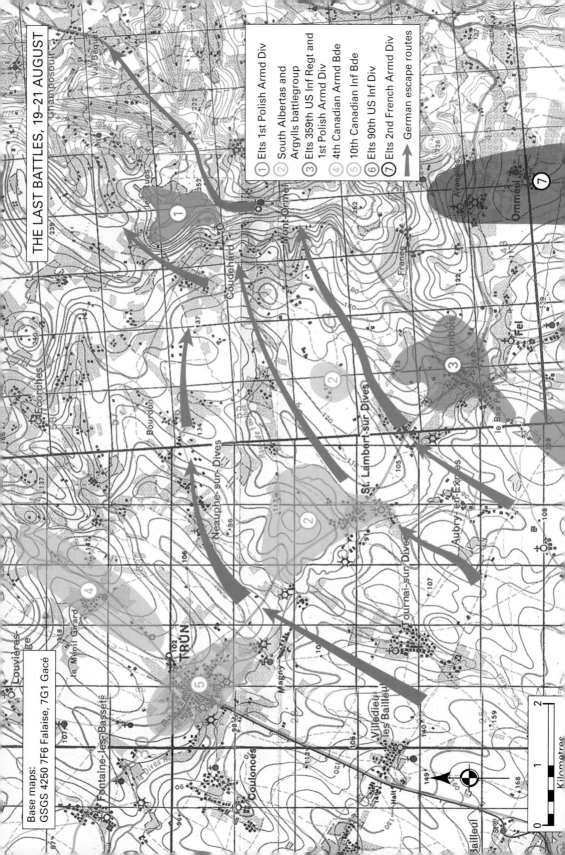

THE LAST BATTLES, 19–21 AUGUST

Base maps:
GSGS 4250 7F6 Falaise, 7G1 Gacé

① Elts 1st Polish Armd Div
② South Albertas and Argylls battlegroup
③ Elts 359th US Inf Regt and 1st Polish Armd Div
④ 4th Canadian Armd Bde
⑤ 10th Canadian Inf Bde
⑥ Elts 90th US Inf Div
⑦ Elts 2nd French Armd Div
→ German escape routes

Kilometres
0 1 2

below. Moreover, it was an important crossroads where roads leading both to Argentan and Chambois intersected, making it valuable to the Germans seeking to escape the pocket. On 16 and 17 August 1st Battalion, 359th Infantry Regiment (1/359th Infantry) and supporting units fought to hold this key village against persistent German infantry and tank attacks that saw le Bourg-St-Léonard change hands several times (*see Tour C, pp. 161–74*). By 18 August the village was firmly under American control, and from it they directed artillery concentrations onto targets near Chambois. The battle for le Bourg-St-Léonard provided a critical prelude to the final push to close the gap.

The juncture of the Allied armies was finally achieved at Chambois on 19 August. Elements of a Polish battlegroup, consisting of tanks from 24th Armoured Regiment, infantry of 10th Dragoon Regiment and armoured reconnaissance elements from 10th Mounted Rifle Regiment, along with an anti-tank detachment, entered Chambois from the northwest in the late afternoon. From the south, 2/359th US Infantry fought its way into Chambois, with the Poles and

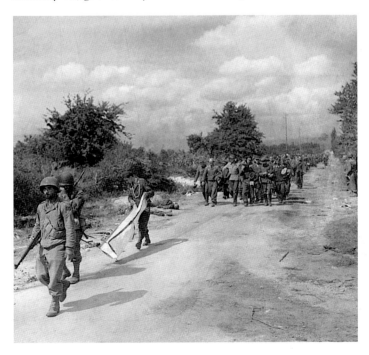

German prisoners are brought in by US infantry in Chambois. In the closing stages of the battle masses of prisoners had to be managed and taken to the rear. *(USNA)*

German dummy
tank turrets and
anti-tank gun
in a farmyard
on the Livarot
road, in the
Chambois–Trun
area. *(IWM SF)*

Americans meeting around 1900 hours. Lieutenant Jan Karcz, commanding a platoon of 3rd Squadron, 10th Dragoon Regiment, and Captain L.E. Waters, leading G Company, 359th Infantry, were the officers whose units had the distinction of achieving the link-up between the two armies. The Polish battlegroup, cut off from its divisional logistic support, was re-supplied by 90th US Infantry Division, which provided food, fuel and ammunition and which relieved the Poles of a mass of German prisoners. Between 19 and 21 August a joint defence of Chambois saw the northern half of the town assigned to the Polish battlegroup with 359th Infantry Regiment taking responsibility for the southern portion. The joint defence faced continued German attempts to escape the pocket, mainly west of Chambois.

The meeting of Polish and US troops in Chambois signified the closure of the Falaise Pocket. Virtually all German escape routes were swept by Allied direct and indirect fire as a consequence of the Allied positions held at St-Lambert, the Mace and Chambois. However, the movement of German forces out of the pocket was never fully stopped. An escape corridor between St-Lambert and Chambois at the ford across the River Dives at Moissy remained open and German

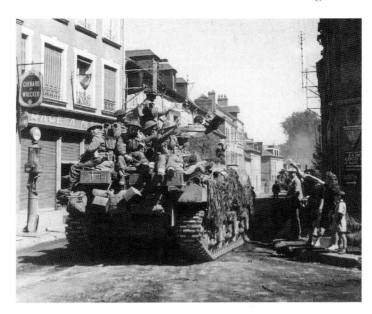

British troops
passing through
liberated Gacé,
23 August.
(IWM SF)

troops continued moving north-east, skirting the western side
of the Polish position on the Mace. The explanation why
this route was not sealed rests on the lack of Allied combat
power, notably in the shape of infantry to occupy blocking
positions. The experience of the Canadians at St-Lambert
and the Poles on the Mace demonstrated that, to seal a
pocket from which the enemy was exiting in large numbers,
infantry were vital. What is less easily explained is the fact
that the bulk of 4th Canadian Armoured Division's fighting
strength remained inactive during this critical period. Most
of the division's armour and infantry failed to help the South
Albertas to seal the line of the River Dives. Nor did they
join up with the Poles to close the German escape routes
west of the Mace or to reopen Polish supply lines to sustain
their combat effectiveness. Dissatisfied with the performance
of 4th Canadian Armoured Division's commander, Maj-
Gen Kitching, Lt-Gen Simonds relieved him on 21 August.
Nevertheless, the final stage in the battle of the Falaise Pocket
highlighted the critical importance of supporting artillery to
the units trying to stem the tide of escaping German soldiers.
It was a major factor in preventing the South Albertas and
the Poles on the Mace from being overwhelmed.

VICTORY IN NORMANDY

THE DRIVE TO THE SEINE AND THE LIBERATION OF PARIS

Concurrent with the battle of the Falaise Pocket was Third US Army's drive to the Seine. After Bradley authorised Patton to advance east on 15 August, Third US Army's advance involved a three-corps attack. Haislip's XV Corps, which had been on the southern shoulder of the Falaise Pocket, was split: 5th Armored Division and 79th Infantry Division were detached and, along with the corps headquarters and artillery, were directed eastwards towards Dreux. XX Corps, under Maj-Gen Walton H. Walker, was given the mission of taking Chartres. Haislip's and Walker's corps were to establish bridgeheads across the River Eure in both these towns. The third element in Patton's drive was Maj-Gen Gilbert R. Cook's XII Corps, consisting of 4th Armored Division and 35th Infantry Division. It was to advance towards Orléans while protecting Third US Army's southern flank. With bridges over the Loire demolished, the threat of a German counter-attack into the soft flank of Third US Army was negligible. Cook was therefore able to concentrate on taking Orléans, which he did on 16 August. Walker's XX Corps ran into much stiffer resistance at Chartres and the famous cathedral town was not secured until 18 August. Haislip's XV Corps, advancing against light resistance, took Dreux on 16 August. The forward echelons of Patton's Third US Army now stood less than 70 km from the French capital, Paris.

With little German opposition standing in front of Patton's three corps, further advances were now inhibited by logistic problems as the US divisions moved further and further away from their supply bases. Shortages of fuel and rations represented the most significant limitations, as against the light resistance ammunition consumption had been relatively

A 'Red Ball
Express' convoy
passes a traffic
regulation
point on one
of the one-way
highways set
up to facilitate
movement to the
front-line areas.
As the Allied
armies moved
away from the
Normandy coast,
maintaining the
flow of supplies
became more
difficult. *(USNA)*

low. As a consequence of supply shortages, Patton decided
to concentrate his advance on Haislip's XV Corps, while
holding his other two corps in their forward positions. In
addition to the brake that logistical problems exerted on
forward movement Bradley, concerned about intelligence
pointing to a possible German counter-attack to cut the
road between Argentan and Alençon, ordered Patton to halt
soon after he began his drive eastwards. The intelligence
proved unfounded, but the delay meant that the possibility of
cutting the Germans' escape routes across the Seine receded.
The delay clearly limited the possibility of achieving a wider
encirclement of German forces retreating from Normandy.

On 19 August Patton managed to get XV Corps moving
again. He sent 5th Armored Division north-west to attack
along the west bank of the Seine to disrupt German attempts
to cross the river, while 79th Infantry Division crossed the
river and consolidated a bridgehead near Mantes-Gassicourt.
Soon, Third US Army would achieve other bridgeheads

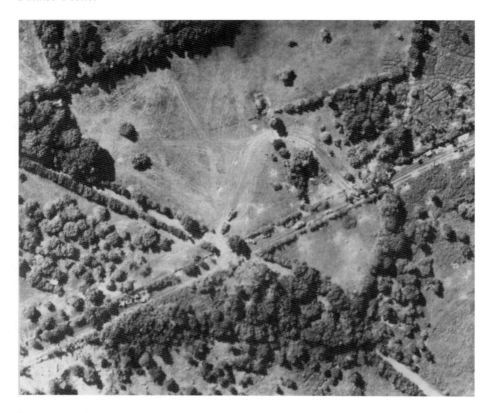

At a crossroads near Orbec wrecked German vehicles can be seen blocking the road. The track marks in fields indicate efforts to get around the obstacles. *(IWM CL868)*

across the Seine, rendering any organised defence of the river impossible. The prize that now remained was the capture of Paris. Given the political symbolism of liberating the city, Maj-Gen Leclerc and his 2nd French Armoured Division had been keen to extricate themselves from the Falaise Pocket battle and move on to the French capital. After much inter-Allied discussion, it was decided that Leclerc and his armoured division, along with 4th US Infantry Division, would take Paris. With the liberation of Paris on 25 August 1944, the Battle of Normandy was clearly over and the Allied gaze shifted towards Germany itself.

INCOMPLETE VICTORY?

With the guns falling silent over the Falaise Pocket, the battlefield produced some of the most iconic images of death and destruction that would emerge from the Second World War.

Visiting the battlefield to see the results of victory in Normandy, General Eisenhower experienced the grim aftermath of the battle:

'The battlefield at Falaise was unquestionably one of the greatest "killing grounds" of any of the war areas. Roads, highways, and fields were so choked with destroyed equipment and dead men and animals that passage through the area was extremely difficult. Forty-eight hours after the closing of the gap I was conducted through it on foot, to encounter scenes that could be described only by Dante. It was literally possible to walk for hundreds of yards at a time, stepping on nothing but dead and decaying flesh.'

Source: D.D. Eisenhower, *Crusade in Europe*, p. 306.

Eisenhower's description does not exaggerate the scale of the carnage. Allied pilots reported that a nausea-inducing stench permeated their cockpits as they flew over the battlefield. For the French inhabitants, the long process of clearing the detritus of the battle and the return to normality began.

Canadian soldiers have a good look at a 170-mm medium gun abandoned in the German retreat near Tosters, 30 August. *(NAC PA-132817)*

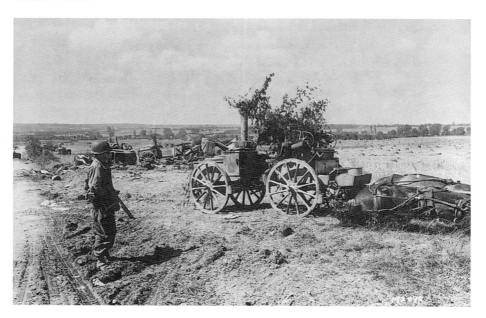

An American soldier examines a German horse-drawn field kitchen near Chambois on 22 August. Much of the German Army's transport was horse-drawn, with Allied transport being wholly motorised. *(USNA)*

Amid the scenes of unspeakable carnage were the beginnings of the controversies that would haunt historical debates on the outcome of the battle. As noted earlier in this book, the battle of the Falaise Pocket cannot be considered anything but a victory. But many historians interpreting the dramatic events in Normandy during the summer of 1944 have argued that Falaise was a lost opportunity to achieve a more complete victory. Indeed, the great British military thinker Maj-Gen J.F.C. Fuller argued that 'the destruction of the Seventh German Army [in the Falaise Pocket] and not the occupation of Paris should have been the strategical objective at that time'. Foremost among the interpreters of the battle of the Falaise Pocket is the American historian Martin Blumenson. On the point of the incomplete result of the battle Blumenson has argued:

> 'Large operations of encirclement are extremely difficult to execute, but the Allies let the chance for an overwhelming victory slip through their fingers. What should have been a finely tuned and well oiled maneuver was inept and bungled, displaying contradictory impulses. Hesitation, wrangling, and uncertainty marred the venture.

The Germans themselves had foolishly pushed their heads into a noose, and the Allies had been unable to pull the string shut.'
Source: M. Blumenson, *The Battle of the Generals*, pp. 22–3.

Although the criticisms made against senior Allied leaders over their failure fully to capitalise on the opportunity presented to them at the Falaise Pocket in August 1944 are convincing, they do not tell the entire story in military terms. Indeed, there may have been more fundamental military issues that led to the Falaise Pocket not ending in a more complete victory:

'The one episode of the Battle of Normandy that raises most questions about Allied offensive doctrine, however, is the Falaise battle. Aspects of command in this battle, on the part of American and British commanders alike, were very obviously suspect, yet what is equally obvious is that on the Allied side there was no doctrinal base for the conduct of a battle of encirclement and annihilation... The very great strength of the Allied armies in Normandy lay in their ability to win a battle of attrition, but for all the speed of the Allied breakout across France in

An overturned lorry near Chambois which has spilled its load of ammunition boxes on to the road. Clearing the battlefield of dangerous explosive materials was another major challenge after the fighting ended. *(PISM 2592)*

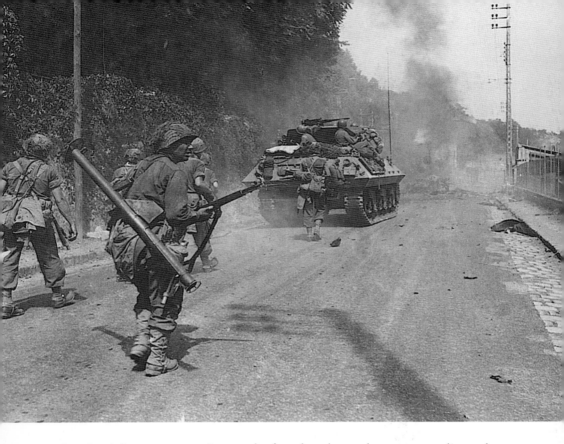

American infantry
follow an M10
tank destroyer
on the road to
Fontainebleau, 23
August. Two days
later American
and Free French
soldiers liberated
Paris. (USNA)

August the fact that these advances were directed
along divergent rather than convergent axes
indicates a doctrine geared to a general repulse
rather than the encirclement and annihilation of
a defeated enemy.'

Source: H.P. Willmott, *The Great Crusade*,
pp. 360–1.

Willmott captures what, in the final analysis, was an
approach in Allied military thinking that was not conducive
to achieving a comprehensive battle of annihilation against
their German enemy. Although the Red Army had mastered
by 1944 the art of large encirclement battles on the Eastern
Front, the Allies in Normandy demonstrated their inability to
execute operations in a similar way to deliver overwhelming
results against a weakening opponent.

Allied plans in Normandy sought to establish a strong
lodgement in France bordered by the Rivers Seine and Loire

by D+90 days. From this lodgement they planned to develop offensive operations leading to the final defeat of Germany. What is striking about the Allied aims in Normandy was the focus on establishing a secure base in France rather than on destroying enemy forces. The over-arching Allied aim in Normandy seems to support Willmott's analysis of the doctrinal limitations that undermined Allied military thinking.

Shifting the view of the battle from the strategic and operational levels to the tactical level, the Allied attempt to close the pocket points to some challenging questions. Troops attempting to escape encirclement can direct their strength on a narrow, if often predictable sector, while the encircling force is spread more thinly around the perimeter, trying to hold the ring. Given the Germans' ability to concentrate their strength, the first question faced by the Allies was how to meet this challenge. Was it necessary to seal the exits with troops on the ground or good enough to cover the escape routes with direct or indirect fire or air power? The amount and type of combat strength available is critical to answering this question. The example of the Falaise Pocket indicates that the Allied commanders deployed too few troops, particularly infantry, to achieve the necessary density of forces to block all German movement. The two armoured divisions of II Canadian Corps lacked sufficient manpower even though they commanded considerable firepower. Both at St-Lambert-sur-Dive and on the Mace, the lack of infantry was critical to the crisis experienced in those actions by the Canadians and Poles. Significantly, the American part in the encirclement was played by 90th Infantry Division which, apart from having to control a wide frontage, was a more suitable force to occupy blocking positions. Its employment, however, was cautious as indicated by the American preference, at least initially, for relying on firepower to stem the escape of the encircled German forces.

What the Allies lacked in boots on the ground to plug the remaining exits from the Falaise Pocket they certainly made up for in terms of firepower. With a crushing preponderance in artillery (it has been estimated that 2,600–3,000 guns ranged over the area of the pocket by 19 August) and air

Crowds of Parisians celebrate the liberation of the French capital at the Arc de Triomphe, 26 August. *(USNA)*

supremacy, it would seem that covering the remaining gap with firepower was a viable option. To be sure, Allied firepower took a crushing toll of German forces. Given the numbers of Germans that escaped the Falaise Pocket, however, it is clear that the effects of firepower were over-rated. A report by the British Operational Research Section that surveyed the cause of destruction of German vehicles in the pocket estimated that only about 7 per cent of them were destroyed by air-delivered munitions, with about 34 per cent destroyed by artillery fire. The remaining 60 per cent, it seemed, were either abandoned or destroyed by their crews. Despite the unquestionable damage inflicted on the German Army, firepower alone could not stop many Germans from escaping the cauldron. Lost opportunity or not, the battle to close the Falaise Pocket brought victory in Normandy by D+77, earlier than anticipated, and made the German position in France untenable. Moreover, the battle set the scene for the Allied pursuit of the Germans out of France to the borders of Germany.

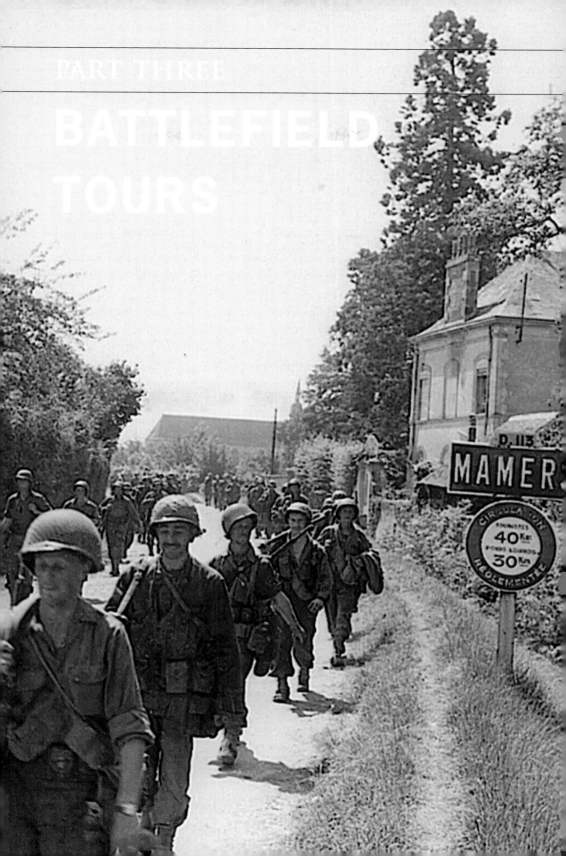

D. 113

MAMER

CIRCULATION
40 Km
PONTS LOURDS
30 Km
REGLEMENTÉE

GENERAL TOURING INFORMATION

Normandy is a thriving holiday area, with some beautiful countryside, excellent beaches and very attractive architecture (particularly in the case of religious buildings). It was also, of course, the scene of heavy fighting in 1944, and this has had a considerable impact on the tourist industry. To make the most of your trip, especially if you intend visiting non-battlefield sites, we strongly recommend you purchase one of the general Normandy guidebooks that are commonly available. These include: *Michelin Green Guide: Normandy*; *Thomas Cook Travellers: Normandy*; *The Rough Guide to Brittany and Normandy*; *Lonely Planet: Normandy*.

TRAVEL REQUIREMENTS

First, make sure you have the proper documentation to enter France as a tourist. Citizens of European Union countries, including Great Britain, should not usually require visas, but will need to carry and show their passports. Others should check with the French Embassy in their own country before travelling. British citizens should also fill in and take Form E111 (available from main post offices), which deals with entitlement to medical treatment, and all should consider taking out comprehensive travel insurance. France is part of the Eurozone, and you should also check exchange rates before travelling.

GETTING THERE

The most direct routes from the UK to Lower Normandy are by ferry from Portsmouth to Ouistreham (near Caen), and from Portsmouth or Poole to Cherbourg. Depending

Page 99: Soldiers of 314th Infantry Regiment, 79th US Infantry Division, march north out of Mamers, 12 August. Long marches in hot weather over many days made for footsore and exhausted infantrymen. *(USNA)*

on which you choose, and whether you travel by day or night, the crossing takes between four and seven hours. Alternatively, you can sail to Le Havre, Boulogne or Calais and drive the rest of the way. (Travel time from Calais to Caen is about four hours; motorway and bridge tolls may be payable depending on the exact route taken.) Another option is to use the Channel Tunnel. Whichever way you decide to travel, early booking is advised, especially during the summer months.

Although you can of course hire motor vehicles in Normandy, the majority of visitors from the UK or other EU countries will probably take their own. If you do so, you will also need to take: a full driving licence; your vehicle registration document; a certificate of motor insurance valid in France (your insurer will advise on this); spare headlight and indicator bulbs; headlight beam adjusters or tape; a high visibility jacket for use in the event of vehicle breakdown; a warning triangle; and a sticker or number plate identifying which country the vehicle is registered in. Visitors from elsewhere should consult a motoring organisation in their home country for details of the documents and other items they will require.

Normandy's road system is well developed, although there are still a few choke points, especially around the larger towns during rush hour and in the holiday season. As a general guide, in clear conditions it is possible to drive from Cherbourg to Caen in less than two hours.

ACCOMMODATION

Accommodation in Normandy is plentiful and diverse, from cheap campsites to five star hotels in glorious châteaux. However, early booking is advised if you wish to travel between June and August. Apart from some *gîtes*, there are relatively few places to stay in the immediate vicinity of Omaha Beach. The nearest large town is Bayeux, about 14 km south-east of Colleville-sur-Mer, which offers a good range of hotels to suit all budgets. The coastal resorts of Grandcamp-Maisy and Port-en-Bessin, and the town of Isigny, provide more limited accommodation; telephone or

The imposing twelfth-century rectangular keep at Chambois. In the foreground is a stele commemorating the meeting of the Allied armies in the town. *(Author)*

visit their tourist offices for details (*see below*). There are also several campsites in the area, including one at either end of Omaha Beach. Useful contacts include:

French Travel Centre, 178 Piccadilly, London W1J 0AL;
 tel: 0870 830 2000; web: www.raileurope.co.uk
French Tourist Authority, 444 Madison Avenue, New
 York, NY 10022 (other offices in Chicago, Los Angeles
 and Miami); web: www.francetourism.com
Office de Tourisme Intercommunal de Bayeux, Pont Saint-
 Jean, 14400 Bayeux; tel: +33 (0)2 31 51 28 28;
 web: www.bayeux-tourism.com
Calvados Tourisme, 8 Rue Renoir, 14054 Caen;
 tel: +33 (0)2 31 27 90 30;
 web: www.calvados-tourisme.com
Manche Tourisme; web: www.manchetourisme.com
Maison du Tourisme de Cherbourg et du Haut-Cotentin,
 2 Quai Alexandre III, 50100 Cherbourg-Octeville;
 tel: +33 (0)2 33 93 52 02;
 web: www.ot-cherbourg-cotentin.fr

A surviving example of a German Tiger I tank near Vimoutiers. Although not numerous in the Normandy fighting, they were greatly feared for the range and penetrating power of their 88-mm gun. *(Author)*

Office de Tourisme Grandcamp-Maisy, 118 Rue A-Briand; tel: +33 (0)2 31 22 62 44.

Office de Tourisme Port-en-Bessin, 2 Rue du Croiseur-Montcalm; tel: +33 (0)2 31 21 92 33.

Office de Tourisme Isigny-sur-Mer, 1 Rue Victor Hugo, BP 110; tel: +33 (0)2 31 21 46 00.

Gîtes de France, La Maison des Gîtes de France et du Tourisme Vert, 59 Rue Saint-Lazare, 75 439 Paris Cedex 09; tel: +33 (0)1 49 70 75 75; web: www.gites-de-france.fr

In addition to those listed, there are tourist offices in all the large towns and many of the small ones, especially along the coast.

BATTLEFIELD TOURING

Each volume in this series contains from four to six battlefield tours. These are intended to last from a few hours to a full day apiece. Some are best undertaken using motor transport, others should be done on foot, and many involve a mixture of the two. Owing to its excellent infrastructure and relatively gentle topography, Normandy also makes

a good location for a cycling holiday; indeed, some of our tours are ideally suited to this method.

In every case the tour author has visited the area concerned before the original edition of this book was published, in 2004. Since then, land use, infrastructure annd rights of way have altered in some areas, although this is not necessarily reflected in current French mapping. With care, however, it should not be too difficult to identify those small changes that have occurred and to amend one's route accordingly. If you encounter difficulties in following any tour, we would very much like to hear about it, so we can incorporate changes in future editions. Your comments should be sent to the publisher at the address provided at the front of this book.

To derive maximum value and enjoyment from the tours, we suggest you equip yourself with the following items:

- Appropriate maps. European road atlases can be purchased from a wide range of locations outside France. However, for navigation within Normandy, the French Institut Géographique National (IGN) produces maps at a variety of scales (www.ign.fr). The 1:100,000 series ('Top 100') is particularly useful when driving over larger distances; sheet 06 (Caen – Cherbourg) covers most of the invasion area. For pinpointing locations precisely, the current IGN 1:25,000 Série Bleue is best. Extracts from map editions available in 2004 were used for the tour maps in this series, although in a few cases newer editions have appeared since then. These maps can be purchased in many places across Normandy and from specialist dealers in the UK (e.g. www.themapcentre.com or www.stanfords.co.uk). Allow at least a fortnight's notice, as maps are not always in stock.
- Lightweight waterproof clothing and robust footwear are essential, especially for touring in the countryside.
- Take a compass, provided you know how to use one!
- A camera and spare memory cards.
- A notebook to record what you have photographed.
- A French dictionary and/or phrasebook. (English is widely spoken in the coastal area, but is much less common inland.)

- Food and drink. Although you are never very far in Normandy from a shop, restaurant or *tabac*, many of the tours do not pass directly by such facilities. It is therefore sensible to take some light refreshment with you.
- Binoculars. Most officers and some other ranks carried binoculars in 1944. Taking a pair adds a surprising amount of verisimilitude to the touring experience.

SOME DOS AND DON'TS

Battlefield touring can be an extremely interesting and even emotional experience, especially if you have read something about the battles beforehand. In addition, it is fair to say that residents of Normandy are used to visitors, among them battlefield tourers, and generally will do their best to help if you encounter problems. However, many of the tours in this series are off the beaten track, and you can expect some puzzled looks from the locals, especially inland. In all cases we have tried to ensure that tours are on public land, or viewable from public rights of way. However, in the unlikely event that you are asked to leave a site, do so immediately and by the most direct route.

In addition: Never remove 'souvenirs' from the battlefields. Even today it is not unknown for farmers to turn up relics of the 1944 fighting. Taking these without permission may not only be illegal, but can be extremely dangerous. It also ruins the site for genuine battlefield archaeologists. Anyone returning from France should also remember customs regulations on the import of weapons and ammunition of any kind.

Be especially careful when investigating fortifications. Some of the more frequently visited sites are well preserved, and several of them have excellent museums. However, both along the coast and inland there are numerous positions that have been left to decay, and which carry risks for the unwary. In particular, remember that many of these places were the scenes of heavy fighting or subsequent demolitions, which may have caused severe (and sometimes invisible) structural damage. Coastal erosion has also undermined the foundations

A peaceful, summertime view of the Dives river valley near Chambois, the scene of much carnage and destruction in the battle to close the Falaise Pocket. *(Author)*

of a number of shoreline defences. Under no circumstances should underground bunkers, chambers and tunnels be entered, and care should always be taken when examining above-ground structures. If in any doubt, stay away.

Beware of hunting (shooting) areas (signposted *Chasse Gardée*). Do not enter these, even if they offer a short cut to your destination. Similarly, Normandy contains a number of restricted areas (military facilities and wildlife reserves), which should be avoided. Watch out, too, for temporary footpath closures, especially along sections of coastal cliffs.

If using a motor vehicle, keep your eyes on the road. There are many places to park, even on minor routes, and it is always better to turn round and retrace your path than to cause an accident. In rural areas avoid blocking entrances and driving along farm tracks; again, it is better to walk a few hundred metres than to cause damage and offence.

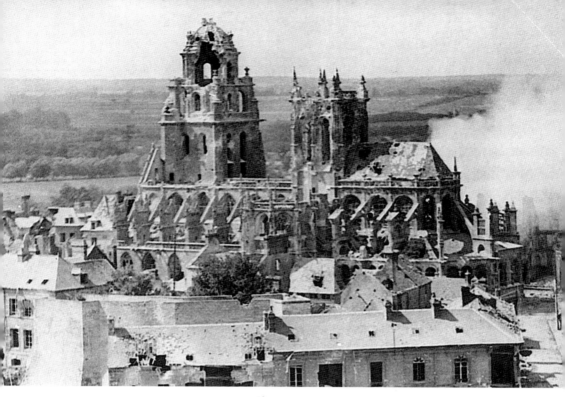

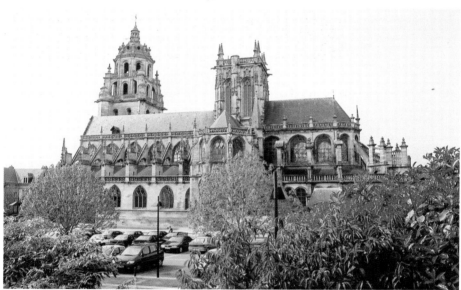

Then: This aerial view of the church of St-Germain in Argentan shows the extensive damage to it and the centre of the town, 21 August 1944. *(USNA)*

Now: The restored church in the centre of Argentan today. One of the challenges of battlefield tours is that both urban and rural landscapes have changed, often as a consequence of wartime destruction. *(Author)*

THINGS TO DO IN THE FALAISE POCKET AREA

For visitors, Normandy offers a great deal of diversity in things to do and places to see. With the French tradition of fine food and drink, opportunities abound to sample and enjoy the regional cuisine of Normandy. From the Falaise Pocket it is roughly an hour and a half's drive to visit the Normandy coast or larger urban centres such as Bayeux or Caen to the north. If you are seeking sandy beaches for a family outing, or architecture, museums and restaurants for a more cultural day out, then these places are within easy reach of the battlefield tour area.

Birthplace of William the Conqueror, Falaise itself is well worth a visit. Dominating the western part of the town is the impressive fortress built on the rocky outcrop above the Ante valley. The two square keeps of the William the Conqueror castle dating from the twelfth century and the later round tower have undergone much restoration in recent years. There is plenty to satisfy the keen visitor and even those with a lukewarm interest should not be disappointed. A guided tour lasting two hours and an audio/visual one-hour tour are both available with commentaries in English. Whichever option is taken the striking visual effects and video scenes, together with the narrative, help to create the atmosphere of medieval Normandy.

USEFUL ADDRESSES: FALAISE

Office de Tourisme du Pays de Falaise Le Forum, Boulevard de la Libération, 14700 Falaise; tel: +33 (0)2 31 90 17 26; email: <info@otsifalaise.com>; web: <www.otsifalaise.com>. Open 0930–1230 & 1330–1830 Mon–Sat, 1000–1200 & 1500–1700 Sun 1 May–30 Sept, otherwise 0930–1230 & 1330–1730 Mon–Sat, closed Sun.

Château Guillaume-le-Conquerant 14700 Falaise; tel: +33 (0)2 31 41 61 44; email: <chateau-falaise@wanadoo.fr>; web: <www.chateau-guillaume-leconquerant.fr>.

Automates Avenue Boulevard de la Libération, 14700 Falaise; tel: +33 (0)2 31 90 02 43; email: <automates@mail.cpod.fr>; web: <www.automates-avenue.com>.

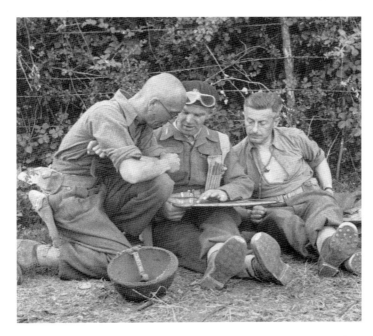

Senior officers of 10th Polish Armoured Brigade study maps during the first half of August 1944. *(PISM 2611)*

For the young (and young at heart) a visit to *Automates Avenue* is also recommended. This magical museum of mechanical actors is situated in the Boulevard de la Libération, close to the Tourist Office. Street scenes of Paris in the first half of the twentieth century are brought to life and fairyland tableaux as well as cycling's Tour de France are also included. In addition to the above, Falaise contains a variety of shops and restaurants as well as a range of accommodation including hotels, *gîtes*, B&Bs, and a campsite at the foot of the castle.

Around Falaise, places of interest can be found in many of the surrounding areas. To the west lies the town of Thury-Harcourt and the region known as la Suisse Normande, while to the east the small town of Vimoutiers with its central bovine sculpture and interesting cheese museum may be worth an excursion. An attractive array of shops, restaurants and accommodation also make this a viable base for the battlefield tours. (5 kilometres south of Vimoutiers is the tiny village where Marie Harel invented the famous Camembert cheese.) Similarly the larger town of Argentan to the south offers a range of amenities as well as points of

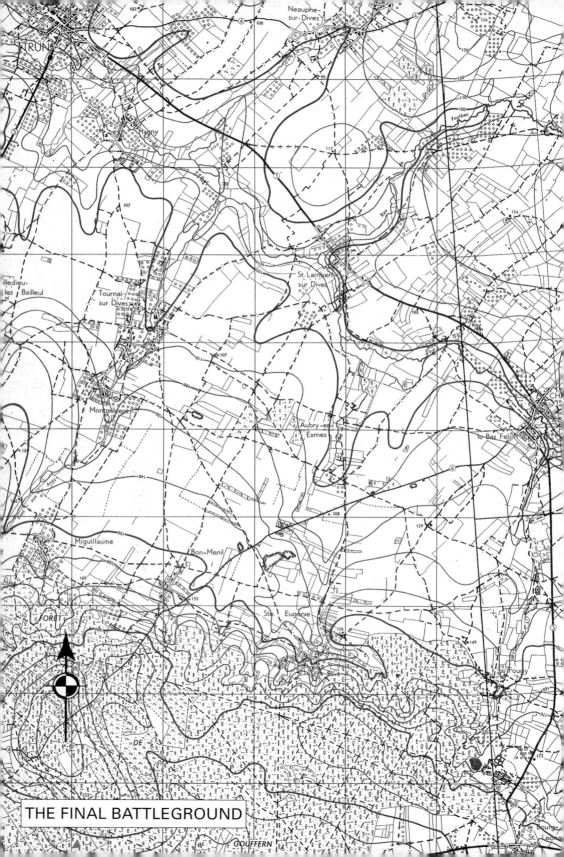

THE FINAL BATTLEGROUND

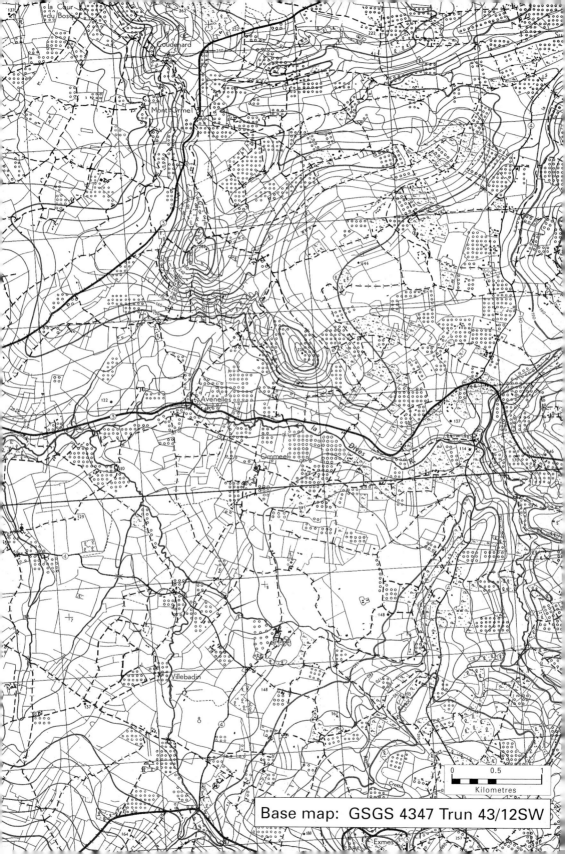

Base map: GSGS 4347 Trun 43/12SW

interest for the non-military visitor (churches, lace-making, etc.) and would also provide a convenient base for the battlefield tours.

THE FALAISE POCKET TOURS

The following sections contain four battlefield tours looking at the efforts of the Allied coalition to close the Falaise Pocket in the second half of August 1944. Despite the large dimensions of the battle of the Falaise Pocket, both in terms of the size and number of major Allied formations involved and the geographical distances covered, the sealing shut of the final exit from the Falaise Pocket took place in a relatively small area of Normandy. The critical engagements to close the pocket were left to units of three Allied formations: 1st Polish Armoured Division, 4th Canadian Armoured Division and 90th US Infantry Division. The four tours therefore focus on the actions of the Canadian forces at St-Lambert-sur-Dive, the Polish division at the Mace (*maczuga* – in the vicinity of Mairie de Coudehard), the US Army at le Bourg-St-Léonard and the juncture of the Poles and Americans at Chambois.

While these tours are designed to illuminate the critical events in the later stages of the battle, they are by no means the only aspects of the battle of the Falaise Pocket that could be toured. Two other examples could be made into do-it-yourself tours. If you are interested in getting the feel of a rapid advance of larger, divisional-sized formations, then the XV Corps drive from Le Mans to a line just south of Argentan could be a ready-made motor tour, using information contained in Chapter 2 of this book. Similarly, 4th Canadian Armoured Division's advance from the vicinity of Morteaux-Coulibœuf to Trun could be undertaken using material included in later chapters. There are, of course, other possibilities for DIY tours related to the Falaise Pocket. With additional research, the reader could enjoy the highly satisfying, if occasionally frustrating, exercise of attempting to reconstruct the events of August 1944.

There are some basic practical points to note when embarking on the tours listed below. In all four tours,

Falaise is the starting point of the journey into the area where the actual tours begin. This is not because the author favours Falaise over Argentan or Vimoutiers, but simply because the tour has to begin somewhere. Given that Falaise is the closest town to the Channel ports and at the end of a dual carriageway road (the N158) linking it to those ports, it seemed a logical choice. The reader would be well advised to acquire suitable maps covering the tour area, as these will aid navigation on what are sometimes very small, narrow country roads. Several of the current IGN 1:25,000 Série Bleue maps are required to cover the four battlefield tours. The two most necessary are Trun (1714O) and Haras du Pin (1715OT). Useful but not essential is the Série Bleue map Morteaux-Coulibœuf (1614E).

Although the part of Normandy the reader is visiting has all the charm of a peaceful and bucolic rural setting, it is worth remembering that it was the scene of some of the most shocking carnage and destruction in the Second World War. Battlefields are not places defined by counters on the map or by cliché portrayals of cinematic derring-do. The same is true of the battle to close the Falaise Pocket. This battlefield was a place where thousands of human beings perished and where ordinary soldiers experienced the full horrors of war. The local population caught up in the fighting, as in other parts of Normandy, also suffered from the conflict that enveloped them at the moment of their liberation. One of this author's most moving experiences in researching this book was hearing a retired French woman give an account of her journey from Vimoutiers to Chambois soon after the battle was over. As she described the things she witnessed, it was clear from her face that those terrible sights of death and destruction remained vivid in her mind's eye over half a century later. Let us not forget the human cost associated with the Allied victory in the battle to close the Falaise Pocket.

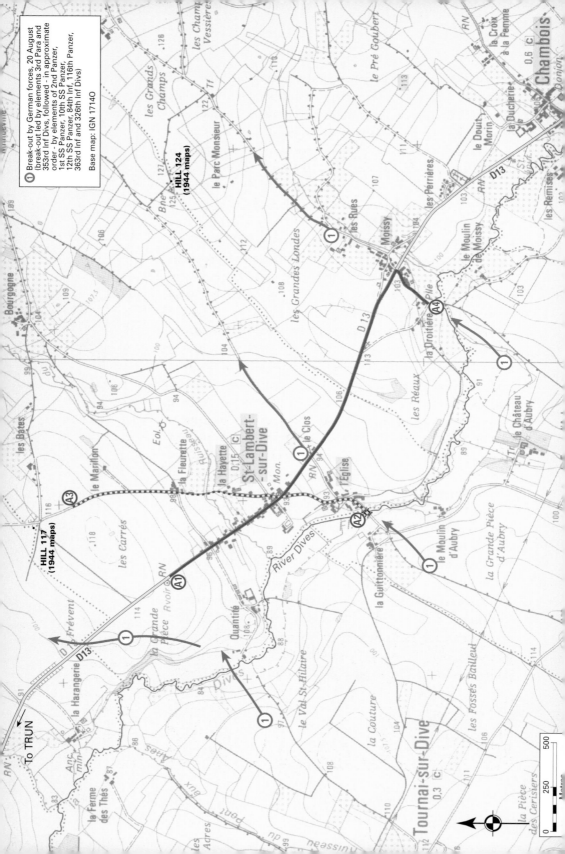

Break-out by German forces, 20 August
(break-out led by elements 3rd Para and
353rd Inf Divs, followed by elements of 2nd Panzer,
order - by elements of 2nd Panzer,
1st SS Panzer, 10th SS Panzer,
12th SS Panzer, 84th Inf, 116th Panzer,
363rd Inf and 326th Inf Divs)

Base map: IGN 1714O

HILL 124
(1944 maps)

HILL 117
(1944 maps)

To TRUN

Chambois

St-Lambert-
sur-Dive

Tournai-sur-Dive

River Dives

Moissy

Bourgogne

les Bates

le Marillon

les Carrés

THE CANADIANS AT ST-LAMBERT-SUR-DIVE

OBJECTIVE: This tour describes the action of the Canadian battlegroup led by Major David V. Currie VC of the South Alberta Regiment to occupy the village of St-Lambert-sur-Dive. Currie's mission was to gain control of the village in order to close German escape routes across the River Dives.

DURATION/SUITABILITY: The scope of this tour could span the better part of a day if the weather is good and you enjoy walking and picnicking. It is probably best to allocate at least half a day. Although the tour amounts to only a few kilometres, the distance to the starting point from where you are staying must be taken into account. For those inclined to cycle, the route around the village of St-Lambert-sur-Dive presents no major difficulties for either a touring bike or mountain bike. In inclement weather it is advisable to use only your vehicle and to be equipped with

The view of the path leading up the Canadian Battlefields Foundation Belvedere on the edge of St-Lambert-sur-Dive. Stand A1 is at the top. *(Author)*

Soldiers from
B Company,
Argylls of
Canada, take
cover behind
some German
vehicles in
St-Lambert-
sur-Dive on
19 August. *(NAC
PA-131350)*

Wellington boots and waterproof clothing. For anyone with mobility difficulties all points described can be seen from your vehicle.

STAND A1: CANADIAN BATTLEFIELDS FOUNDATION BELVEDERE

DIRECTIONS: Leave Falaise by the D63, following the signs for *Le Dénouement Normandie 1944* and Trun, some 18 km distant through pleasant open countryside. At Trun (by which time the road has become the D13) go straight on at the crossroads (a slightly awkward junction) following signs for St-Lambert-sur-Dive (4 km). As the road begins to slope down into St-Lambert pull in at the lay-by on the right hand side just past a mound and adjacent to the French and Canadian flags. A walk up the slope will take you to the observation point from which you can look down upon the village.

THE SITE: From the Canadian Battlefields Foundation Belvedere, it is possible to see the objective of Major

Currie's South Alberta Regiment battlegroup. The village of St-Lambert-sur-Dive consists of a string of stone houses lining both sides of the D13 for about 1 km. On the right hand side of the D13 in the distance can been seen a church steeple in a cluster of buildings. Near this church at the south end of the village is a stone bridge across the River Dives, which was vital for the escaping German forces in 1944. Also to the right of the D13, meandering roughly parallel to the village beyond the line of houses, is the River Dives. Although its course is scarcely visible, this section of the Dives is nevertheless on average about 3 metres wide with steep 2-metre banks. Its features present a serious obstacle to vehicles but not to men swimming or wading the shallow stream. Tracing the road around to the left, the houses and trees of the settlement at Moissy (site of an important ford across the Dives) can be seen and in the far distance the imposing castle keep at Chambois. In this vista can be seen most of the gap that the Allies tried to close in order to prevent the Germans escaping from the Falaise Pocket. For Stand A1 look down the D13 towards the church in St-Lambert.

THE ACTION: With only a narrow gap remaining between Trun and Chambois for the German forces to escape through, the task of closing the pocket in 4th Canadian Armoured Division's sector fell to a small battlegroup led by Major David V. Currie of the South Alberta Regiment. At 1800 hours on Friday 18 August, Currie departed Trun with the mission of capturing 'Rooster', the code-name for the village of St-Lambert-sur-Dive, roughly half the distance to Chambois. Weather conditions that evening were dry, with reasonable visibility. Under Currie's command was a mixed force consisting of 15 Sherman tanks from C Squadron, South Albertas, and 55 soldiers of a depleted B Company, Argyll and Sutherland Highlanders of Canada, led by Major Ivan Martin. The Argylls rode on the rear decks of Currie's tanks, with the battlegroup covering the distance on the D13 in a short time and arriving on high ground at the northern edge of the village.

The view from
the top of the
Belvedere.
On the left
upper corner
is the keep at
Chambois. The
line of the road
can be followed
to it past Moissy.
(Author)

When Currie arrived at St-Lambert, he decided to mount
an attack with a troop of tanks in the lead, with the infantry
following the armour to consolidate any penetration of
the northern end of the village. As the light faded, the lead
troop began to move into St-Lambert, but as the Canadian
Shermans reached the first stone houses, the Germans
opened fire and launched flares from positions in the village.
The flares improved visibility and the lead Sherman was
knocked out by anti-tank fire. As the attack stalled under
German fire, further problems arose with the arrival of
RAF Spitfires. The Spitfires strafed Currie's column in one
of the many friendly-fire incidents that occurred in the fluid
situation in the later stages of the battle to close the Falaise
Pocket. While the men under Currie's command scrambled
for cover or tried to deploy yellow smoke canisters or yellow
identification panels, the Spitfires only pressed home their
attacks with greater persistence. For at least one officer,
the frustration with the Allied air forces was too much; he
attempted to fire at the errant aeroplanes with his tank's
.50-calibre machine gun, but they proved too fast to hit.
Fortunately the Spitfires soon broke off their attack, but not
until they had done some damage. The medical half-track
was knocked out and its driver wounded. Even Major Currie
suffered from the attention of the RAF. The Spitfires had set
alight kit at the back of his tank's turret, which Currie had

to douse with a fire extinguisher. Thus the combination of German and RAF fire halted the attack on St-Lambert.

The lead troop with its three remaining tanks maintained its position on the northern edge of the village, screened by buildings and failing light from German anti-tank fire. Currie decided to reassess the situation and walked into St-Lambert to see if the German positions could be outflanked. With the Dives limiting room for manoeuvre on the south-western side of the village, Currie's new plan was to dismount the majority of his tank crews to augment the infantry and, with three tanks in support, to mount a night attack. It was not at all uncommon for Allied armoured units to clear villages using tank crews when infantry were in short supply. Moreover, Allied tanks were vulnerable to hand-held German anti-tank weapons such as the *Panzerfaust* in the confines of a built-up environment when not working in conjunction with infantry. Currie's second attack on 18 August, however, did not take place. When he requested permission from his commanding officer, Lt-Col 'Swatty' Wotherspoon, to launch the attack, he was told by Wotherspoon to wait until first light before moving into St-Lambert.

Having received his orders, Currie moved his battlegroup to Hill 117, a piece of high ground about 800 metres to the

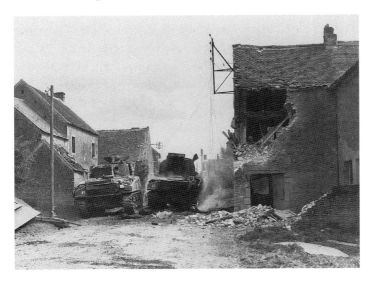

The two knocked-out Shermans in St-Lambert-sur-Dive after being hit by German anti-tank fire on 19 August. *(NAC PA-116522)*

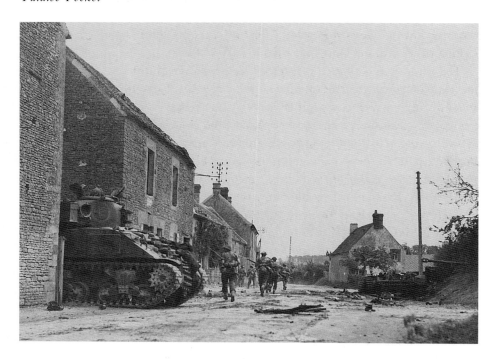

Infantry of the Argylls of Canada clear St-Lambert-sur-Dive, supported by a South Albertas Sherman, 19 August. (NAC PA-131348)

north of St-Lambert, to 'harbour' for the night in a defensible position (the action at Hill 117 is discussed at Stand A3). The position on Hill 117 was to become the anchor of Canadian efforts at St-Lambert. With the weather worsening and it beginning to rain, Wotherspoon decided to move from Trun and join Currie on Hill 117. Arriving at 2300 hours, Wotherspoon brought with him his Regimental Headquarters Troop (four Shermans); the Reconnaissance Troop (Stuart light tanks); B Squadron (Shermans); and four M10 Achilles tank destroyers (17-pounder gun versions) of K Troop, 5th Anti-Tank Regiment, Royal Canadian Artillery (RCA).

Wotherspoon gave Currie his orders to attack at 0500 hours – first light – on Saturday 19 August. After making his preparations and moving into his starting positions, Currie began his advance into St-Lambert at 0630 hours. With B Squadron providing covering fire, Currie deployed the lead troop of C Squadron to the northern edge of the village. He attached one tank to the Argylls of Canada to move with them down the D13, providing direct support for the advancing infantry. The other two tanks of the troop he

directed down the long slope on the Dives side of the village to look over buildings close to the river.

The tank supporting the Argylls advanced about 300 metres into St-Lambert before it was knocked out by two armour-piercing rounds from a Panzer IV and a Tiger tank, firing from positions at the southern end of the village. The second anti-tank round wounded the driver and co-driver but the rest of the crew managed to get out. The other two Shermans of the lead troop were then ordered into the village to support the attack. When one of the two remaining tanks of the lead troop moved forward past the disabled Sherman, it too was hit by anti-tank fire and halted. Most of the crew evacuated this vehicle but some of them were wounded. The remaining Sherman of the lead troop covered the escape of the crew. Elsewhere in the attack, other Shermans of Currie's C Squadron enjoyed more success. With Currie following the infantry on foot, his own command tank, while moving forward to find him, engaged and destroyed a Panzer IV with six rounds, under the direction of Captain John Redden.

With Currie's tanks unable to make headway, the task of clearing St-Lambert fell to the infantry. The lead platoon, under the command of Lieutenant Gil Armour, began methodically to clear the houses as sections of infantry leapfrogged their way forward. As they reached the crossroads at the southern end of the village, a Panther tank parked next to a building barred the way to their objective. Lieutenant Armour with some volunteers moved forward to disable it. After brief fisticuffs between Armour and the dismounted German tank commander, a grenade down the Panther's hatch rendered it *hors de combat*. For good measure, a PIAT anti-tank weapon was brought forward to finish the Panther off. By 1037 hours, Currie's battlegroup had captured 'Rooster' after four hours of fighting.

STAND A2: THE CHURCH AND BRIDGE AT ST-LAMBERT

DIRECTIONS: Return to your vehicle and continue down into the village. As you enter the village, note the Canadian

flag and memorial to Currie and the South Albertas on the right-hand side. Proceed straight over the crossroads and look for the sign 'Site de St-Lambert 150 metres à gauche'. Turn left towards Coudehard, pulling in immediately to the gravel parking area on the right. This is the *mairie* car park and the site of an old school. Walk across the main road (a sign points to Aubry-en-Exmes) and on to the church, stopping after the church when you can see the bridge. The walk should take about five minutes.

THE ACTION: Having taken St-Lambert, Currie's problem was now to hold it. Altering his dispositions, Currie left Lieutenant Armour's platoon at the crossroads in the southern end of the village (where you parked), supported by three tanks. Controlling the stone bridge across the Dives was a key task for this group. He deployed the remainder of his command at the northern end of the village, where he also established his headquarters. His tanks took up positions with fields of fire facing west to cover German movements emerging from the pocket. Despite the success in seizing St-Lambert, the position of Currie's force was precarious. After the two attempts to take the village, Currie only had 12 Shermans and about 50 infantrymen remaining. His lack of infantry meant that German infiltration was a major concern. With the Dives

The church at St-Lambert-sur-Dive near the stone bridge and crossroads at the southern end of the village. *(Author)*

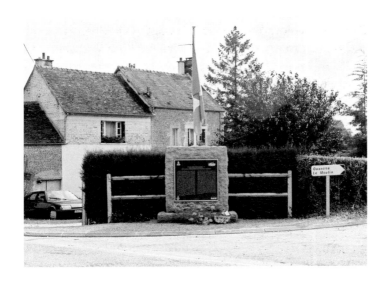

The monument to Major David Currie and the South Albertas' gallant action in the village of St-Lambert-sur-Dive. *(Author)*

presenting few problems to crossing German soldiers, infiltration into the parts of the village not covered by Canadian infantry meant that contending with parties of the enemy was an ever-present danger. Some Germans preferred not to surrender and, as a result, snipers continued to take a toll. Most of the Germans entering the area, however, had little fight in them. After a few rounds exchanged they would more often than not give up. In this context, one of the most famous Canadian photographs of the war was taken by Lieutenant Don Grant of No. 1 Canadian Army Film and Photographic Unit showing Major Currie and his men receiving surrendering German soldiers in the early afternoon of 19 August (the famous photograph was taken opposite the South Albertas' memorial plaque on the D13). Controlling and evacuating the swelling numbers of German prisoners became a growing problem for the Canadians. Almost 2,000 German prisoners were captured on 19 August in St-Lambert.

Despite the constant pressure, Currie's position had not yet become critical. Indeed, in the course of the afternoon, 4th Canadian Armoured Division's artillery moved into range, along with II Canadian Corps' medium regiments, giving the South Albertas much needed artillery support. In the afternoon of 19 August, the arrival of Captain

Fred Clerkson, forward observation officer of 15th Field Regiment, RCA, meant that artillery fire could now be called down on targets in the vicinity and particularly during a crisis. Another major factor aiding Currie's position was the fact that his command was still being supplied with ammunition, fuel and rations. Tanks, for example, would take turns to withdraw from their positions to visit Currie's headquarters at the north end of St-Lambert, where they were re-supplied. Moreover, the ability to evacuate Canadian casualties undoubtedly bolstered morale.

By late afternoon on the 19th, break-out attempts by groups of Germans were creating difficulties for Currie. In the forward position near the crossroads, church and stone bridge, the forward infantry platoon and tanks faced increasing pressure. Currie requested artillery fire to be brought down near this position to ease some of the pressure. Much to his surprise, artillery support came not in the form of 25-pounder rounds from the field regiments but from medium 5.5-inch guns. The situation alarmed Currie because shells falling short would not only be lethal to the Argylls but could also knock out his tanks. Despite some hair-raising moments, no Canadian casualties resulted. The medium guns had achieved the desired effect of reducing German pressure. With a lull in German activity at the southern end of St-Lambert, Currie rotated his Shermans back from their forward positions to his headquarters for them to refuel and replenish ammunition.

At 1900 hours Currie received some welcome infantry reinforcements. Major Gordon Winfield's C Company, Argylls of Canada, arrived in St-Lambert along with a scratch company of the Lincoln and Wellands. Currie ordered C Company to move south down the D13 towards Moissy and Chambois. Winfield's mission was to reconnoitre German activity and possibly make contact with the Polish units in Chambois. C Company got only as far as Moissy when it took casualties, including Winfield. Abandoning further movement towards Chambois because of German fire, C Company returned to St-Lambert with its wounded, reaching Canadian positions there around midnight.

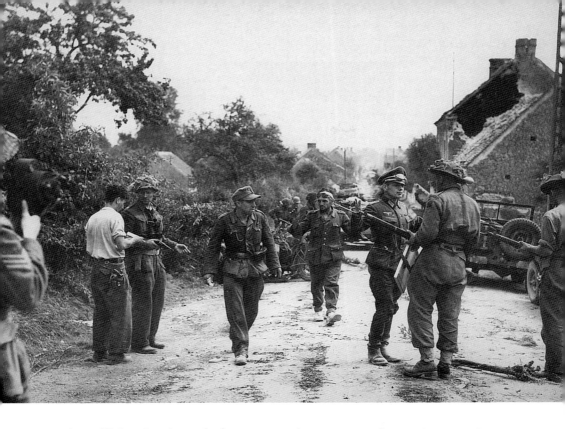

At twilight, Currie took the opportunity to reorganise his positions in St-Lambert. The forward platoon, led by Lieutenant Armour, was positioned on the D13 near the *mairie* with three Sherman tanks. Other elements of the Argylls' B Company covered the stone bridge over the Dives. A platoon of the Lincoln and Wellands covered the area near Currie's headquarters, and what was left of the infantry took up positions in the middle of St-Lambert. The remaining tanks supported the infantry positions in the middle and north end of the village.

The night of 19/20 August was the build-up to the crisis in the Canadian action at St-Lambert. The German forces were beginning their final break-out attempt to try to save as many men and as much equipment as possible. The men at the southern end of the village near the church and crossroads were the first to notice the increased activity. Indeed, throughout the rainy night, the Argylls near the church and bridge listened to German vehicles (possibly from 353rd Infantry Division, which crossed the Dives

Lieutenant Don Grant's famous photo of Major Currie (to the right of the man in the white shirt) supervising the surrender of German soldiers on 19 August. (NAC PA-111565)

The stone bridge crossing the Dives at St-Lambert-sur-Dive can be seen just before the sign on the right. *(Author)*

that night) crossing the bridge only metres away from their positions. Although the increased German activity in the form of nearby infiltration and fire on Canadian positions made for a sleepless night, it was only the prelude to the final break-out attempt.

As daylight increased, the light rain began to diminish and visibility improved around the village. Between 0800 and 0830 hours on Sunday 20 August, with little warning, the German break-out began in earnest, with mass infantry attacks supported by armour (from 2nd Panzer Division) that hit Currie's positions throughout St-Lambert. Almost immediately, Currie's infantry and tanks were engaged in an intense close-quarter battle. With German infantry attacking in droves, the Argylls were forced to withdraw from their positions at the southern end of the village near the *mairie* and church. Covered by two Shermans firing smoke shells, the remaining 30 soldiers withdrew towards the north end of the village. Indeed, so intense was the pressure that Currie was forced to abandon all of his positions in the southern and middle parts of the village and concentrate his remaining fighting power at the northern edge. Having lost further Shermans on the morning of 20 August, the strength of his command in the area of the South Albertas' memorial plaque was now five Shermans and 120 infantry. After consolidating his remaining force at the northern

end of St-Lambert, Currie repeatedly called down artillery concentrations on the area of the stone bridge and along the D13 whenever the Germans moved against his positions.

By afternoon, Currie's position in St-Lambert had grown even more precarious. Casualties among his officers were high, and at one point he asked Wotherspoon for permission to abandon the village and withdraw. Wotherspoon, making a difficult decision, told him to stay put. Just as Currie's battlegroup was coming to terms with the fact that no apparent relief was in sight, help arrived to augment its combat power. Around 1500 hours, eight 17-pounder towed anti-tank guns of 103rd Battery, 6th Anti-Tank Regiment, RCA, led by Lieutenant J.R. Flowers (the only remaining officer in the battery), moved into action in support of Currie's embattled command. Deploying seven of his guns to cover St-Lambert with one pointing to the rear of the position towards Trun, Flowers' men went into crash action in what was a target-rich environment. The 17-pounder guns quickly knocked out a number of German armoured vehicles including a Tiger tank. Other elements of Flowers' two troops augmented Currie's exhausted infantry and were soon making an impact on the battle by taking a heavy toll of enemy soldiers.

The arrival of 103rd Battery represented the climax of Currie's battle at St-Lambert. By late afternoon the pressure was slackening as most of the surviving German combat elements escaped to the north-east, and more Germans were surrendering. Indeed, the night of 20/21 August was comparatively quiet for Currie's battlegroup. It was eventually relieved at 1700 hours on Monday 21 August by elements of 9th Canadian Infantry Brigade. The battlegroup's losses in the fighting amounted to 13 dead and 36 wounded. The Argylls of Canada lost 8 dead and 21 wounded and the combined strength of B and C Companies at the end of the action was 70 soldiers. In Currie's C Squadron, of the 15 Shermans at the start of the battle, only five remained operational. Over three difficult days, Major Currie's calm and determined leadership at St-Lambert earned him the Victoria Cross.

MAJOR DAVID VIVIAN CURRIE VC

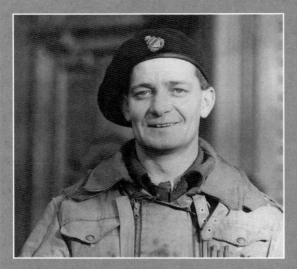

For British and Commonwealth forces in the Second World War, the highest military decoration was the Victoria Cross. Introduced in 1856 by Queen Victoria, the award of this decoration was made retrospective and applied to the Crimean War so that the life of the Victoria Cross dates from June 1854. Made out of bronze in the shape of a Maltese Cross with the simple inscription 'For Valour', the medal has been awarded to soldiers who have shown conspicuous bravery, daring, self-sacrifice and an extreme devotion to duty on the field of battle.

Since its inception, 79 Canadians serving in Canadian forces have received Victoria Crosses (90 if one takes into account Canadians who served in British or other Commonwealth units). During the Second World War, 13 Canadians were awarded Victoria Crosses in the Canadian armed forces. One of them was Major David Vivian Currie. His was the only Victoria Cross awarded to a Canadian soldier in the Normandy battle serving in the Canadian Armoured Corps. Born in Sutherland, Saskatchewan, on 8 July 1912, Currie by trade was an automobile mechanic and welder. On the outbreak of war, Currie joined the Canadian militia and a year later he entered the regular army as a lieutenant. Promoted to captain in 1941 and major in 1944, he served in the South Albertas in 4th Canadian Armoured Division. The qualities on the field of battle that earned Currie the Victoria Cross are well illustrated by the following extract from his citation, published in *The London Gazette* on 27 November 1944:

> 'Throughout three days and nights of fierce fighting, Major Currie's gallant conduct and contempt for danger set a magnificent example to all ranks of the force under his command.
>
> On one occasion he personally directed the fire of his command tank on to a Tiger tank which had been harassing his position and succeeded in knocking it out. During another attack, while the guns of his command tank were taking on other targets at longer ranges, he used a rifle from the turret to deal with individual snipers who had infiltrated to within fifty yards

of his headquarters. The only time reinforcements were able to get through to his force, he himself led the forty men forward to their positions and explained the importance of their task as part of the defence. When, during the next attack, these new reinforcements withdrew under the intense fire brought down by the enemy, he personally collected them and led them forward into position again, where, inspired by his leadership, they held for the remainder of the battle. His employment of the artillery support, which became available after his original attack went in, was typical of his cool calculation of the risks involved in every situation. At one time, despite the fact that short rounds were falling within fifteen yards of his own tank, he ordered fire from medium artillery to continue because of its devastating effect upon the attacking enemy in his immediate area.

Throughout the operations the casualties to Major Currie's force were heavy. However, he never considered the possibility of failure or allowed it to enter the minds of his men.'

STAND A3: CANADIAN POSITIONS ON HILL 117

DIRECTIONS: This stand may be approached by foot or by car. The total distance from the *mairie* car park, there and back, is 2.5 km. Rejoin the small road from the gravel car park (signed Coudehard, la Hayette and *Circuit Août 44*) and immediately take the left-hand fork marked la Hayette. Follow this single track lane over the stream and past farm buildings, going straight over at the crossroads and continuing uphill to the clump of trees from where you can see the village you have just left. If driving it is probably best to proceed beyond the trees and park on the summit near the next crossroads (where a left-hand turn will take you back on to the D13). Look back towards St-Lambert.

THE ACTION: From the late evening of Friday 18 August, when Lt-Col Wotherspoon moved his regimental headquarters to Hill 117 (marked as Point 116 on modern maps), it became the key position from which the South Albertas' action around St-Lambert was orchestrated. Control of this high ground, 800 metres north of the village, served to support Major Currie's battlegroup

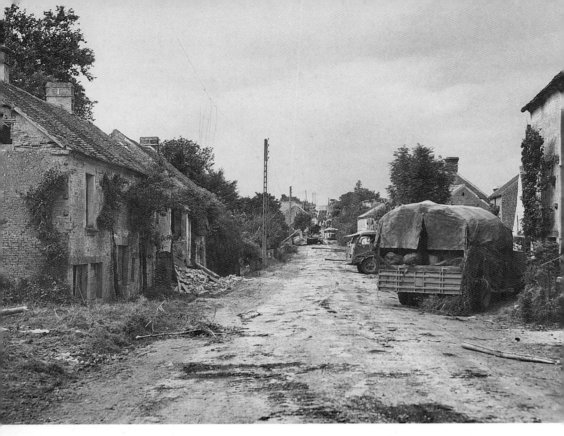

Then: The damage to St-Lambert-sur-Dive as a result of intense fighting is clearly visible. In the distance on the D13 can be seen a column of German prisoners being marched off. *(NAC PA-152373)*

Now: The same view today, with a rare bit of vehicle traffic to be seen where once German prisoners marched. *(Author)*

while maintaining contact with lines of communication, thus ensuring re-supply and evacuation of the wounded. The regimental aid station was on Hill 117. It was also the collection point for the many hundreds of German prisoners taken in the village before they were transported to the rear.

On 19 August Lt-Col Wotherspoon deployed the remaining combat elements of the South Albertas to St-Lambert to buttress his position to the north of the village. A Squadron and the reconnaissance troop moved to the D13 between St-Lambert and Trun to cover that section of the Dives and secure supply lines to the rear. B Squadron was initially kept as a regimental reserve. Later, Wotherspoon deployed B Squadron to Hill 124 (Hill 125 today) 2 km to the east, where it attempted to block an escape route used by the Germans. It stayed on Hill 124 until overrun and forced to withdraw during the German break-out attack of 20 August.

On Hill 117 itself, the Anti-Aircraft Troop of Crusader tanks with 20-mm guns, the M10 tank destroyers armed with 17-pounders and the Headquarters Troop with Shermans protected the position, which was under frequent sniper fire from tree lines and hedges. In response the twin 20-mm cannon on the Crusaders swept these areas to devastating effect. When Canadian artillery came into range, the forward observation officer operated from Hill 117 and

The view towards Chambois from Hill 117, illustrating the better fields of fire and observation opportunities afforded by ground even modestly higher. The road on the right side leads to St-Lambert-sur-Dive. *(Author)*

co-ordinated the laying down of artillery concentrations with Wotherspoon. From this vantage point, accurate fire could be directed at German columns near St-Lambert and Moissy.

Hill 117 did not escape the crisis brought about by the German break-out attack on the morning of 20 August. Indeed, German penetrations were not limited to St-Lambert but also took place in A Squadron's area along the D13. The consequences of these German efforts were directly to imperil Canadian positions on Hill 117. On Hill 117 itself, Wotherspoon had a considerable amount of firepower but lacked infantry. At 0930 hours on 20 August, his situation became so critical that he had to order A Squadron on the D13 to attack towards his hill to break up the dangerous German pressure on his positions. Throughout the action of 18–21 August the position on Hill 117 was critical to sustaining the Canadian efforts to stem the escaping German forces.

STAND A4: MOISSY: CORRIDOR OF DEATH

DIRECTIONS: Return to the D13, turn left and leave St-Lambert. After about 1.5 km there is a very small cross-roads at which you should turn right, signposted to Moissy. Where this narrow little road bends to the right with a house on the corner (Gué de Moissy) pull in on the left within sight of the ford.

THE ACTION: The ford across the River Dives at Moissy was one of the critical escape routes for the German forces trapped in the Falaise Pocket. Indeed, it was not fully closed until the battle was virtually over. Unlike Chambois or St-Lambert, where American, Canadian or Polish units took control or kept under direct fire the bridges across the Dives, Moissy remained in German hands and as such was the one escape route kept open. In an increasingly confined area with few good roads and a river to cross with few bridges that could take vehicles, Moissy became a vital exit from the Allied encirclement. The ford, however, was not ideal for vehicles and was soon clogged with

wrecked German equipment. Although Allied forces did not control Moissy, it was heavily shelled by the bigger guns of II Canadian Corps and XV US Corps. The effect of Allied artillery fire was devastating, earning Moissy the label of 'Corridor of Death' from the German soldiers running the gauntlet of high explosive there. The harrowing experiences of the German soldiers attempting to escape the pocket through the narrow gap between Moissy and St-Lambert, under a torrent of Allied (indirect and direct) fire, were vividly described by *Generalleutnant* Heinrich von Lüttwitz, commander of 2nd Panzer Division.

Lüttwitz recalled:

'On the evening of 19th August, large numbers of our troops were crowded together in the restricted area of Fourches–Trun–Chambois–Montabord. Some of them had already made repeated attempts to escape to the north-west with vehicles and horse-drawn columns. Quite apart from attacks from the air, the entire terrain was being swept by enemy artillery fire and our casualties increased from hour to hour. On the route leading into St-Lambert-sur-Dive from Bailleul, where my division was collected, a colossal number of shot-up horses and vehicles

The peaceful ford at Moissy today that was so critical to the escaping German Army and the scene of so much destruction and loss of life. *(Author)*

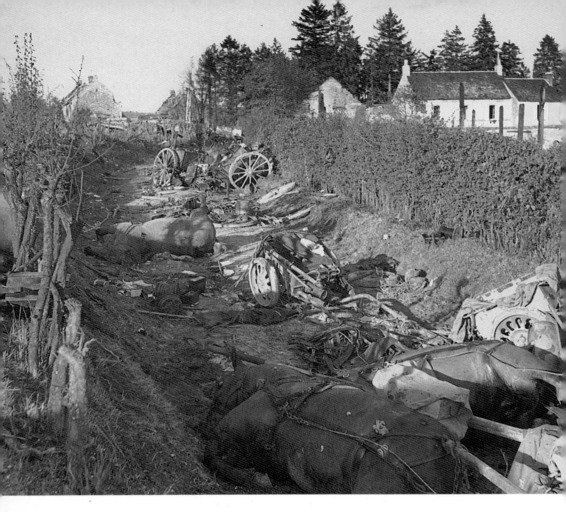

Then: The road leading to the D13 from the ford at Moissy, as it looked in 1944. The German Army called it the 'Corridor of Death'. *(IWM B9668)*

lay mixed together with dead soldiers in large heaps which hourly grew higher and higher. That evening the order was given to force a break-through near St-Lambert. I ordered all my remaining tanks (there were fifteen left out of the 120 with which I arrived in Normandy) and other armoured vehicles to form a vanguard behind which we intended to break through from Bailleul to St-Lambert.

... for some unknown reason enemy artillery fire had practically ceased on the evening of 19 August and remained quiet until the next morning. In this lull we began to move in the early morning mist of 20 August. As a narrow

lane near St-Lambert was known still to provide an escape route across the Dives river, columns of all the encircled units were streaming towards it, some of them driving in rows of eight vehicles abreast. Suddenly, at seven o'clock in the morning, the artillery fire which had been so silent now broke out into a storm such as I had never before experienced. Alongside the Dives the numerous trains of vehicles ran into direct enemy fire of every description, turned back, and in some cases drove round in a circle until they were shot-up and blocked roads. Towering pillars of smoke rose incessantly from petrol tanks as they were hit, ammunition exploded, rider-less horses stampeded, some of them badly wounded. Organised direction was no longer possible, and only a few of my tanks and infantry got through to St-Lambert.'

Source: M. Shulman, *Defeat in the West*, pp. 181–2.

The horror of the approach to the 'Corridor of Death' at Moissy was also recalled by Jupp Steinbüchel, a soldier of 1st SS Panzer Division Leibstandarte:

'After we had crossed the Falaise–Argentan road, the whole mess descended on us. Artillery fire, the likes of which we had never known, rained down upon us. We raced forward, trying to escape this area. Here and there tanks took hits and burst into flames. We just kept driving. Stopping meant certain death. Right next to us, the air was full of planes. The roads were jammed. We drove straight off through the fields, not caring what happened to the vehicles. Infantry fire alternated with artillery, only to be replaced by anti-tank guns. The horse-drawn units raced through the area. Horses hitched to driverless wagons went wild and ran, dragging everything behind. Wounded men groaned and screamed.

We loaded some onto our vehicle. One died on it. After that, he protected us from countless pieces of shrapnel.

On our route between Ville-de-Dieu and Tournai-sur-Dives, the enemy artillery had a direct shot at us. I need hardly describe what that felt like. Shells fell just in front of, beside, or behind our Panzer. We coursed over that road as fast as we could.

We reached a village. The town was a traffic jam of horse-drawn wagons, Panzers, and automobiles. The enemy tanks were now firing into that mess with high-explosive shells. One can hardly imagine the chaos which reigned. Guns without crews. Panzers without drivers. Everyone trying to flee. Men running around and finding no way out. Fire from all sides. Our retreat was stuck; the enemy forces were too strong. Then someone found a new way. On we went. Enemy guns fired at us from six hundred meters away,

but they missed. We saw the Canadians standing at the guns wearing white gym shorts.

The number of vehicles abandoned or burning kept on growing. One could barely move forward on the road. Off we went again through the fields. If we had not been in tracked vehicles, it would have been all over for us.

Then came the last step, the so-called 'Road of Death'. It was the most terrible part of the whole trip. No one can describe what we saw and lived through here.'

Source: Quoted in Lehmann and Tiemann, *The Leibstandarte*, Vol 4, Pt 1, pp. 215–6.

The events at the ford at Moissy epitomise the death of the German Army in Normandy. Given the horrific circumstances under which the trapped German forces operated in the second half of August 1944, the fact that so many soldiers managed to escape those desperate conditions is an indication of the Germans' cohesion and continuing morale in the face of disaster and defeat.

ENDING THE TOUR: Return down the narrow road to the D13. A right turn here will enable you to proceed with Tours B, C and D. A left turn will take you back through St-Lambert and Trun from where you can retrace your route to Falaise.

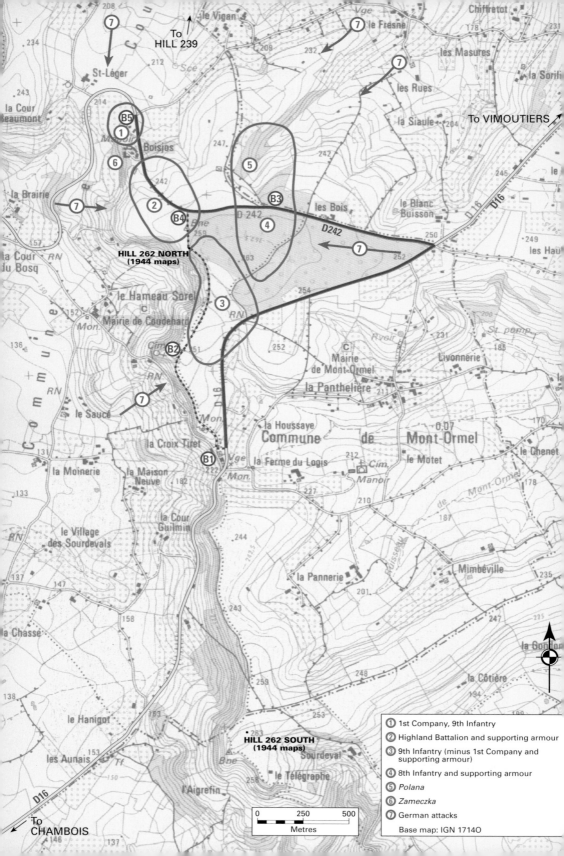

To HILL 239

To VIGAN

le Vigan

le Fresne

Chiffretot

les Masures

la Sorili

St-Léger

les Rues

la Siaule

To VIMOUTIERS

la Cour Beaumont

Boisjos

Polana

Zameczka

le Blanc Buisson

la Brairie

HILL 262 NORTH (1944 maps)

les Bois

D242

la Cour du Bosq

le Hameau Sorel

Mairie de Coudehard

le Saucé

le Village des Sourdevals

la Croix Tiret

la Maison Neuve

la Moinerie

la Houssaye

la Ferme du Logis

Commune de Mont-Ormel

le Motet

Mairie de Mont-Ormel

la Panthelière

Livonnerie

le Chenet

la Cour Guilmin

la Pannerie

Mimbéville

la Côtière

la Chasse

HILL 262 SOUTH (1944 maps)

Sourdeval

le Télégraphe

l'Aigrefin

les Aunais

le Hanigot

To CHAMBOIS

① 1st Company, 9th Infantry

② Highland Battalion and supporting armour

③ 9th Infantry (minus 1st Company and supporting armour)

④ 8th Infantry and supporting armour

⑤ *Polana*

⑥ *Zameczka*

⑦ German attacks

Base map: IGN 1714O

0 250 500

Metres

THE POLES ON THE MACE

OBJECTIVE: This tour examines the defence of the Mace by Polish battlegroups between 19 and 21 August 1944. This brigade-sized force occupied one of the most important Allied blocking positions during the attempt to close the Falaise Pocket.

DURATION/SUITABILITY: This tour lasts up to one day. The location, with its superb views, is an ideal picnic spot in fine weather. Moreover, you may want to linger to reflect upon its present-day tranquillity, compared to the momentous

A knocked-out Panzer IV in the area of the Mace. The Panzer IV saw combat from 1939; upgraded versions remained in service until the end of the war. *(PISM 2605)*

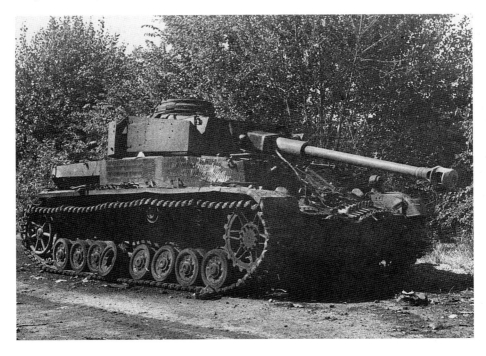

MACE MUSEUM

Mémorial de Montormel, Les Hayettes, 61160 Montormel;
tel: +33 (0)2 33 67 38 61; email: <memorial.montormel@worldonline.fr>. Open daily
0900–1800, May–Sept; 1000–1700 Wed, Thur, Fri, Oct–Apr. Admission charge.

events of some 60 years ago. The museum at the Mace is worth visiting with its displays, films and gift shop. For those with mobility difficulties all points described can be seen from the vehicle, with the exception of Stand B2. On the other hand the walk to Stand B2 can be extended to Stands B3, B4 and B5. If pressed for time, you can complete the tour in half a day by using your vehicle.

STAND B1: POLISH FORCES ARRIVE, 19 AUGUST

DIRECTIONS: Follow the directions given at the start of Tour A as far as St-Lambert-sur-Dive. Continue through St-Lambert on the D13 to Chambois. At the crossroads in Chambois turn left onto the D16 towards the Mémorial de Coudehard Mont-Ormel. Follow this road for about 5 km and turn left into the car park of the memorial. Walk back along the driveway to the grassy area on the left of the green-fenced pond and look towards the D16.

THE ACTION: Maj-Gen Maczek, commanding 1st Polish Armoured Division, saw the Mace as a key position from which to support his formation's thrust to Chambois and to seal the gap through which German forces were retreating. The place he chose to deploy the bulk of his fighting strength was along a ridge line running roughly north–south between the River Dives and the town of Vimoutiers. Along the ridge were a series of hills; Maczek made control of Hills 262 North and 262 South (both measured as 263 metres today) the objective for his battlegroups. This position fell away steeply to the west, affording wide vistas over the surrounding countryside; it therefore allowed the Poles to block the key D16 and D242

roads on the German line of retreat toward Vimoutiers. In short, it was a strong position from which to dominate terrain vital to the escaping German forces. As Maczek admitted in his memoirs, his experiences as a mountain infantryman influenced his choice of the ground upon which to fight, even though his tanks had to struggle up steep gradients to reach their objective.

Driving from the north, the first battlegroup to arrive on the Mace on 19 August consisted of 1st Polish Armoured Regiment plus two infantry companies of the Polish (Highland) Battalion. The tanks and infantry continued southwards past Hill 262 North and about half way to Hill 262 South before making contact during the early afternoon with German forces on the road between Chambois and Vimoutiers (now the D16). Here they encountered a slow-moving column of retreating vehicles packed nose to tail on the road. The column included a few Panther tanks and some armoured cars, as well as command vehicles, towed artillery, lorries and horse-drawn transport. The German vehicles had little room for manoeuvre and offered the Poles a target-rich environment of a kind rarely presented. Opening fire at 1240 hours, the Shermans of 1st Armoured Regiment poured a murderous barrage into the trapped column for half an hour. The nearest vehicles were engaged from as close as 40 metres. The column was smothered in shell detonations, smoke and flame. Amazingly, some German soldiers managed to get a *Nebelwerfer* into action, and this caused a few casualties among the Poles. The Polish response was swift, with further heavy fire against the German column. So rapid was the shooting of 3rd Squadron, 1st Armoured Regiment, that it expended all the ammunition for its tanks' main armament. After 30 minutes it became pointless to maintain the fusillade as nothing moved on a 3-km stretch of the D16. Indeed, the road had become such a tangled mass of wreckage that it presented an obstacle to further Polish movement. Moreover, the burning vehicles created a dense smokescreen that seriously hampered visibility to the south. Taken together, the obstacles posed by the destroyed column and thick smoke meant that the Polish attack to seize

The D16,
looking north-
east toward
Vimoutiers.
On 19 August
it was a scene
of destruction,
fire and smoke.
(Author)

The view
towards Hill
262 South. 2nd
Polish Armoured
Regiment was
unable to reach
it on 19 August.
(Author)

Hill 262 South had to be abandoned. In the lull, however, some German wounded were collected and sent to an aid station that had been established at the Boisjos manor house near Hill 262 North.

The D16 now became the southernmost edge of the perimeter of the Polish positions. As the day continued, the Poles consolidated their position on the Mace. At 1750 hours a second battlegroup arrived, consisting of 2nd Polish Armoured Regiment and 8th Polish Infantry Battalion. Around 1930 hours the remaining elements of the Polish (Highland) Battalion and 9th Polish Infantry Battalion, less one company, also reached the Mace. The missing company of 9th Infantry Battalion arrived around midnight. With the

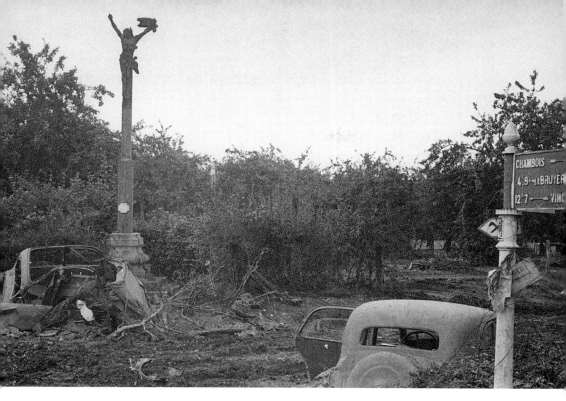

Then: The calvary on the D16 at the southern end of the Mace, illustrating the ferocity of the fighting. *(PISM 2832)*

Now: The calvary today, restored and presenting a more peaceful image of hope. *(Author)*

addition of towed anti-tank gun and tracked anti-aircraft elements, by the end of 19 August the Polish order of battle on the Mace was complete. Indeed, since they were cut off from their logistic support by the strength of the intervening German forces, the Poles found that they were going to have to fight with their existing stocks of equipment and ammunition for the next three days.

The night of 19/20 August passed off relatively peacefully, with only sporadic mortar fire falling on the Polish positions. It was, however, the lull before an intense storm of German counter-attacks in the following days.

STAND B2: POLISH DISPOSITIONS ON THE MACE

DIRECTIONS: Return to the car park in front of the museum. On the far right a gravel track path can be seen. Follow this on foot for approximately 350 metres. Turn left towards the small church (the twelfth-century Église de Coudehard) and if possible climb the observation mound behind the church. (At the time of the author's last visit works were in progress to improve the facilities at this site for those with military interests.)

OPTIONAL WALK: By returning to the gravel track path through some woodland, turning left and continuing along it, bearing left as you go, Stand B4 will be reached where the path joins the D242 (monument on the left). The round trip walk from the car park to this stand and back should take under an hour. From the end of the path that joins the D242, Stand B3 is along the road to your right and B5 to your left. Both are only a few minutes walk away from this point (each about half a kilometre).

THE ACTION: By the evening of 19 August the Polish formations on the Mace occupied the positions that they would hold throughout the action. The dispositions placed infantry– armour groups, generally supported by anti-tank guns, in two sectors, one apiece covering the

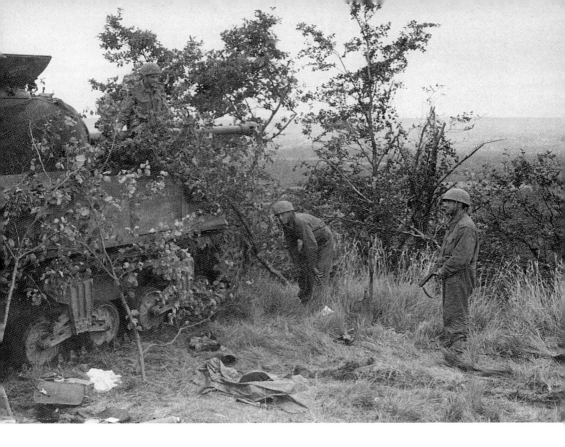

eastern and western flanks of the Mace position. Running north to south on the eastern sector were 1st, 2nd and 3rd Squadrons of 2nd Armoured Regiment, with 8th Infantry Battalion's companies occupying integrated positions. The deployments on the western sector were more complex. The northernmost unit was 1st Company, 9th Infantry Battalion, with the Highland Battalion further south, covering the middle part of the sector. At the southern end of the western flank was the main body of 9th Infantry Battalion. 1st Armoured Regiment deployed its 3rd Squadron in the north and 1st and 2nd Squadrons at the southernmost point of the western sector. During the three days of fighting, some of the squadrons of 2nd Armoured Regiment were also shifted to the northern part of the western sector.

The eastern sector of the Mace position was more conducive to manoeuvre, although the country remained quite close with limitations on fields of fire caused by *bocage*,

A Polish Sherman Firefly on the western flank of the Mace position, with the view of the Dives river valley below. *(PISM 2836)*

A knocked-out
Panther tank
in the area of
the Mace. The
closed feel of
the country is
made evident
by the *bocage*
hedgerows of
fields astride
the road.
(PISM 2842)

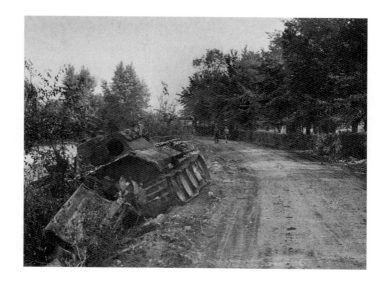

woods and the undulating terrain. The western sector was most vulnerable to attack at its northern and southern tips. The western side was generally very steep making an uphill assault a daunting, if not suicidal, prospect. The tanks of the two armoured regiments generally occupied concealed positions along the edge of woods or behind the *bocage* hedges that lined the fields, tracks and lanes. Infantry were dug in between the tanks and occupied some locations in front of the supporting armour and anti-tank guns.

Command and control on the Mace was very decentralised, and was built around the armoured regiments and infantry battalions, either in combination or singly. The fact that neither of the division's brigade headquarters was on the Mace, and that they were often out of radio contact, meant they exercised little control over events on the ground. On the Mace itself, the co-ordination of the armour and infantry was loosely done. The most senior officer on the Mace was Lt-Col Zdzisław Szydłowski, commanding 9th Infantry Battalion. While no one questioned his seniority, neither did he impose his authority rigidly, preferring instead to work within a co-operative arrangement. The fact that Szydłowski lacked a headquarters to manage a brigade-sized battlegroup and that he had his hands full with his own battalion's actions explains why more centralised

control was not exercised. Each unit, in effect, looked after its own section of the 'city wall', although they did send help to other parts if required. Having committed his division, Maj-Gen Maczek's principal task was to get Canadian help to re-establish contact with the Mace before his units there were overwhelmed.

STAND B3: GERMAN COUNTER ATTACKS, 20 AUGUST

DIRECTIONS: Return to the car park to rejoin your vehicle. Turn left back onto the D16, following *l'encerlement dénouement* signs. The road bends right and climbs. At the crossroads with the D242 turn left toward Trun and les Bois. Shortly after passing les Bois (a farm) views to the right across fields will appear. Soon after the road has curved left, pull in on the right-hand side where there is a new paved area.

THE ACTION: The most testing time for the Polish soldiers on the Mace came on 20 August. Realising the threat presented to the extraction of their forces from the pocket, the Germans launched a series of furious counter-attacks, some well-planned and organised, with others coming from *ad hoc* formations seeking to escape the cauldron. The German attacks came from virtually all directions. Some of the most serious blows, however, took place against the eastern flank of the Mace position, occupied by 2nd Armoured Regiment and 8th Infantry Battalion. During the day this battlegroup endured very determined attacks by elements of II SS Panzer Corps (notably from 2nd SS Panzer Division *Das Reich*, which was still fairly strong).

The first German attacks on the eastern flank of the Mace began at 0900 hours and came from a north/north-easterly direction. German infantry, probably from 2nd and 3rd Battalions, 4th SS Panzergrenadier Regiment *Der Führer*, advanced in strength against 8th Infantry Battalion's positions. The attack developed into a close-quarter battle involving 2nd Armoured Regiment and 8th Infantry Battalion. By 1030 hours the Poles had succeeded in beating

back the enemy. As the German assault on the eastern flank began to falter, however, around 1000 hours German paratroops (from 3rd Paratroop Division), supported by three assault guns, attacked the northern end of the western flank of the Mace. Although the paratroops were quickly stopped and all the assault guns knocked out by 3rd Squadron, 1st Armoured Regiment, the attack revealed much about the Germans' intentions. The counter-attacks aimed, at the minimum, to fix the Poles in their positions so German forces could continue to move north of the Mace unimpeded or, ideally, to sweep the Poles out of the way to create a wider escape corridor.

Because of the relatively small area of the Mace, the Polish armour and infantry were very exposed to the effects of German supporting fire from indirect weapons. Mortars, artillery and multiple rocket-launchers kept up a stream of fire throughout 20 August. This caused a steady flow of casualties in the densely packed position. Throughout the day the Poles also had to deal with the swelling numbers of prisoners of war. They soon held hundreds and with them came the problem of where to put them and how to keep them under control. The Germans were kept in a glade (*polana* in Polish accounts) screened by a ridge line in the zone of 2nd Armoured Regiment and 8th Infantry Battalion. By the afternoon of 20 August, German prisoners here numbered about 800. The open area allowed them to be kept under what amounted to a loose guard. Like all other parts of the Mace, it was exposed to German fire and the prisoners suffered casualties along with the Poles.

The peak of the attacks on the eastern flank began in the early afternoon and proved to be the most serious threat to the Polish positions. At 1400 hours an attack started against 8th Infantry Battalion, once again from the north and north-east. The German attack was in battalion strength and was supported by some Panzer IVs. It was stopped, however, and 8th Infantry Battalion took many prisoners. Two panzers were destroyed by fire from 2nd Armoured Regiment and towed anti-tank guns. 1st Squadron, 2nd Armoured Regiment, lost two tanks in the action.

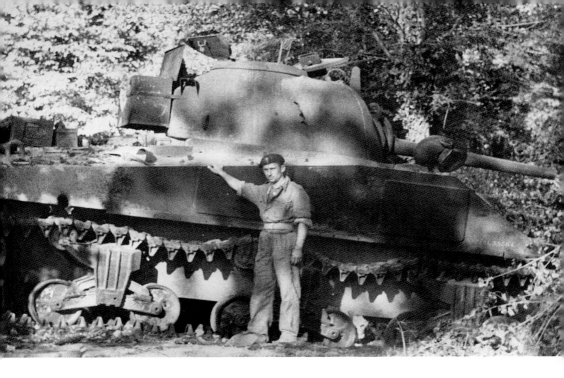

The attack from the north/north-easterly direction was a prelude to the most dangerous of all the German assaults. Beginning at 1500 hours, the Germans thrust out of some woods against the Polish positions on the eastern side of the Mace. The attack advanced between the two roads (D16 and D242), over relatively flat terrain. Panzer IVs once again supported the strong German infantry force. The axis of attack hit a vulnerable point at the southern end of the eastern flank, close to the boundary between 8th and 9th Infantry Battalions. In essence the Germans aimed for the heart of the Mace with the object of penetrating into the rear areas of the Polish formations. The scale and direction of this German effort showed this was no fixing attack. If it succeeded, the attack would split the defence and roll up the entire Polish position on the Mace.

At 1700 hours the battle to stem the German attack from the east reached its full intensity in a confused close-quarter combat.

> *Even the commander of 2nd Armoured Regiment, Lt-Col Stanisław Koszutski, was caught up in the mêlée:*

A Polish soldier poses beside his disabled tank. The shot hole in the engine compartment on the left can be seen above the track. *(PISM 2552)*

The gap and
ridge line
north of the
Mace position.
German control
of this area cut
off the Polish
battlegroup
from its logistical
support. *(Author)*

'Suddenly, while I am talking with 2nd Lieutenant
"B", I see a tank with a diamond shaped turret
and a rectangle with a black cross on it from
my hatch, about ten steps away from the barrel
of the gun. Soon afterwards I hear a second and
third coming. These [German] tanks are moving
across the front of the tanks belonging to the
1st Squadron, also ten metres away from their
barrels. They are not yet visible from the position
of the 3rd Squadron who are on the shorter incline
of the hill. These are certainly the [German] tanks
supporting the infantry who entered the forest
and are now attacking us from behind.

My gunner and radio operator, Kuba Zemlik
is shouting something into the radio receiver.
"Kuba", I call, "the Germans are in front. Fire!"

Kuba fires. The shell, however, ricochets and
breaks up above the heads of the [German]
prisoners. The soldier guarding the prisoners gets
his legs crushed by the "Panther". Simultaneously,
rapid fire coming from the shorter incline breaks
out. Ten tanks from the 3rd Squadron and the
anti-tank battery have spotted the German tanks.
In a few seconds they are virtually torn apart
by the shells. Not even one German manages to
escape the tanks.

My Kuba is now firing directly ahead with
his machine gun. I am firing to the rear towards
the forest with the anti-aircraft machine gun

[.50–calibre on top of turret], thinking that if my machine gun jams, the Germans will climb onto my turret.

An incredible situation. All of the Regiment's machine guns are firing at the same time, all of the turret machine guns and all of the anti-aircraft machine guns in both directions – 44 tank guns and around 90 machine guns. The drone of German Schmeissers can be clearly heard among the explosions.

The nervous tension is incredible. One can feel it running like an electric current across all units. It cannot last for long. It is the culminating point of the battle, the war, life, of something fundamental. Something has got to give. There is no leader in overall command, each one is fighting with weapon in hand.'

Source: Stanisław Koszutski, *Wspomnienia z różnych pobojowisk*, p. 213.

The weight of the attack led to deep German infiltration of the Polish positions by tanks and infantry. Indeed, three Panzer IVs reached as far as the *polana* where the German prisoners were kept. The arrival of the tanks triggered a ferocious firefight. The prisoners, caught in the middle, panicked and ran for cover in nearby woods. A Sherman from 3rd Squadron, 1st Armoured Regiment, knocked out one of the panzers in an engagement that was literally barrel to barrel. 9th Infantry Battalion and the Highland Battalion engaged in some hard fighting to eliminate German encroachments into the Polish positions. A particularly noteworthy role was played by 9th Infantry Battalion's mortar platoon. Having expended all the available mortar ammunition, the platoon fought an enterprising infantry action to restore the situation. By 1900 hours the German incursion had been eliminated and the original positions regained.

After the severest trial for the Polish defenders on the Mace during 20 August, the night of 20/21 August seems to have passed off quietly for the exhausted soldiery on both

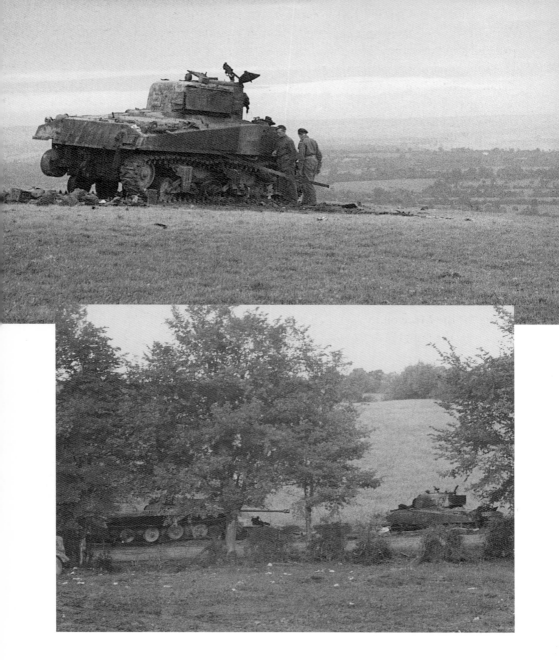

sides. Some German sources, however, claim that an escape route along the D16 was successfully cleared and remained open for several hours overnight.

It is impossible to identify the mass of German forces involved in the counter-attacks on the Mace on 20 August with any certainty. However, in addition to the elements of 2nd SS Panzer Division and 3rd Paratroop Division mentioned above, it is clear that large numbers of troops from 12th SS Panzer Division and 1st SS Panzer Division participated in the fighting. Although all these formations had suffered heavy casualties during the Battle of Normandy, they were amongst the elite of the *Wehrmacht*, and were fighting with a courage born of desperation as they tried to escape from the pocket. Seen in this light, the Poles' achievement appears all the more remarkable.

STAND B4: ARTILLERY IN THE ACTION ON THE MACE

DIRECTIONS: Continue along the D242 for a few hundred metres until you see a brown monument commemorating the battle for the Mace on the left. Pull in to the gravel area and park near the monument.

THE ACTION: The Polish troops on the Mace had considerable firepower at their disposal but there was one additional factor that was crucial to their success – Allied artillery. Using the good vistas provided by the Mace, artillery could be directed onto targets in the Dives river valley below. On the Mace each infantry battalion and armoured regiment had a forward observation officer (FOO) attached, with those in the armoured regiments each having their own tank. In addition to the five observation officers organic to the Polish formations, there was also a Canadian FOO on the Mace, Captain Pierre Sévigny. He was from 4th Medium Regiment, RCA, which was part of 2nd Army Group, RCA. This regiment of medium guns had been attached to the Polish armoured division for most of the operations in August. The artillery organic to 1st Polish

German and Polish medical orderlies worked side by side to tend the wounded in the desperate conditions that existed on the Mace. Note that the Polish medic standing between the two Germans is wounded himself. *(PISM 2606)*

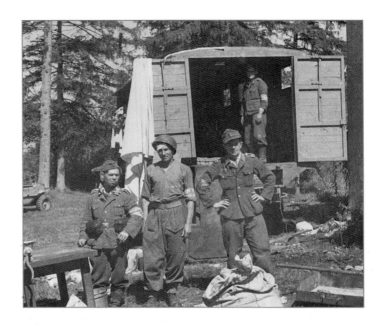

Armoured Division thus consisted of two regiments of 25-pounders and a regiment of 5.5-inch medium guns.

During the fight for the Mace, the Polish defenders repeatedly called down artillery in front of their positions. The volume of artillery fire was high, not only in terms of the numbers of shells used but also the concentration of fire. 1st Polish Armoured Division's after-action report states that, on the peak day of expenditure, around 7,000 shells were fired at German positions. So high was the

The monument near Boisjos marks the end of the gallant action fought on the 'Mace'. *(Author)*

consumption of ammunition on 20 August that 2nd Polish Field Artillery Regiment's war diary recorded the gunners' fears that they were going to run out of ammunition at 2000 hours. 4th Medium Regiment, RCA, also did sterling work in support of 1st Polish Armoured Division. Sévigny called down very large concentrations of fire in the area of the Mace. He repeatedly called for Mike and Uncle targets (all the guns of a regiment or a division respectively) and on one occasion requested a Victor target using the artillery of II Canadian Corps. 4th Medium Regiment,

RCA, fired over 400 rounds per barrel per day during this period of the battle. The rate of fire was so high that, at the end of the action, the regiment had to replace six gun barrels among its artillery pieces, which were worn out from the intensity of fire.

The Canadian military historian Terry Copp has argued that 'the artillery, and the determination of Polish soldiers, prevented the Germans from overrunning the fortress position' of the Mace. The after-action report of 10th Polish Armoured Brigade was more blunt in its assessment, saying that the artillery saved the brigade from destruction and that it was a vital ingredient in maintaining the soldiers' morale.

STAND B5: FINAL GERMAN ATTACKS, 21 AUGUST

DIRECTIONS: Continue along the D242, which bends right and slopes down. At the junction with the C4 towards Champosoult, pull in safely on the right. Cross to the left side of the road and orientate yourself to two features: on your left the imposing Boisjos manor house and to your right the next ridge line beyond the gap.

THE ACTION: At the northern tip of the Mace position there was a gap in the ridge line with the Germans in control of the other side, blocking Polish contact with the rest of the armoured division. Also at the northern end of the Mace position was a manor house, Boisjos, that served as the aid station where all the wounded were collected. The Poles dubbed it the *zameczka*, or 'little castle', as the architectural lines of the building reminded them of a medieval castle. As was the case with all other parts of the Mace position, it was exposed to fire. At 0700 hours on the 21st the Germans mounted a strong infantry attack, supported by three Panther tanks, moving south toward Boisjos. The consequences of the attack were felt by the Polish ambulance section further down the hill. Fire poured into the medical unit as the Germans ignored the prominently displayed Red Cross flags. The popular padre

'DYING ONLY FOR POLAND'

The 1st Polish Armoured Division fought in the last month of the battle for Normandy and quickly distinguished itself on the 'Mace' in one of the grittiest actions of the battle to close the Falaise Pocket. The story of 1st Polish Armoured Division is personified in its commanding officer, Maj-Gen Stanisław Maczek. Born in Lwów in 1892, Maczek came from a generation of Poles that saw the re-emergence of an independent Poland. As a subject of the Austro-Hungarian Empire, Maczek was a junior officer in the *Kaiserlicht und Königlicht Armee* in the First World War, serving with distinction in an elite mountain regiment on the Italian front. With the collapse of Germany and Austria-Hungary, an independent Poland emerged in November 1918 with every border contested by its neighbours. Like so many Austro-Hungarian officers of Polish nationality, Maczek's military

Colonel Franciszek Skibiński during his service with 1st Polish Armoured Division in Normandy. (PISM 2531)

experience took him to the newly created Polish Army. It was an army that would fight a major conflict while in the process of rebirth. In 1919–21 Maczek had a number of wartime assignments on the Polish–Soviet front including infantry, cavalry and staff officer posts. Among the most interesting of his wartime assignments was the creation of a mobile unit that was an early exposure to the potential of motorised military formations.

After seven years of war, Maczek settled down to the humdrum life of peacetime soldiering. Finishing the war as a captain, he was promoted to major in 1922. The Polish Army saw potential in Maczek and sent him to the General Staff College from which he graduated in 1924. In 1927 he rose to lieutenant-colonel and became a colonel in command of his own infantry regiment in 1931. In October 1938, with war clouds gathering, he received what was a prestigious appointment in the inter-war Polish Army – command of a cavalry brigade. His assignment, however, did not lead him to don cavalry boots and sabre because 10th Cavalry Brigade (*10 Brygada Kawalerii*) was what would today be called a 'transformational unit'.

In the 11 months before the outbreak of the Second World War, Maczek managed to create in 10th Cavalry Brigade Poland's first military formation designed for mechanised warfare. A team of able and forward-thinking officers aided Maczek's efforts. Some of them, such as Franciszek Skibiński and Aleksander Stefanowicz, had published articles in the noted Polish military journal *Bellona* on the organisation and tactics of armoured units. Given the relative lack of resources

and the limited time, Maczek succeeded in establishing an innovative formation that would prove its worth under the most testing of conditions – war.

The invasion of Poland by Nazi Germany in September 1939 heralded the beginning of the Second World War. For the Polish Army, the September campaign was a disaster of staggering proportions. In the midst of the catastrophe, however, the performance of 10th Cavalry Brigade was a rare positive feature. During the campaign the brigade fought an effective delaying action against superior German forces and then crossed the border into Hungary, allowing most of its survivors to escape to fight another day. After they made their way to France, a light motorised division was built on the basis of the cadre of 10th Polish Cavalry Brigade. Not fully formed or retrained on their new French equipment, the new unit fought a fighting retreat and avoided encirclement in June 1940. With the collapse of France a foregone conclusion, once again some 20,000 Polish soldiers escaped, this time to Britain. Maczek and his key cadre of 10th Polish Cavalry Brigade were among them. In Britain, from the remnants of the formations that fought in Poland and France would emerge 1st Polish Armoured Division (*Pierwsza Dywizja Pancerna*).

In February 1942 Maczek was named commanding officer of 1st Polish Armoured Division. Organised, equipped and trained on the basis of British doctrine, the division nevertheless incorporated an overlay of Polish military practice, tradition and, above all, the experience of two previous campaigns. When the 52-year-old Maczek took his soldiers to Normandy, he had arguably one of the best motivated and most experienced groups of men fighting on the Allied side in North-West Europe.

Soon after 1st Polish Armoured Division's arrival in Normandy, however, Maczek reminded his men about their priorities in the cause they were serving:

'The Polish soldier fights for the freedom of other nations but only dies for Poland.'

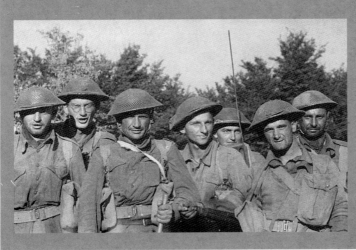

The faces of soldiers of 10th Polish Dragoon (Motor) Regiment, August 1944. The intense combat in Normandy depleted the ranks of the Polish infantry and, for an exile army, losses were difficult to replace. (PISM 2530)

of 9th Infantry Battalion, Father Hupa, was killed, as were several wounded in an ambulance riddled with bullets. Polish armour, responding to the German assault, knocked out or drove off the Panthers. Without tank support the German infantry attack soon faltered, but the morning saw continued artillery and mortar fire around Boisjos. The aid station struggled to look after 300 wounded, both Polish and German, many lying in the open because of the lack of space inside.

The crisis experienced by the Poles on the Mace, however, was drawing to a close. The last significant German attack took place at 1100 hours on the 21st at the southern end of the Mace position, on the western side near the church at Coudehard. Soldiers of 12th SS Panzer Division launched a suicidal assault at one of the steepest places along the ridge line, only to be cut down by the guns of the anti-aircraft detachment. The last German attack could not have come at a more difficult time as the Poles, cut off from re-supply during three days of intense combat, were running out of food, water, medical supplies and ammunition. Although already tired when they reached the Mace, their exertions were only just beginning and since then they had had their powers of endurance tested to the limit. At 1200 hours on the 21st, however, 4th Canadian Armoured Brigade broke through from the north, ending the Poles' three days of isolation.

The view from the eastern edge of the Mace position looking north-east in the direction of Vimoutiers, where 2nd Polish Armoured Regiment and 8th Polish Infantry Battalion experienced repeated attacks on 20 August. (Author)

Then: The Boisjos manor house called the *zameczka*, or little castle, by the Poles. It served as the aid station throughout the three-day battle. *(PISM 2846)*

Now: Boisjos appears little changed today apart from an extension and changes to out-buildings. *(Author)*

The ambulance which was riddled with bullets during the German attack near Boisjos on the morning of 21 August. *(PISM 2842)*

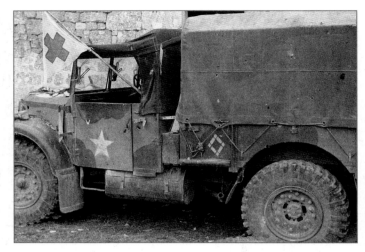

The war diary of the Canadian Grenadier Guards described the scenes encountered by the Canadian soldiers:

'The picture at [Hill] 262 was the grimmest the regiment has so far come up against. The Poles had no supplies for three days; they had several hundred wounded, who had not been evacuated, about 700 prisoners of war lay loosely guarded in a field, the road was blocked with burned-out vehicles, both our own and enemy. Unburied dead and parts of them were strewn about by the score... The Poles cried with joy when we arrived and from what they said I doubt if they will ever forget this day and the help we gave them.'

Source: C.P. Stacey, *The Victory Campaign*, vol. III, p. 264.

ENDING THE TOUR: Continue along the D242 for approximately 9 km following signs to Trun. Turn right on to the D13 at Trun to retrace your route to Falaise.

THE AMERICANS AT LE BOURG-ST-LÉONARD

OBJECTIVE: This tour describes the action of 1st Battalion, 359th US Infantry Regiment and supporting units to contain German attacks and regain control of the key village of le Bourg-St-Léonard on 16 and 17 August 1944.

DURATION/SUITABILITY: This tour will take several hours and, if weather conditions are favourable, the entire route can be walked. In inclement weather, however, it is advisable to use only your vehicle and to be equipped with Wellington boots and waterproof clothing. For those with mobility difficulties all points described can be seen from the vehicle, though visibility from Stand C4 is somewhat limited.

STAND C1: THE GERMAN COUNTER-ATTACK, 16 AUGUST

DIRECTIONS: Follow the directions given at the start of Tour A (*p. 115*) through St-Lambert-sur-Dive. Continue on the D13 to Chambois. When you reach this town turn right at the crossroads onto the D16, signposted to le Bourg-St-Léonard. The road soon bears left at Mairie de Fel and gradually climbs out of the town. Continue for about 4–5 km until you reach the outskirts of le Bourg-St-Léonard. Having passed the château on the right-hand side, pull in just after the church.

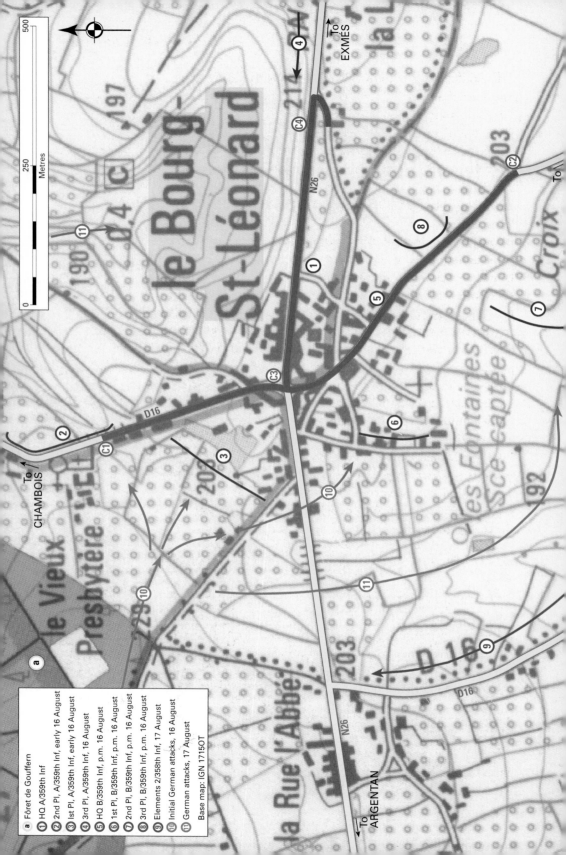

THE ACTION: For both the US and German forces, le Bourg-St-Léonard was a critical road junction. The retreating Germans sought to control the village since it offered a hard shoulder protecting their units moving north-east from Argentan to escape the pocket. For 90th Infantry Division the village was an essential jumping-off point from which to attack towards Chambois and Trun to close the pocket.

The 90th Infantry Division sector covering le Bourg-St-Léonard was assigned to Major Leroy S. Pond's 1/359th Infantry. This battalion was responsible for a wide front running from le Bourg-St-Léonard in the west to Exmés. Generally speaking, infantry battalions were expected to hold an area no more than about 700 metres across. In this case, however, 1/359th Infantry occupied a frontage of about 5.5 km! To cover this area, the battalion's three rifle companies were deployed with A/359th at le Bourg-St-Léonard, C/359th at Exmés and B/359th near le Pin-au-Haras (where the battalion's command post was located) as a reserve. At le Bourg-St-Léonard, A/359th Infantry's 1st and 2nd Platoons were in the village, with 3rd Platoon deployed at a road junction just to the east. In support, A/359th Infantry had one section of heavy machine guns, some 81-mm mortars and two Sherman tanks from A Company, 712th Tank Battalion. In addition, two towed anti-tank guns were positioned in the centre of le Bourg-St-Léonard, with others at the road junction covered by 3rd Platoon.

The church of le Bourg-St-Léonard in the northern part of the village. Most of the American positions roughly followed the line of the road on the right of the picture opposite the church when the initial German attack began. *(Author)*

1/359th Infantry had moved into the area on 15 August, relieving elements of 5th Armored Division that were being sent east to the Seine. It is clear from after-action reports that Pond was concerned about how thinly his companies were spread and about the lack of firepower to bolster his positions, particularly compared to the armoured unit he had just relieved.

After moving into position A/359th Infantry experienced a quiet night, with only sporadic artillery fire against its forward defences. Initially, the company's 2nd Platoon was dug in on the eastern side of the road to Chambois (now the D16) where it bends opposite the church. 1st Platoon was in positions on the western side of the Chambois road, south of the church, occupying a line that completed the triangle between the D16 and the road running east–west, now the N26. The platoons were supported by towed anti-tank guns at the crossroads, covering an arc of fire from north to west.

On the morning of 16 August the situation changed dramatically. Around mid-morning, A/359th Infantry's 2nd Platoon moved across the D16 while 1st Platoon sent a patrol to the west, through some orchards and into the Forêt de Gouffern. The patrol, of six or seven men, was led by Second Lieutenant Morency R. Dame. It moved north of the church and after penetrating only about 180 metres into the forest in a north-westerly direction met a larger German force. A firefight broke out that quickly forced Dame's patrol back toward the town. The German force increased in numbers and it became clear that it was the advance element of a much larger force, which was intent on attacking le Bourg-St-Léonard. Dame was wounded during the exchange of fire and he and his patrol retired in haste back on the main company positions:

> *2nd Lieutenant Vernon Cross, A Company's Weapons Platoon commander, recalled what happened:*
>
> 'The sudden opposition and the fact that he was wounded slightly must have rattled Dame, for

he grew excited. The patrol pulled back hastily, in complete confusion. The rest of the platoon, seeing this and noting the little finger of Dame's left hand gashed and spouting blood as well as seeing him with blood all over his face, from an unknown cause (though, probably, from rubbing it with his bloody hand) got excited, too, and withdrew in poor order. They fell back across to the east side of the road, badly shaken and out of control, men going in all directions.'

Source: 90th Infantry Division Combat Interviews, RG 407, Box 24065, Folder 194, USNA.

The bazooka, firing a rocket projectile with a shaped warhead, was the American infantry's means of taking on tanks at close ranges. In the action at le Bourg-St-Léonard, American soldiers had mixed success in knocking out German tanks operating in the centre of the village. *(USNA)*

As they fell back Dame's men dislodged the rest of 1st Platoon from its positions. Pond acted swiftly to redress the situation. From A Company's command post on the N26 at the eastern edge of the village, he ordered Captain Hickman, his Operations Officer, to bring B/359th up to le Bourg-St-Léonard. Brushing aside a force of around 50 Germans, B Company moved into positions in the south-east corner of the village, where it set up its command post in a farmhouse on the battalion supply line. The portion

of le Bourg-St-Léonard north of the N26 was assigned to A/359th, with the area south of the road allocated to B/359th. In addition, Pond sent an engineer platoon to the road junction east of le Bourg-St-Léonard to replace A Company's 3rd Platoon in providing close protection for the anti-tank guns located there. He ordered 3rd Platoon to le Bourg-St-Léonard to rejoin the rest of A Company. Pond personally put the engineer platoon into its positions, knowing that its men had not seen combat before.

In addition to setting the new dispositions in motion, Pond instructed Hickman to sort out the two platoons of A/359th that had been dislodged from their original positions. Hickman acted energetically to steady and reorganise the panicky soldiers and at 1400 hours on 16 August ordered a counter-attack to retake the original A Company positions. At about 1515 hours Hickman reported that the counter-attack had succeeded. (Meanwhile, B/359th launched counter-attacks toward the south-west sector of the village, but failed to reach all its objectives.) Hickman's success, however, was short-lived. Indeed, it marked the beginning of a battle that was to see le Bourg-St-Léonard change hands several times.

STAND C2: THE BATTLE FOR LE BOURG-ST-LÉONARD, 16–17 AUGUST

DIRECTIONS: Return to your vehicle and travel on in the same direction to the crossroads in le Bourg-St-Léonard, where the D16 intersects with the N26. Leave the D16 here and go straight over toward le Vieux Pin. The route will take you down a narrow lane lined with houses which eventually give way to small fields. You will reach a point where the lane forks. Pull in here and stop where it is safe to do so. Look back up the lane toward le Bourg-St-Léonard.

THE ACTION: Having regained their initial positions, A/ and B/359th attempted to strengthen them during the afternoon of 16 August. At around 1600 hours Pond ordered the reserve platoon of tanks to support B Company in le Bourg-St-Léonard, and it seemed that the American position was

settling down. One hour later, however, the Germans (later identified as elements of 2nd SS Panzer Division's tank and panzergrenadier regiments) launched an even stronger attack to dislodge the Americans from the village. At 1700 hours a brief but intense artillery bombardment was followed by a German assault in considerable strength (an estimated 1,100 men) with tank support. A Company's 3rd Platoon was the first to succumb to the tide of German soldiers sweeping into the village. Encircled by the enemy, 3rd Platoon used the protection and firepower of the two Sherman tanks attached to it to fight its way to the south-eastern edge of the village. A/359th Infantry's other two platoons resisted German pressure for a little longer, but by 1930 hours had withdrawn east down the N26 to the eastern edge of the village.

> *During the German attack, A Company's command post was briefly overrun:*
>
> '... the Germans reached the vicinity of the A Company CP with some infantry, followed closely by tanks. This forced almost complete abandonment of the CP and for a while the Germans ransacked everything in the lower portion of the house which was being used for this field headquarters, while eight men of A Company defied them in the upstairs part of the house. These men – Pvt. LaHaye, Pvt. Eugene

The east–west road running through le Bourg-St-Léonard. The centre of the village witnessed hard fighting as it repeatedly changed hands. *(Author)*

167

M. Blythe, PFC Charles Sylvester, PFC Barnes, PFC Rusnick, all runners and assistants, and T/5 Walbloom, company armorer – withstood a shower of German grenades and a flood of rifle bullets as the Germans called up, intending them to surrender, "Hands up, or I kill." LaHaye and Blythe took over leadership of the group and, tossing a "Fuck you" to the German demand for surrender, eventually managed to escape through a back part of the house.'

Source: 90th Infantry Division Combat Interviews, RG 407, Box 24065, Folder 194, USNA.

Pond responded vigorously to German pressure by ordering another counter-attack with machine-gun and mortar support. In the twilight, A and B Companies once again fought their way towards their original positions. By 2130 hours the two companies had regained most of the lost ground, but as the fighting ebbed at nightfall the Germans continued to cling on to the north-west corner of le Bourg-St-Léonard. German tanks also stood in the centre of the village, dominating the crossroads. After an exhausting see-saw battle, the two companies settled down to a tense night.

1st Lieutenant Charles Kinsley, a platoon commander in B Company, describes the situation on the evening of 16 August:

'Just a short distance in front of our positions, about 100 yards away, a house was on fire. The light from it gave the Germans on the west side [of the north–south road] pretty damn good observation of our positions. It began to get hot around there. The Jerries started tossing in hand grenades [they were just across the road – apparently not more than 25–30 yards separated the Americans and Germans at this point] and kept up strong harassing fire with burp [sub-machine] guns and rifles. We could hear them talking, shouting orders and swearing. Then they moved a tank...

onto our right flank... With all this stuff coming at us, tank fire, machine gun fire and grenades... I decided to withdraw my platoon to the next field about 75 yards to the east. There was a hedgerow there which would give us better concealment and cover. Also, it would give us a better field of fire and give me a better chance of contacting the rest of the company. None of the men in the platoon was hit during this withdrawal. This took place about 2400–0100 hours.'

Source: 90th Infantry Division Combat Interviews, RG 407, Box 24065, Folder 194, USNA.

Upon returning to his battalion command post, Pond found Brig-Gen William G. Weaver, the Assistant Divisional Commander, and his regimental commander, Colonel Robert L. Bacon, waiting for him. The senior officers had come to get a measure of the situation and to organise a stronger counter-attack for the next morning. In addition to 1/359th Infantry, the task of regaining control of le Bourg-St-Léonard was also to be given to 2/358th Infantry. Two companies of this fresh battalion (F and G) were to attack due northwards up a road on the western side of le Bourg-St-Léonard to reach the crossroads on the N26 at la Rue l'Abbé. A/ and B/359th would continue to drive westwards astride the N26 until they made a juncture with 2nd Battalion. The attack was scheduled for 0800 hours on 17 August. Like so many plans, however, it would be altered by events.

STAND C3: REGAINING LE BOURG-ST-LÉONARD, 17 AUGUST

DIRECTIONS: Retrace your route to the crossroads in le Bourg-St-Léonard and park nearby. Walk to the crossroads to a position where you can see north along the D16 toward Chambois, as well as east along the N26 toward Exmés.

THE ACTION: The night of 16/17 August passed relatively quietly in le Bourg-St-Léonard. Before 1/359th Infantry

could launch its morning attack, a renewed German assault pre-empted American plans.

> *In the early hours, a German tank in the centre of le Bourg-St-Léonard started firing:*
>
> 'Then about dawn at 0515, the Germans tried an old trick. One of their tanks went clanging and banging down the road into our lines, halting and firing several times back toward their own troops to give the impression that it was an American vehicle. The ruse did not work. It was knocked out.'
>
> *Source*: 90th Infantry Division Combat Interviews, RG 407, Box 24065, Folder 194, USNA.

The ruse, however, was only the prelude to a larger German attack. At 0530 hours the Germans mounted another assault with an estimated two battalions of infantry, supported by a dozen or so tanks. The Germans attempted to outflank 1/359th Infantry's positions by enveloping the town. Fierce fighting raged, with the Germans mounting attack after attack. The cost was high; B Company's commander, Captain Hutchens, was killed and German casualties were very much in evidence in front of the US positions. The decisive moment in the morning's fighting came when a scratch force consisting of five Sherman tanks supported by infantry, led personally by Pond, counter-attacked at about 0615. The action of this tank–infantry force led to 1/359th Infantry regaining the initiative and clearing the village by 0915 hours.

By late morning, however, German armour and infantry were once again entering le Bourg-St-Leonard. An American counter-attack was planned for noon, but was pre-empted by the Germans, who assaulted with tanks, infantry and artillery. B/359th Infantry, which was down to only 40 effectives, held on to most of its positions, but part of A Company was driven back. Its 3rd Platoon was surrounded, and when the company commander, Lieutenant Fritz, went forward to try to locate them, he was killed or

The objective of the American counter-attacks was to regain control of 1/359th Infantry's original positions near the church. It took two days of hard fighting to restore the village to American control. *(Author)*

An American M10 tank destroyer, armed with a high-velocity 3-inch gun. The American counter-attack that finally gained control of le Bourg-St-Léonard on 17 August benefited from the support of such tank destroyers. *(Author)*

captured. Although 3rd Platoon managed to fight its way out of the encirclement back to the eastern edge of the village, this had a disruptive effect on the American plans.

The two companies of 1/359th Infantry paused to reorganise themselves and at 1445 hours launched yet another counter-attack in the prolonged test of will that characterised the struggle for le Bourg-St-Léonard. With the support of a platoon of C/359th Infantry and some M10 tank destroyers from A Company, 733rd Tank Destroyer Battalion, the Americans succeeded in crossing the D16, making contact with F/358th Infantry, and regaining control of le Bourg-St-Leonard by 2300 hours on 17 August. At midnight 2/359th Infantry moved up to relieve their exhausted comrades, who had been fighting for the better part of two days. By dawn on 18 August 2/359th had

completed the relief of 1st Battalion and the village was under firm American control.

STAND C4: AMERICAN ARTILLERY AND THE GERMAN RETREAT, 18 AUGUST

DIRECTIONS: Turn on to the N26 in the direction of Exmés (eastwards). After passing the sign denoting the end of le Bourg-St-Léonard (name with a cross through it) turn right. The road doubles back on itself. Pull in by the antiques (*antiquités*) shop on the left and park. Walk back to the main road and cross it. Take care in crossing as traffic can be heavy. From the far side, Chambois and its famous twelfth-century keep can be sighted.

THE ACTION: With the village of le Bourg-St-Léonard secured, the problem of containing the escaping German forces became more important for 90th Infantry Division. The ridge line that le Bourg-St-Léonard occupied provided an ideal vantage point to observe German activity in the Dives river valley below. At 0800 hours on 18 August, taking tactical advantage of the excellent view of the battlefield to the north, Colonel Robert L. Bacon (commanding 359th Infantry) established an observation post near this stand. From this position, retreating German columns could be brought under the fire of five battalions of artillery (60 guns). For most of 18 August, from 0900 hours onwards, 359th Infantry Regiment's main effort was to bring devastating artillery fire down on the retreating Germans.

The consequences of the artillery shoot were vividly described in an after-action report:

'Shortly after noon, it was decided that it would be necessary to wreck the RJs [road junctions] in Chambois to prevent the Germans from going through and force them to pile back up into the fields to the southwest and west of Chambois... The numbers given to the artillery concentrations for these points were 305 and 306. So confused

were the Germans and so completely in control of the situation were the Americans at all times during this day, that the artillery forward observer's "Concentration 305 (or 306)" repeated time after time, became the watchword of the day. The Germans kept blundering along the same routes and the Americans simply plastered them with artillery... For instance, concentration 305 or 306 was fired at 1400 with devastating effect. Chambois was blocked from the west. The Germans began to spill over backwards into the fields as had been hoped and the artillery and air began to pour into them with deadly effect. The boys in the battalion who were watching this, just cheered and cheered as horses, carts, trucks, German "jeeps", soldiers, tanks, vehicles and weapons of all description went flying into the air, disintegrating in flashes of smoke and generally catching hell. The scene has been called an "artilleryman's dream".'

Source: 90th Infantry Division Combat Interviews, RG 407, Box 24065, Folder 194, USNA.

Initially, 90th Infantry Division's headquarters decided that German escape routes through Chambois and Moissy

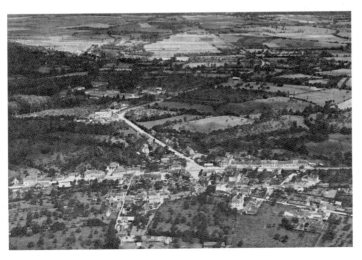

An aerial view of le Bourg St-Léonard from the south, looking north across the village to the wide open plains beyond. (USNA)

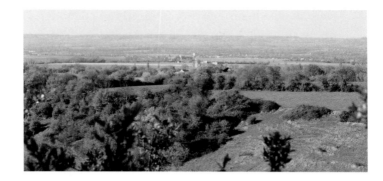

The view of Chambois from the eastern edge of le Bourg-St-Léonard along the N26. The line of the D16 running to Chambois and the keep can be seen in the distance. Panoramas such as this allowed artillery observers excellent visibility to bring down devastating fire on the retreating Germans. *(Author)*

could be covered by interdicting artillery fire. Despite the successes of the artillery, however, interdiction by firepower alone did not stop completely the flow of retreating Germans. Consequently, it was decided that 359th Infantry Regiment would have to seize Chambois, with 2/359th Infantry given the task on 19 August. The action at Chambois is described in Tour D.

ENDING THE TOUR: Return to le Bourg-St-Léonard and turn right on to the D16 towards Chambois. At Chambois turn left on to the D13 to return to Falaise. If you wish to continue with Tour D turn right from the D16 onto the D305 as you approach Chambois and follow the remaining directions given at Stand D1.

Some American soldiers (on left) and a Polish soldier (on right) inspect the landscape after the battle, probably near Chambois, August 1944. *(PISM 2593)*

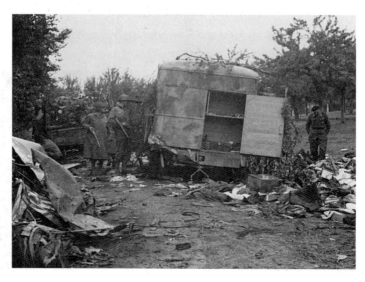

THE LINK AT CHAMBOIS

OBJECTIVE: This tour describes the meeting of American and Polish forces at the town of Chambois on 19 August 1944. When 2/359th Infantry and supporting units, advancing from the south, met elements of 1st Polish Armoured Division's battlegroup fighting its way into the town from the north, the last significant exit from the Falaise Pocket was effectively closed.

DURATION/SUITABILITY: This tour lasts about half a day and it is advisable to use your vehicle throughout. The final stand is in the centre of Chambois and the little town can then be explored on foot. For those with mobility difficulties, all points described can be seen from the vehicle.

STAND D1: THE MEETING OF THE ALLIED ARMIES, 19 AUGUST

DIRECTIONS: Take the D13 from Falaise to Chambois as described in previous tours. At the crossroads in Chambois, turn right onto the D16, sign-posted to le Bourg-St-Léonard. The road soon bears left at Mairie de Fel and gradually climbs out of the town. About 500 metres after Mairie de Fel, turn left onto the D305 at the first crossroads after passing a *usine* (factory) sign and before reaching a water tower on the right-hand side. Half a kilometre later turn left at the T-junction and bear right where the road forks, sign-posted

Major Leonard C. Dull (*right*), officer commanding 2/359th US Infantry, confers with Lieutenant Władysław Klaptocz. G/359 US Infantry of Dull's battalion made first contact with the Polish battlegroup. (*USNA*)

to Église and la Fontaine (there is a water tower here that
you pass on your left). On reaching the church, pull in on the
left and look across the fields towards Chambois.

THE ACTION: In the early afternoon of 19 August the
Polish battlegroup tasked with taking Chambois mounted
its attack on the town from the north-east. In the lead
were motorised infantry from 10th Dragoon Regiment and
the Sherman tanks of 24th (Lancer) Armoured Regiment.
The divisional reconnaissance unit, 10th Mounted Rifle
Regiment, provided supporting fire. By late afternoon
the Polish force had fought its way into Chambois and
controlled the bulk of the town north of the D13.

On 19 August 90th US Infantry Division also ordered
2/359th Infantry to take the town. The attack began at
1300 hours with two companies advancing astride the D16
towards Chambois: E/359th was on the left of the road and
G/359th on the right, with F Company following in reserve.
The troops advanced across the relatively open and flat
country, accompanied by supporting M10 tank destroyers.
G/359th, under the command of Captain L.E. Waters, was
the first unit to reach the town. Its route was along a farm
track running parallel to the D16. The track continued
as far as a substantial manor house, where it forked into
two branches, passing farm buildings at intervals. Waters
followed the right fork to the church at this stand. At this

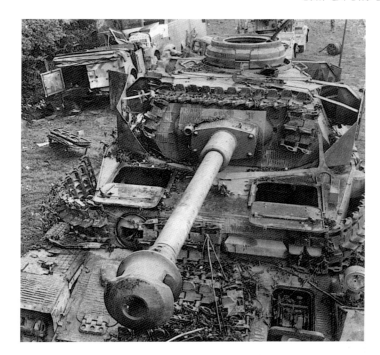

A wrecked
Panzer IV tank
at Chambois,
21 August.
(USNA)

point G Company left the track and crossed the open fields
separating it from the town. In its path was the River Dives,
and beyond, the houses of Chambois lining the D13.

In front of G/359th Infantry at the edge of the town was
Lieutenant Jan Karcz, commanding a platoon of infantry
from 3rd Squadron, 10th Polish Dragoon Regiment. When
Karcz was warned that a large body of infantry was advancing
on his position he opened fire, but soon ordered the firing to
cease. As he studied the advancing infantry carefully through
his field glasses, he saw soldiers wearing what looked like
German helmets but in khaki uniforms. Realising that they
might be Americans, Karcz took a German rifle and put his
flat, British-pattern helmet on the barrel end and waved it
in the air as a recognition signal. Approaching the Polish
position under a flag of parley, Waters greeted Karcz with a
warm 'glad to see you buddy'. When Karcz reported to his
boss, Lt-Col Władysław Zgorzelski, by radio, his response
to the arrival of the Americans was simply to say '*Wiwat*'
(perhaps best translated as 'Rejoice'). The two Allied armies
had met at around 1900 hours on 19 August.

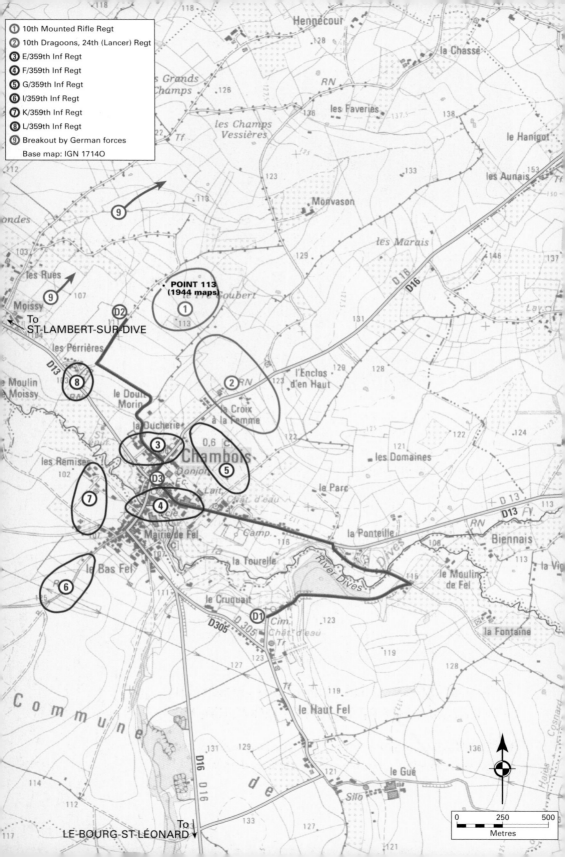

① 10th Mounted Rifle Regt
② 10th Dragoons, 24th (Lancer) Regt
③ E/359th Inf Regt
④ F/359th Inf Regt
⑤ G/359th Inf Regt
⑥ I/359th Inf Regt
⑦ K/359th Inf Regt
⑧ L/359th Inf Regt
⑨ Breakout by German forces
 Base map: IGN 1714O

Across these fields G/359th US Infantry advanced into Chambois and made contact with Polish infantry of 3rd Squadron, 10th Dragoon Regiment, to close symbolically, if not practically, the Falaise Pocket. *(Author)*

With the arrival of Allied soldiers in Chambois came accounts of the Dante-esque scenes that confronted them in the town.

This account from a 359th Infantry Regiment report is representative of what they encountered:

'Moving into Chambois the Jerry motor pool before us consisted of more than a dozen trucks, some American manufacture, two half tracks, a supply truck, a chow wagon horse drawn. Around the vehicles and in the traces of the horses were scores of dead Germans, some hideously dismembered by artillery shells. On the main street just at the junction of the alley was an abandoned German troop carrier and beside it two Mk V Panther tanks, knocked out and burning. This street was littered with dead Germans, SS and Panzer troopers. The gutters ran with blood and the houses were in flames on either side of the road.'

Source: 359th Infantry, Operational Activity 1–31 August 1944, USNA.

STAND D2: POLISH INTERDICTION OF GERMAN ESCAPE ROUTES, 20 AUGUST

DIRECTIONS: Continue in the same direction past the church over a small bridge. The road bends right and goes uphill.

Take the first turning on the left, which is a very narrow, single-track lane with grass in the middle. This will bring you back to the D13 east of Chambois, from which you can turn left towards the town. (This is a slightly tricky junction with poor visibility so the less adventurous may prefer simply to retrace their route from the church at Stand D1.) On reaching the town turn right at the crossroads onto the D16. Take the first road on the left, Rue Louis Pellerin, and follow this windy, single-track lane as it ascends gradually out of the village. When you come to a T-junction turn right and stop at the dirt track on the right, at the end of the first field. This position affords a fine view of the *donjon* (castle keep); for Stand D2 look westwards toward Moissy and St-Lambert-sur-Dive.

THE ACTION: After providing supporting fire for the Polish assault on Chambois, on 19 August 10th Mounted Rifle Regiment remained north-west of the town near Hill 113. From here it could cover the ground west towards Moissy and St-Lambert and interfere with German movements out of the pocket. From its positions on Hill 113 the Polish reconnaissance regiment's Cromwell tanks and a detachment of self-propelled anti-tank guns took a fearful toll on German columns attempting to break out to the north. A mass German break-out attempt past 10th Mounted Rifle Regiment's positions began at 0245 hours on 20 August. The Germans were met with a rain of fire that destroyed scores of armoured and soft-skinned vehicles and which left an estimated 1,000 dead and wounded in front of the Polish positions, according to the regiment's war diary.

During this action an estimated 800 German prisoners were taken, including a number of very high rank. The most senior was *Generalleutnant* Otto Ellfeldt, commander of LXXXIV Corps. Controlling and removing these prisoners to a secure area was quite a problem and they were therefore handed over to 90th US Infantry Division for evacuation.

At 0830 hours 10th Mounted Rifle Regiment's commanding officer, Major Jan Maciejowski, was killed by a German sniper, and a shortage of ammunition made the

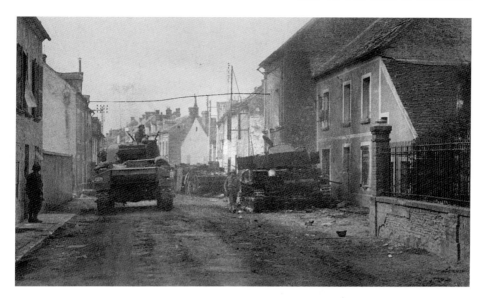

regiment's situation increasingly difficult as the day wore on. 10th Mounted Rifle Regiment's 3rd Squadron ran out of ammunition for its Cromwell tanks, using up its last belts of machine-gun rounds and all the shells for the tanks' cannon. Given the lack of means with which to fight and the fact that it had a mass of prisoners to control, in the late afternoon 10th Mounted Rifle Regiment was ordered to move to the eastern side of Chambois, near the US positions. Its battle ended at 2030 hours on 20 August.

A Polish Sherman moves down a street in Chambois. At the edge of the road can be seen American soldiers of 90th Infantry Division. (PISM 2569)

STAND D3: CHAMBOIS, 20–21 AUGUST

DIRECTIONS: Retrace your route to the centre of Chambois and pull in at the parking area beside the *donjon*. Walk to the monument commemorating the juncture of the Allied armies.

THE ACTION: After the Americans and Poles linked up in Chambois, the next problem became organising and co-ordinating the defence of the town and interdicting the remaining German escape routes, particularly between Chambois and St-Lambert. After consultation the US and Polish forces agreed zones of responsibility. Six rifle companies of 359th US Infantry Regiment, supported by

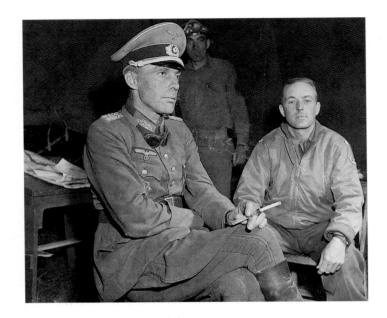

Generalleutnant Otto Ellfeldt, commander of LXXXIV Corps, as an American prisoner of war. Captured by the Poles near Hill 113 on 20 August, he was subsequently placed in American custody. Ellfeldt was the most senior German officer to become a POW in the battle to close the Falaise Pocket. *(USNA)*

tanks and tank destroyers, took responsibility for most of the southern portion of the town. The Polish battlegroup, consisting of tanks from 24th Armoured Regiment, motorised infantry of 10th Dragoon Regiment and the armoured reconnaissance elements of 10th Mounted Rifle Regiment, along with an anti-tank detachment, took the north side.

The combat strength of the combined force was quite substantial. 2/ and 3/359th Infantry enjoyed the advantage of remaining in contact with 90th Infantry Division's supply chain and also enjoyed considerable artillery support. The Polish battlegroup, however, was the most forward element of 1st Polish Armoured Division and was cut off from its logistical support. Moreover, the Poles were exhausted by two weeks of operations, with the last week being particularly intense and conducted at a high tempo. 359th Infantry Regiment's leadership, exhibiting flexibility and a 'can do' attitude, convinced higher echelons of command of the critical nature of the Polish supply situation. Polish armour, for example, lacked enough petrol even to drive to le Bourg-St-Léonard to refuel. V US Corps, once convinced of the acuteness of the problem, acted swiftly and delivered

4,400 gallons of fuel, 140,000 rounds of .30-calibre ammunition and 189 rounds of 75-mm tank ammunition. This re-supply was vital in keeping the Polish battlegroup in action. Apart from looking after its own sector of Chambois, the Poles were able to give their US counterparts occasional support in the form of Sherman Fireflies of 24th Armoured Regiment, as well as providing artillery observers so that fire from II Canadian Corps could be added to that of the US Army at critical points.

The American and Polish soldiers in Chambois faced constant pressure and risks of infiltration by German soldiers seeking to escape from the pocket. As at St-Lambert and the Mace, 20 August was filled with activity around Chambois, with the Allies attempting to interdict German movement, particularly between Chambois and St-Lambert. Moreover, with large numbers of German soldiers surrendering, managing prisoners and evacuating them to POW pens was a considerable challenge. Although fighting continued on 21 August, by evening it was clear that the battle to close the Falaise Pocket was nearing an end as the German soldiers were either dead, prisoners or had escaped the encirclement. In the coming days, the American and Polish soldiers would withdraw from Chambois to staging areas to rest before their next tasks.

The view of Chambois from the north side of the village. From positions on Hill 113 in this area, the Polish battlegroup attempted to interdict the escape of German forces in the Moissy corridor to the west. (Author)

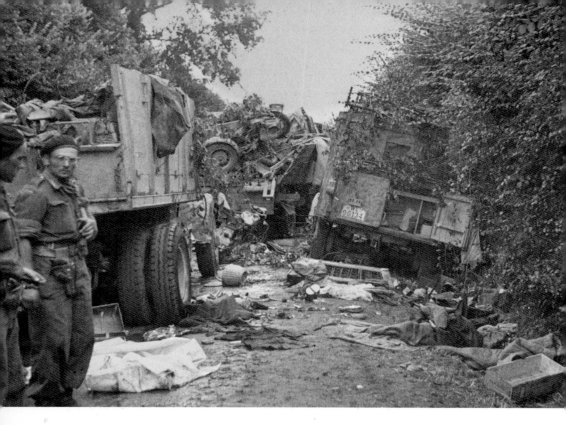

Polish soldiers
survey the
wreckage of the
German defeat
in Normandy
on a road near
Chambois,
August 1944.
(PISM 2585)

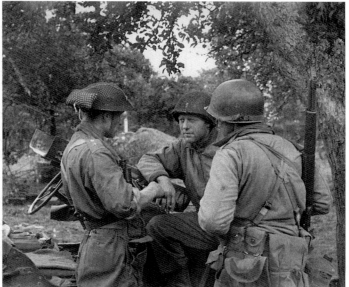

A Polish officer consults his American counterparts in Chambois. Cut
off from its own supply chain, the Polish battlegroup was supplied by
the US Army. *(PISM 2575)*

When relieved by British 50th Infantry Division, 359th US Infantry Regiment left Chambois celebrating victory in considerable style:

'On Monday the order came to leave Chambois and the word to the men was "take anything you can drive". In a frantic scouring of the fields the take included: thirty-five fine cavalry horses, twenty-five automobiles and trucks, including one 1939 Studebaker President, converted into a truck... It was a gay happy convoy that moved south that day to the cheers of the French along the roads, and the British troops who moved into Chambois to relieve us.'

Source: 359th Infantry, Operational Activity 1–31 August 1944, USNA.

ENDING THE TOUR: From the centre of Chambois follow the D13 towards St-Lambert-sur-Dive and Trun from where you can retrace your route to Falaise.

American soldiers pose with a Nazi flag in Chambois on 20 August. Another day of hard fighting remained before the guns fell silent over the Falaise Pocket. *(USNA)*

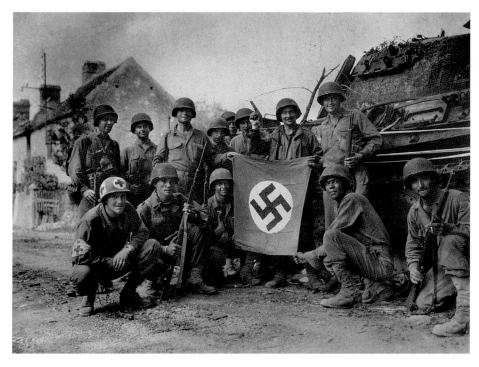

ON YOUR RETURN

FURTHER RESEARCH

If this book has stimulated your interest in the battle of the Falaise Pocket, you may wish to learn more about the battle and its participants. Indeed, it can be particularly rewarding to 'prep' a visit by finding out more about the fighting before walking the ground on a tour.

The research for this book included much primary source material including war diaries and after-action reports detailing events on the battlefield. For the Canadian Army, The Public Archives of Canada in Ottawa, the UK National Archives (formerly called the Public Record Office) and the Imperial War Museum are key record depositories. These institutions also hold some records related to 1st Polish Armoured Division. The most important source for the Polish armoured division, however, is the Polish Institute and Sikorski Museum in London. For the US Army, the US National Archives in Washington DC contain much valuable material on operations in Normandy. Copies of period military maps covering the area of the battlefield in various scales can be acquired from the British Library in London. Memoirs and unit histories provide further insights into the events of 1944. The published accounts of individual participants provide an indispensable source of first-hand information. As with other sources, these personal accounts vary in quality, quantity and accessibility. For example, memoirs of soldiers of 1st Polish Armoured Division are abundant but many are in Polish. Many published sources may be out of print, necessitating the services of inter-library loan or a visit to a major research library. The following select bibliography contains some of the most valuable and useful memoirs and books:

Blumenson, Martin, *Breakout and Pursuit*, Washington DC, 1961

Blumenson, Martin, *The Battle of the Generals: The Untold Story of the Falaise Pocket – The Campaign that Should Have Won World War II*, New York, 1993

The crew of a Polish Sherman Firefly relax after battle. *(PISM 2626)*

Page 186: A Canadian anti-tank gun and its cheerful crew drive down a dusty road in pursuit of the German forces' retreat from Normandy. *(NAC PA-132421)*

Bradley, Omar N., *A Soldier's Story of the Allied Campaigns from Tunis to the Elbe*, London, 1951

Cooper, Belton Y., *Death Traps: The Survival of an American Armored Division in World War II*, Novato, CA, 1998

Copp, Terry, *Fields of Fire: The Canadians in Normandy*, Toronto, 2003

D'Este, Carlo, *Decision in Normandy*, London, 1994

Eisenhower, Dwight D., *Crusade in Europe*, London, 1948

Ellis, L.F., *Victory in the West: The Battle of Normandy* Vol. I, London, 1962

Florentin, Eddy, *Battle of the Falaise Gap*, London, 1965

Fuller, J.F.C., *The Decisive Battles of the Western World and Their Influence Upon History*, London, 1954

Fürbringer, Herbert, *9. SS-Panzerdivision*, Bayeux, 1984

Gooderson, Ian, *Air Power at the Battlefront: Allied Close Air Support in Europe, 1943–45*, London, 1998

Hart, Russell A., *Clash of Arms: How the Allies Won in Normandy*, London, 2001

Hart, Stephen Ashley, *Montgomery and 'Colossal Cracks': The 21st Army Group in Northwest Europe, 1944–45*, Westport, CT, 2000

Isby, David C., *Fighting the Breakout: The German Army in Normandy from 'Cobra' to the Falaise Gap*, London, 2004

Keegan, John, *Six Armies in Normandy: From D-Day to the Liberation of Paris*, London, 1983

Kitching, George, *Mud and Green Fields*, Langley, BC, 1986

Koszutski, Stanisław, *Wspomnienia z różnych pobojowisk*, London, 1972

Leleu, Jean-Luc, *10. SS-Panzerdivision*, Bayeux, 1999

Lehmann, Rudolf & Tiemann, Ralf, *The Leibstandarte*, Vol. IV Pt. 1, Winnipeg, 1993

Maczek, Stanisław, *Od podwody do czołga: wspomnienia wojenne 1918–1945*, Edinburgh, 1961

Meyer, Herbert, *The History of the 12. SS-Panzerdivision Hitlerjugend*, Winnipeg, 1994

Montgomery, B.L., *Normandy to the Baltic*, London, 1947

Neillands, Robin, *The Battle of Normandy 1944*, London, 2002

Patton, George S., Jnr., *War as I Knew It*, Boston, 1995

Reardon, Mark, *Victory at Mortain*, Lawrence, 2002

Rohmer, Richard, *Patton's Gap*, London, 1981

Shulman, Milton, *Defeat in the West*, London, 1986

Stacey, C.P., *The Victory Campaign: The Operations in North-West Europe 1944–1945*, Vol. III, Ottawa, 1960

Willmott, H.P., *The Great Crusade: A New Complete History of the Second World War*, London, 1989

USEFUL ADDRESSES

UK National Archives, Public Record Office, Kew, Richmond, Surrey TW9 4DU; tel: 020 8876 3444; email: <enquiry@nationalarchives.gov.uk>; web: <www.nationalarchives.gov.uk>.

Imperial War Museum, Lambeth Road, London SE1 6HZ; tel: 020 7416 5320; email: <mail@iwm.org.uk>; web: <www.iwm.org.uk>.

Public Archives of Canada, 395 Wellington Street, Ottawa, Ontario K1A 0N3; tel: +01 613 9470 391.

US National Archives, The National Archives and Records Administration, 8601 Adelphi Road, College Park, MD 20740–6001; tel: +01 866 272 6272; web: <www.archives.gov>.

The Polish Institute and Sikorski Museum, 20 Princes Gate, London SW7 1PT; tel: 020 7589 9249.

British Library, 96 Euston Road, London NW1 2DB; tel: 020 7412 7676; <email: reader-services-enquiries@bl.uk>.

University of Keele Air Photo Library, Keele University, Keele, Staffordshire ST5 5BG; tel/fax: 01782 583395; web: <evidenceincamera.co.uk>.

INDEX